SOFA
CHICAGO
SCULPTURE OBJECTS
& FUNCTIONAL ART

The Thirteenth Annual International Exposition of Sculpture Objects & Functional Art

November 10-12
Navy Pier

A project of Expressions of Culture, Inc.
a dmg world media company

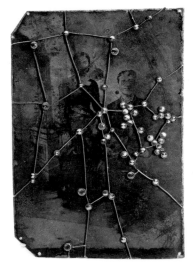

front cover:
Bettina Speckner
Brooch, 2005
ferrotype; silver, marcasite, rubies
3.5 x 2.25
represented by Sienna Gallery

All dimensions in the catalog
are in inches (h x w x d)
unless otherwise noted

Library of Congress – in Publication Data

SOFA CHICAGO 2006
The Thirteenth Annual International
Exposition of Sculpture Objects & Functional Art

ISBN 0-9713714-7-4
2006906807

Published in 2006 by Expressions of Culture, Inc., – a dmg world media company, Chicago, Illinois

Graphic Design by Design-360° Incorporated, Chicago, Illinois
Printed by Pressroom Printer & Designer, Hong Kong

SOFA CHICAGO
SCULPTURE OBJECTS
& FUNCTIONAL ART

Expressions of Culture, Inc.
a dmg world media company
4401 North Ravenswood, #301
Chicago, IL 60640
voice 773.506.8860
fax 773.506.8892
www.sofaexpo.com

Mark Lyman, founder and director
Anne Meszko
Julie Oimoen
Kate Jordan
Greg Worthington
Barbara Smythe-Jones
Patrick Seda
Bridget Trost
Michael Macigewski

Conte

S O F A
CHICAGO
SCULPTURE OBJECTS
& FUNCTIONAL ART

Welcome to SOFA CHICAGO 2006!

Welcome to SOFA CHICAGO 2006!

We are very excited that Chubb and *Collectify* are major sponsors of CHICAGO 2006. Both are high-profile business leaders in the arts. Their generous sponsorship has made special things happen at the exposition, including very strong Lecture Series and Special Exhibit presentations, and the terrific addition of a VIP lounge—a place to meet and greet friends and make new acquaintances.

Much effort has been made to make the exposition and Opening Night a true *mise en scène*—a French theater term that means "putting on stage"—attracting an eclectic mix of established collectors and a younger group of potential ones. Nurturing a new generation of art lovers is key to the development of our field. Central to this effort is the launch of SOFAsphere, SOFA's new interactive online community. Tailored for those interested in creativity, virtuosity and materiality in all media, SOFAsphere's goal is to increase SOFA's reach between expositions and across the art market. Members can connect and communicate with a wide range of international arts-interested persons, anytime, anywhere, both inside and beyond the SOFA community. *Widen your Circle* – is our basic message to the art community. Stop by the SOFAsphere booth at the show, take the site for a "test drive" and build your member profile now!

International participation continues to grow at SOFA CHICAGO 2006. Eleven new galleries from Denmark, Japan, Israel, France, Czech Republic, Hong Kong, South Korea, Switzerland, Ireland, England and Canada, join returning galleries from Australia, Argentina and Italy. These additions make this SOFA CHICAGO the largest ever in terms of square footage. Many exhibitors have designed stunning custom booths and held back artists' work from market to make comprehensive presentations at the show. Special Exhibits mounted by the Crafts Council of Ireland and World Ceramic Exposition Foundation of Korea, producer of the prestigious World Ceramic Biennale Korea, add international scope. The Lecture Series is truly globally diverse—many thanks to the individuals and organizations around the world who contributed programming ideas, expertise, and support.

Special thanks to the Association of Israel's Decorative Arts (AIDA), presenting a curated special exhibit of contemporary decorative artwork by artists currently living in Israel for the fourth straight year at SOFA CHICAGO. Conceived and developed in 2003 by Charles Bronfman, and his late wife, Andrea, or Andy as she was called by her friends, AIDA has fostered the careers of 21 AIDA exhibiting artists to-date, who as a result of their exposure at SOFA CHICAGO, have acquired US gallery representation. Anne and I traveled to Israel this spring as guests of AIDA, and were honored to be present when Charles Bronfman awarded the first Andrea M. Bronfman Prize for the Arts ("The Andy") at the Eretz Israel Museum in Tel-Aviv. Mr. Bronfman established the prize as a 60th birthday present to Andy, honoring her life-long passion for and support of the arts, and to create a showcase for Israeli decorative artists. 41 AIDA supporters from the United States attended "The Andy" award ceremony, at which Israeli Prime Minister Ehud Olmert and his wife, Aliza, a well-known artist, spoke. Special thanks to AIDA for our amazing experience in Israel, especially Charles Bronfman, Doug and Dale Anderson, Norm and Elisabeth Sandler, Erika Vogel and Jason Soloway.

A year ago, Expressions of Culture, Inc. (EOC), producer of SOFA, joined the dmg world media family of global companies; one year later, we are delighted by our strong, positive alliance. Dmg is a great supportive partner that enhances our ability to do business and to grow!

We hope you love SOFA CHICAGO 2006 as much as we enjoyed organizing it. Every SOFA is a new adventure, a new *mise en scène*—a widening of the circle.

ENJOY!

Mark Lyman
Founder and Director,
Expressions of Culture, Inc.

Anne Meszko
Director of Advertising and
Educational Programming

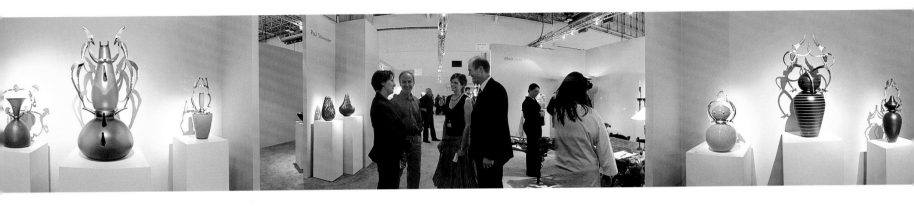

Expressions of Culture, Inc. would like to thank the following individuals and organizations:

Participating galleries, artists, speakers and organizations
American Airlines
American Craft Council
Aaron Anderson
Dale Anderson
Doug Anderson
Art & Antiques
Art Alliance for Contemporary Glass
Art Jewelry Forum
Association of Israel's Decorative Arts
Thomas Samuel Bailey
Bannerville
David Barnes
Judy Bendoff
Barbara Berlin
Kathy Berner
Jim Bradaric
Lou Bradaric
Jonas Breneman
Charles Bronfman
John Brumgart
Desiree Bucks
Anthony Camarillo
Carol Fox Associates
Mark Carr

Chicago Art Dealers Association
Chicago Event Graphics
Chicago Park District
Julian Chu
Chubb Group of Insurance
Pam Clark
Anne Clasen
Kelly Colgan
Collectors of Wood Art
Camille Cook
Keith Couser
John Cowden
Mary Daniels
David Daskal
Design-360°
Dietl International
Digital Hub
Floyd Dillman
Dobias Safe Rental
Hugh Donlan
Anne Dowhie
Lenny Dowhie
Marianne Encarnado
D. Scott Evans
Jane Evans

Sean Fermoyle
Fiberarts Magazine
Focus One
Carol Fox
Friends of Contemporary Ceramics
Friends of Fiber Art International
Don Friedlich
The Furniture Society
Steve Gibbs
Judith Gorman
Luis Granados
Fern Grauer
Kathryn Gremley
Lauren Hartman
Jennifer Haybach
Bruce Heister
Scott Hodes
Holiday Inn City Centre
Hotel Indigo
Irish Crafts Council
J & J Exhibitor Service
Scott Jacobson
James Renwick Alliance
Mike Jentel
Jae Young Kang

John Michael Kohler Arts Center
Howard Jones
John Keene
Brian Kennedy
Dan Klein
Ryan Kouris
Lakeshore Audio Visual
Edward Lebow
Richard Lewis
Lillstreet Art Center
Matthew Lipinski
Ellie Lyman
Nate Lyman
Sue Magnuson
Jeanne Malkin
Marianne Mays
George Mazzarri
Lani McGregor
Laresa McIntyre
Metropolitan Pier & Exposition Authority
Gretchen Meyer
Mark Moreno
Niki Morrison
Iain Muirhead
Bill Murphy
Cathy Murphy
Nancy Murphy

Susan Murphy
Kathleen G. Murray
Museum of Arts & Design
Ann Nathan
Hal Nelson
NFA Space Contemporary Art + Exhibit Services, Inc.
Wells Offutt
John Olson
Mark Parra
Jan Peters
Commissioner Michael J. Picardi
Pilchuck Glass School
Jennifer Piotter
Pressroom Printer & Designer
Christoph Ritterson
Bruce Robbins
Pat Rodimer
Elisabeth and Norman Sandler
Linda Schlenger
Miroslava Sedova
Sheraton Chicago Hotel & Towers
Stacey Silipo
Franklin Silverstone

Dana Singer
Aviva Ben Sira
Ken Sitkowski
Sharon Smolinsky
Dave Smykowski
Society of North American Goldsmiths
Cyndi Solitro
Jason Soloway
Surface Design Association
Craig Swiatkowski
Richard Thompson
UNC Center for Craft, Creativity & Design
Natalie van Straaten
Erika Vogel
Danny Warner
James White
Christina Root Worthington
Don Zanone
Karen Ziemba

RICHARD M. DALEY
MAYOR

November 10, 2006

Greetings

As Mayor and on behalf of the City of Chicago it is my pleasure to welcome everyone attending the 13th Annual International Exposition of Sculptural Objects and Functional Art: SOFA CHICAGO 2006 at Navy Pier.

SOFA CHICAGO 2006 features a wide variety of artistic styles and media from glass, ceramics and wood to metal and fiber. This thirteenth annual art exposition features the works of nearly 800 artists from over 100 international galleries and dealers. Continuing this year will be sculptural glass presentations, over 30 lectures series and several special exhibits.

Chicago has a long and vibrant artistic tradition and we are proud to host SOFA CHICAGO 2006. I commend the artists represented here for their talent and hard work, as well as Expressions of Culture, Inc. for bridging the worlds of contemporary, decorative and fine art. May you all have an enjoyable and memorable exposition.

Sincerely,

Mayor

CHICAGO ART DEALERS ASSOCIATION

730 North Franklin
Suite 308
Chicago, Illinois
60610

Phone
31.649.0065

Fax
312.649.0255

November 9, 2006

Mark Lyman
Executive Director
Expressions of Culture, Inc.
4401 N. Ravenswood, #301
Chicago, IL 60640

Dear Mark,

Congratulations to you and everyone at SOFA CHICAGO for bringing your 13th annual exposition to our city, once again offering outstanding Sculpture, Objects and Function Art to local and international collectors and visitors. With work bridging decorative and fine arts in a wide range of media, SOFA CHICAGO contributes greatly to the cultural life of our city, and attendees look forward to the exposition each year.

On behalf of the members of the Art Dealers Association of Chicago, I extend our appreciation to you and everyone involved in SOFA for your efforts in creating a truly great event. We also send our best wishes to you and all the participating galleries and artists for a very successful show once again this year.

Sincerely yours,

Roy Boyd

Roy Boyd, President
Chicago Art Dealers Association

Lecture Series and
Special Exhibits

ectures

Lecture Series

sponsored by SOFA CHICAGO 2006

Friday

November 10

Admission to the 13th Annual SOFA CHICAGO Lecture Series is included with purchase of SOFA ticket.

9:00 – 10:00 am, Room 309
Emerging Artists 2006
Brooke Marks Swanson, Natalya Pinchuk and Hye-young Suh, all recent MFA graduates from the jewelry and metalsmithing program at the University of Illinois in Urbana-Champaign, speak about the development of their jewelry and objects. *Sponsored by the Society of North American Goldsmiths*

9:00 – 10:30 am, Room 301
Divergent Directions in Fiber Part I
Artists JoAnne Russo, Ruth McCorrison, Beth Nobles, Ayelet Lindenstrauss Larsen and Dorothy Caldwell discuss the material differences in their work. *Presented by Friends of Fiber Art International*

10:00 – 11:00 am, Room 305
Pratt Fine Arts Center: A Resource for Artists
The nurturing, multi-disciplinary environment of Pratt in Seattle, WA, has shaped the work of many established artists since its founding in 1976. Jenny Pohlman and Sabrina Knowles, artists and faculty

10:00 – 11:30 am, Room 309
The Presence of Absence: The Artist's Perspective
Special exhibit curator Hal B. Nelson, director, Long Beach Museum of Art, discusses aspects of negative space and Asian influences with artists Mark Lindquist, Gyöngy Laky and William Hunter. *Presented by Collectors of Wood Art*

10:30 am – 12:00 pm, Room 301
Divergent Directions in Fiber Part II
A further exploration of material differences by fiber artists David Chatt, Judy Mulford, Tom Lundberg, Carol Eckert and Leslie Pontz. *Presented by Friends of Fiber Art International*

11:00 am – 12:00 pm, Room 305
John Michael Kohler Arts Center: The Road Less Traveled
A dynamic overview of the Arts Center in Sheybogan, WI, followed by a discussion of its collection of works of art by vernacular environment builders. Leslie Umberger, director, and Ruth DeYoung Kohler, senior curator of exhibitions and collections

11:30 – 12:30 pm, Room 309
Pala/Palova – Two Individuals, One Team
An important retrospective exhibition is planned for 2007 in Prague, celebrating the partnership of husband and wife glass artists Stepan Pala and Zora Palova, from Slovakia. Dan Klein, art historian and curator, London

12:30 – 1:30 pm, Room 301
For Love or Money - Women and Ceramics in Wales
Based on a current research project, the talk will consider contemporary issues, key artists and different ways that makers draw on a rich cultural heritage. Moira Vincentelli, senior lecturer in art history and curator of ceramics, University of Wales, Aberystwyth, UK

1:00 – 2:00 pm, Room 305
Twenty Years of Glass in a Changing World
Japanese artist Naomi Shioya discusses the evolution of her work in glass from colorful, mosaic-like pieces to cast monochromatic sculptures.

1:00 – 2:00 pm, Room 309
Tangling Classic Lines
Studio jeweler Mary Preston embraces traditional forms of ornamentation in her work, drawing on the decorative arts to expand the lexicon of contemporary jewelry. *Presented by Art Jewelry Forum*

1:30 – 2:30 pm, Room 301
Quality Critical Writing on Craft – Who Benefits?
Bruce Metcalf, co-author, 20th Century American Studio Craft; Andrew Glasgow, director, Furniture Society; Jim Romberg, director, Eagleheart Center for Art and Inquiry, CO; moderated by Jean McLaughlin, director, Penland School of Crafts. *Presented by the UNC Center for Craft, Creativity & Design*

2:00 – 3:00 pm, Room 309
Line, Form, Shadow
Artist Daniel Clayman discusses the ideas which led to his recent installation at the Fuller Craft Museum in Brockton, MA

2:30 – 3:30 pm, Room 301
Transforming Vision: William Hunter Retrospective
An exploration of the nationally touring exhibition Transforming Vision: William Hunter, 1970 – 2005, from three perspectives: Bill Hunter, artist, Kevin Wallace, curator, and Hal B. Nelson, director, Long Beach Museum of Art, CA. *Presented by Collectors of Wood Art*

3:00 – 4:00 pm, Room 309
The Everyday and the Faraway
Bettina Speckner discusses the relationship between her art and travel, and how the use of photography in her jewelry allows her to connect and contradict the intimacy of jewelry. *Sponsored by the Society of North American Goldsmiths*

3:30 – 4:30 pm, Room 301
Where the Rainbow Ends
Artists Steve Klein, Silvia Levenson, Catharine Newell and Ted Sawyer discuss their experiences at North Lands Creative Glass in the Scottish Highlands, and its impact on their work; with Rose Watban, curator, National Museums of Scotland; and art historian / moderator Dan Klein.

3:30 – 4:30 pm, Room 305
New Digs!
In 2009/2010, the Mint Museum of Craft + Design, Charlotte, NC, relocates to a new building. Come see the museum's new digs and learn how the museum will show-case its world class collection. Mark Leach, chief curator, Mint Museum of Craft + Design

4:00 – 5:00 pm, Room 309
Music Through the Loom
Artist and technician Bahram Shabahang explores the technique and artistry of contemporary Persian carpets.

Special Exhibits

Saturday
November 11

9:00 – 10:00 am, Room 301
Art of Steel
Artist **Jim Rose** transforms colorful found steel into functional furniture inspired by Shaker design.

10:00 – 11:00 am, Room 305
Fired with Passion-Contemporary Japanese Ceramics
Co-authors Beatrice Chang, director, Dai Ichi Arts, NY, and Samuel J. Lurie, collector of Japanese ceramics for over 20 years, discuss their recently-published book.

10:00 – 11:00 am, Room 309
Hollowware: Inspired by Natural Elements
A survey by metalsmith **Sue Amendolara** of traditional metal-smithing processes and their use in the creation of natural forms in hollowware. *Sponsored by the Society of North American Goldsmiths*

10:00 – 11:30 am, Room 301
Surface Diversity: Directions in Fiber
Artists **Cindy Hickok, Michael Rohde** and **Barbara Lee Smith** discuss their inspiration, process and current work. *Presented by the Surface Design Association*

11:00 am – 12:00 pm, Room 309
Contemporary Korean Ceramics and the World Ceramic Exposition Foundation: The Total Ceramic Experience
An overview of contemporary Korean ceramics and the multi-complex of facilities that constitute the backdrop for the Korean Biennale-the richest international competition for ceramics. **Dr. Judith Schwartz,** NYU department of art and art professions

11:30 am – 12:30 pm, Room 301
Forty Shades of Green: A Convergence of Irish Art and Craft
Insights into the contemporary craft scene in Ireland and the special exhibit Forty Shades of Green, presented at SOFA by the Irish Crafts Council. **Brian Kennedy,** artist and curator, Ireland

12:30 – 1:30 pm, Room 301
Sergei Isupov: My American Life 1996 – 2006
Isupov presents images from the decade following his debut at SOFA CHICAGO in 1996.

1:00 – 2:00 pm, Room 309
Commercial Value vs. Content: Is there a Survivable Balance
A discussion of ethical questions about visual art, the acceptable reasons for making art ...and who really cares. Artist **Michael E. Taylor**

1:30 – 3:00 pm, Room 301
The Art of Collecting Fiber: Four Perspectives
Curator **Polly Ullrich,** collectors **Sharon Hoogendoorn** and **Cathy Wice,** and **Jane Sauer,** owner/director, Jane Sauer Thirteen Moons Gallery, discuss the who, why and how of collecting fiber art. *Presented by Fiberarts magazine*

2:00 – 3:00 pm, Room 309
Contemporary Ceramic Works from the Aboriginal Lands of Australia's Western Desert: a Historical Perspective
The development of the ceramics movement in the Pitjatjantjara/Yankunytjatjara Aboriginal Lands of Australia's remote Western Desert, and its contemporary practice. **Dr. Christine Nicholls,** senior lecturer, Australian Studies, Flinders University, South Australia

3:00 – 4:00 pm, Room 301
A William Carlson Career Perspective
Carlson holds the Endowed Chair in the Arts at the University of Miami, and is the recipient of Art Alliance for Contemporary Glass' annual award to a program or institution that has significantly furthered the studio-glass movement. *Presented by AACG*

3:00 – 4:00 pm, Room 309
Shaping the Future
Renowned fiber artist **Warren Seelig** and a guest explore how new artists self identify, and the ways in which artists and galleries are expanding, rethinking and redefining traditional parameters. *Presented by the American Craft Council*

4:00 – 5:00 pm, Room 301
Contemporary Chinese Sculpture in Glass
An overview of the contemporary scene in China with artists **Qin Wang, Jaffa Lam Laam** and art historian/curator **Susanne Frantz.**

4:00 – 5:00 pm, Room 309
Basketry as Sculpture: When Form Leaves Function Behind
"Form ever follows function" according to architect Louis Sullivan (1856-1924). What changes as basket forms leave function behind? **Jerry Bleem,** adjunct assistant professor, School of the Art Institute of Chicago. *Presented by National Basketry Organization*

Progressions
A curated exhibit of contemporary decorative artwork by artists currently living in Israel. *Presented by the Association of Israel's Decorative Arts (AIDA)*

Material Difference Too
Fiber objects from private collections in the Midwest, presented by Friends of Fiber Art International in conjunction with their 15th anniversary, complementing their exhibit, *Material Difference*, at the Chicago Cultural Center. *Curated by Polly Ullrich*

The Presence of Absence: Contemplating the Void in Contemporary Wood Sculpture
A selection of contemporary works in wood that celebrate the void – the negative space within or around, their turned, carved or constructed forms. *Presented by Collectors of Wood Art; curated by Hal B. Nelson, director, Long Beach Museum of Art, CA*

40 Shades of Green
A representation of the vision and work of 40 makers across the fields of craft, fine art and writing in Ireland. *Presented by the Crafts Council of Ireland, curated by Brian Kennedy*

Jubilee! 50 Years on 53rd Street
A golden anniversary exhibit presented by the Museum of Arts & Design, New York, featuring masterworks from each decade since the Museum opened in 1956, all from its permanent collection.

Tradition and Innovation – Spotlight on Korean Contemporary Ceramics
Presented by the World Ceramic Exposition Foundation (wocef) Korea, producer of the World Ceramic Biennale. *Curated by Jaeyoung Kang, chief curator, WOCEF*

Turned Wood Art
A selection of pieces presented by the American Association of Woodturners. *Curated by Mary Lacer, assistant executive director, AAW*

SOFA 2006

Essays

Ten Years of North Lands Creative Glass

By Dan Klein

A.

It is ten years since Bertil Vallien rashly agreed to come and lead the first Master Class at North Lands Creative Glass in Lybster, Scotland. He knew very little about us as there was very little to know at the time. A group of friends had come up with the unlikely idea of building a small glass facility in Caithness. The local Member of Parliament Robert Maclennan (now Lord Maclennan) was keen to promote the arts in his constituency (Caithness and Sutherland in Northern Scotland, the largest in Britain). The area covers an enormous expanse of land with a stunningly beautiful North Eastern sea coast that is home to puffins and seals, a lot of sheep and highland cattle, an atomic reactor, some beautiful castles and a fairly sparse farming community, not to mention, salmon fishing, golf courses and whiskey distilleries galore. It includes John O'Groats, the most northerly point in Britain. You can still drive for miles up there without meeting much more than a tractor on the road! The landscape of seemingly endless sea and sky is magical and the quality of light amazing.

Knowing of my interest in contemporary glass, Robert Maclennan, an old friend from university days long ago, spoke of his aspirations for some kind of arts centre in Caithness. Why not an arts centre devoted to contemporary glass? He also spoke to his Caithness friends Iain and Bunty Gunn. Iain had taken early retirement and decided to return North to the area where he grew up and where his ancestry dates back many hundreds of years. The Gunn clan has its centre in Caithness and Iain, as head of the clan, is much in demand in his full Scottish regalia when the clan organises meetings in Britain, the United States and elsewhere. Since returning to Caithness, Iain and Bunty have worked tirelessly to promote the arts and local heritage. In the early 1990s they had opened a small

gallery in Lybster as a retirement project where they sold work by local artists and craftsmen. At the back of the gallery was a shed, once a joiner's and undertaker's workshop, and no longer in use as anything.

Two and two were beginning to make four! Since the beginning, Iain Gunn has been chairman of what we decided to call North Lands Creative Glass even before we knew exactly what we were going to do. The Gunns offered the shed for the project. Robert Maclennan's first job was to persuade local

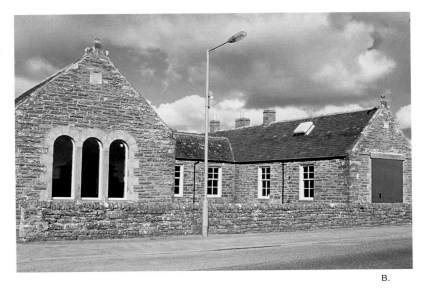

B.

funding bodies to support us, mine to persuade friends in the glass world to believe in what was little more than a dream. The first to offer their expertise, and without whom we would not have been able to get going, were Keith Cummings and Ray Flavell, both of them distinguished British glass artists and teachers. Between them they shared the roles of artistic and technical directors, oversaw the conversion of the shed into a basic yet fully functional hot shop and organised the first year's programme. The first Master Class was held in the summer of 1996 with a handful of enthusiastic students amazed to be learning from Bertil in such an out of the way place. New beginnings always have their

special aura, and this one was marked by enthusiasm and a sense of discovery. The master class also fulfilled a need as there was nothing quite like it anywhere else in Britain. One had the feeling that this was only the start.

As Andrew Page wrote in a recent article in *Urban Glass Quarterly* "The windswept village of Lybster doesn't look like home to an internationally known art center. There's no museum, and the handful of tiny shops sell groceries, not artwork. The closest airport is Inverness, nearly three hours drive on a winding two-lane highway that rises and falls along a hilly Highland coast … Yet its extreme remoteness is part of the allure of North Lands Creative Glass, which has brought artists such as Bertil Vallien, Richard Marquis, Dante Marioni, Vaclav Cigler and Klaus Moje to its workshops nestled amidst the low houses of a former fishing village." Lybster was once a main hub of the herring fishing industry, its main street wide enough for a fish market, the drilling of the local regiment and for carriages to turn without reversing. Now that the herring supply has dwindled, it is a changed community. Glass and glass artists have arrived and are making a difference.

A.
Photo montage of a Caithness croft house and a cast glass piece by Bibi Smit

B.
The Alastair Pilkington Workshop in Lybster

The greatest change happened in 2002 when the new 'Alastair Pilkington Workshop' was opened by His Royal Highness Prince Charles. It was named after the inventor of float glass who had been a good friend of his, a glass collector and someone with whom early plans had been discussed. When he died of a brain tumour, his widow Kathleen Pilkington agreed to the sale of his glass collection in order to finance something that would be a lasting memory to him. With the proceeds of this sale and generous grants from various funding bodies we were able to buy the spacious Victorian village school building and convert it into a glass workshop. Aged well over 90, Kathleen travelled from her home in the United States to Lybster to attend the opening ceremony during which Prince Charles, supervised by the Danish artist Marianne Buus, blew a large mis-shapen bubble and we were open for business!

c.

The artistic director at the time, Elizabeth Swinburne, did an excellent job of designing and working on the installation of the studio. For five years before the workshop opened we made do with our 'shed' which did not seem to put off the likes of Joel Philip Myers, Paul Stankard, Tessa Clegg (our second artistic director), Jan Erik Ritzman and Josiah McElheny. Now there is a hot glass facility, a cold-working studio, a kiln room, a mould making area, a sand-blasting area, a study room and a large kitchen which doubles up as a lecture room. Lybster Bowling Green is next door and the Golf Club immediately across the road. Plenty to do whilst waiting for the kiln temperature to come down! Two years ago we took over and refurbished the school house next door where there is comfortable accommodation for visiting artists and residents.

From the outset it was our intention to widen our scope and involve artists and designers of all kinds to work with glass including sculptors, painters, writers and photographers. Students attending these classes have found them to be as inspiring as the masters themselves. British sculptors Tony Cragg, Richard Deacon, David Nash and Alison Wilding have all taught at North Lands. Each is assisted by a glass artist of some renown. The Master Classes are accompanied by a thematic annual weekend conference between class sessions, where partying and the more serious stuff make good companions. This year the theme is The Skillful Hand and Eye: last year it was The Design Element. Driven forward by all these developments the programme extended further and further into autumn and, with a pause for the cold and dark Caithness winters, started again in spring. Residencies for artists (usually four at a time) are organised and open to anybody who cares to apply whether in mid-career or setting out as a professional. They last between four and eight weeks each during about seven months of the year, bringing people together from the four corners of the earth and often leading to lasting friendships.

In Lybster a glass artist can enjoy what amounts to total immersion. There is nothing to distract you and everything to inspire you. During the long summer evenings the sun still shines at midnight. The weather is unpredictable. Fierce winds, mist from the sea (known as the Haar) and horizontal rain make for an ever-changing land and seascape under the huge vaulted sky above. Sometimes the sea looks like sheet metal, sometimes it reflects an azure sky. When the sun shines land and sea are flooded with light. Nature seems very close at hand and artists frequently feel the urge to respond to it in their work.

Over the years a community of friends and supporters has been building up around North Lands. Iain Gunn, our chairman, lives close by and voluntarily gives up time almost every day to attend to the needs of North Lands. Our administrator, Lorna Macmillan, who is local,

holds everything together, performing a juggling act that would amaze even the most experienced of corporate managers. The office seems to be open all hours and nothing is too much trouble for her. Michael Bullen is our full time technical director responsible for maintaining and running the workshop. The board of directors meets four times a year. Each plays an important supporting role. Alan Poole's regular newsletters let the world know if anything of interest is happening. Another director, Dennis Mann, is also a long time Caithness resident, well known for his glass engraving skills. Together with Patti Niemann, a young jeweller and glass maker in the area, he has developed a series of outreach classes for children from schools in the Highlands and for adults wanting to chance an arm at glass making. Several, including the owner of the most popular local pub, have become addicts and visit the studio whenever they can. During the summer months the whole village becomes involved in North Lands activities offering bed and breakfast accommodation to visiting students and those attending the conference. Dave the local butcher has become world famous for his meat pies and has begun collecting glass.

Everybody who comes to Lybster seems to fall under its spell. Tina Oldknow has been a member of the advisory board for three years now and a visitor every year since joining, taking time off from her busy life as Curator of Modern Glass at Corning Museum of Glass. I asked her to say something about the place.

"North Lands is one of a growing yet still relatively small number of glass schools in the UK and Europe. This is important in itself, but what distinguishes North Lands, for me, is the unique mix of artists who are brought together every summer to teach, and the carefully constructed program for the conference. The annual conference assembles speakers from diverse fields in and out of the arts to address specific themes that are current and of considerable interest to me, and the conference is small enough to have a meaningful interaction between the

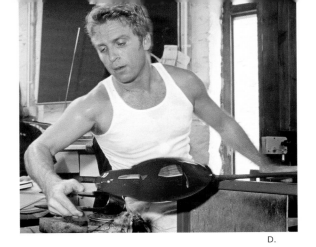

D.

speakers and their audience. What North Lands offers that cannot be matched elsewhere is an exceptional location in the powerful landscape of Caithness, with its sweeping views of ocean and moor and its rare Neolithic-era structures, and the focus that being in a small, historic village provides. While North Lands is Scottish, it is also international, and I hope and expect that the school will attract an increasing number of foreign artists from western and eastern Europe, the Mediterranean, southeast Asia and Japan, Australia, and the United States."

C.
The cold workshop at
the Alastair Pilkington
workshop

D.
Dante Marioni doing a
demonstration in the
old workshop during
his first Master Class
at Lybster in 2001

E.
H.R.H. The Prince
of Wales blowing a
bubble during his visit
to North Lands to open
the Alastair Pilkington
Workshop in 2002

F.
Kirstie Rea with work
made during a master
class led by her at
North Lands in 2004

F.

Jane Bruce, our artistic director for the last four years, has been responsible for putting together the summer programs and in this, our tenth anniversary year, has brought together old friends and new to run classes. Tessa Clegg, Dick Marquis, Dante Marioni and Steve Klein have all taught at North Lands before and are returning to help celebrate this anniversary. Alison Kinnaird, Britain's best known glass engraver, will be giving her first Master Class at North Lands, although she has been up before as a student in one of Bertil Vallien's classes during which she was introduced to sand casting. Carol McNicoll (a well known British potter) and Michael Brennand Wood (a leading textile artist) complete this year's cast list.

The anniversary is being celebrated further South as well. The National Museums of Scotland in Edinburgh have staged an exhibition called *Reflections* in their main exhibition gallery as their summer show, which runs during the Edinburgh Festival and ends in January 2007. In it 60 works donated to North Lands by visiting artists and students are exhibited along with videos that show the landscape and what it is we are doing in Caithness. The exhibition was curated by Rose Watban, curator of Scottish and European Applied Arts at the museum, who will be one of the panellists in the panel discussion about North Lands at SOFA CHICAGO. Another North Lands related

E.

19

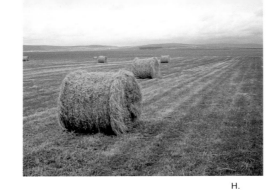

H.

G.

I.

20

event in Edinburgh is a benefit-selling exhibition generously organised by the Scottish Gallery, one of Britain's leading decorative arts galleries and a regular exhibitor at SOFA CHICAGO.

The main reason for this essay about North Lands being included in the SOFA CHICAGO catalogue is our special relationship with The Bullseye Gallery. Their stand in Chicago this year is devoted to 15 artists who work using Bullseye Glass and who have visited North Lands in one capacity or another, as masters, as technical assistants or as students. Our relationship started in 2001 with a casual conversation during SOFA shortly after 9/11 when Lani McGregor asked where one could go and hide in the world. She asked about North Lands which had been described to her by Dick Marquis and Dante Marioni as "the most amazing place in the world." I said I would send her more information which led to her and her husband Dan Schwoerer attending the 2002 conference, and suggesting a Bullseye Master Class at North Lands with glass donations and technical support staff. They were not put off by the plumbing even though Dan couldn't find the hot water switch in what we describe as a superior hotel bedroom and had to take a cold shower. The Bullseye Master Classes are now a regular feature at North Lands. Lani and Dan have since become 'addicts' to the point where they are now part-time Caithness residents in a splendid 'Manse' overlooking a wide expanse of coast line. Religious artefacts that might once have graced a vicar's home have been replaced by contemporary glass, much of it by Bullseye artists who have been lured to Caithness over the years: Jessica Lauglin, Klaus Moje, Richard Whiteley and others. Mark Zirpel, who did a North Lands residency in 2004, made a body of work inspired by the Caithness landscape which was exhibited at the Bullseye Connection Gallery in Portland, OR. As a result of the Bullseye connection with North Lands, Lani McGregor was invited to join the board this year.

On September 1, 2006 a new era begins for us with the appointment of Peter Aldridge as Chief Executive. He and his wife Jane Osborn Smith, a gifted potter and painter,

have decided to return home to Britain after spending 27 years in America living in Corning, NY. Peter has been involved with Steuben Glass both as a designer and as an executive as well as doing freelance design. His first visit to North Lands was in 2005 and it seems fitting to conclude with his feelings about coming to Caithness.

"It seems like everyone who goes to North Lands comes through the experience feeling 'changed' in some way. I was no exception. Maybe, compared to the frenetic pace of our contemporary life there is something precious about the ageless isolation in that part of Scotland that universally focuses the awareness and somehow stills the mind to question, to make new connections.

Certainly, there is an immense power in the quality of light that illuminates the sea and surrounding landscape, which makes it a magical and inspirational place to be.

The thing that further sets North Lands apart from most successful glass schools is not just great facilities and informed technique. Those requirements go without saying these days. It has attracted some of the most outstanding practitioners from around the world not just to have students emulate their technique but because there is a mature dialogue central to every course, which brings about individual growth regardless of where a person may be in their professional life."

Dan Klein is known internationally as a writer, curator and collector of contemporary glass. After many years first as a dealer (1975-1985) and later as an auction house expert (1985-2002) he now has an interest in the secondary market and continues to be actively involved in the world of contemporary glass in a variety of ways. He was a founding director of North Lands Creative Glass and is Chairman of their advisory board. He is also a trustee of the National Glass Centre in Sunderland and visiting professor at the University of Sunderland.

Published in honor of the 10th anniversary of North Lands Creative Glass in Lybster, Scotland. Artworks by 15 artists using Bullseye Glass, who have visited the Centre are exhibited by The Bullseye Gallery at SOFA CHICAGO 2006.

J.

K.

G.
Land, sea and sky
near Lybster

H.
Bales of hay in a
Caithness Field

I.
April Surgent
More Than You
2006
fused and cameo-engraved glass
18 x 17.875 x 2.25
photo: R. Watson

J.
Steve Klein
Lybster Field
Cast glass sculpture
based on a Caithness
landscape with bales
of hay

K.
The hot shop at the Alastair
Pilkington Workshop

The Presence of Absence: Exploring the Void in Contemporary Wood Sculpture

By Hal Nelson

A.

For over fifty years, artists throughout this country, Europe and Asia, have investigated the seemingly infinite formal and expressive potential of contemporary wood sculpture. Through a broad range of approaches to form and process, these sculptors have exploited wood's most fundamental properties, including a natural association with its source – the enduring, but constantly-changing, nature of the tree itself.

While some artists have emphasized the substance of their medium, its weight, bulk and mass, others have investigated its opposite – the pure empty space surrounding form. Turners, in particular, who typically remove mass to create shapes that contain empty space – vessels – are keenly aware of the inter-relationship of solid and void, a relationship that results from the dynamic process of turning wood.

From the elegantly-proportioned lathe-turned vessels of Bob Stocksdale to the witty constructs of John McQueen, artists have used wood to celebrate the void – the negative space within or around their turned, carved or constructed forms – and have considered "the presence of absence" central to their work.

Many contemporary artists who have been particularly influenced by non-Western culture, view empty space as a fundamental element in their formal vocabulary, as essential to their sculpture as its weight and mass. Numerous sculptors, Eastern and Western, alike, have embraced the concept of Ma (the recognition and celebration of negative space), a principal central to Asian aesthetics, as fundamental to their work. This is particularly true of wood sculpture, fiber, and basketry which are so deeply indebted to Asian traditions, forms and practice.

The Presence of Absence explores contemporary artists' investigations of negative space through a selection of approximately twenty three works in wood. Among the artists included in the exhibition are Dorothy Gill Barnes, Derek Bencomo, Christian Burchard, Barbara Cooper, David Ellsworth, Marion Hildebrandt, Robyn Horn, Todd Hoyer, William Hunter, Gyöngy Laky, Stoney Lamar, Mark Lindquist, Kari Lonning, John McQueen, Christophe Nancey, Michael Peterson, Binh Pho, Harry Pollitt, Joseph Shuldiner, Hisako Sekijima, Kay Sekimachi, Takeo Tanabe, Hans Weissflog and Howard Werner.

While many of the sculptors featured in The Presence of Absence work within long-standing wood turning traditions, each artist's distinctive exploration of form, combined with an experimental approach to process, has advanced the field in bold new directions.

For over thirty years, David Ellsworth has explored sculptural form using both traditional and distinctly non-traditional wood turning techniques. Typically, Ellsworth starts with a block of wood and reduces it to the desired shape through a conventional turning process. In his early work he used exotic woods such as Brazilian rosewood. However, over the years, he has begun to reclaim discarded and often imperfect wood in a desire to engage and bring new life to abandoned natural material. Once he has defined the overall shape of a sculptural form, he uses a bent-shaft cutting tool to open the mass and create a vessel with a vast interior and an increasingly small opening. Through this process he creates exceptionally thin-walled vessels that are adroit exercises in wood turning virtuosity.

Homage Pot # 24 is a fine example of Ellsworth's inventive approach to the turning process. In this extraordinarily thin-walled vessel, a cavernous space within – an area of absence sensed only through the light weight of the vessel itself – is counterbalanced by the visually rich patterns of the wood, a spalted sugar maple, on the vessel's exterior.

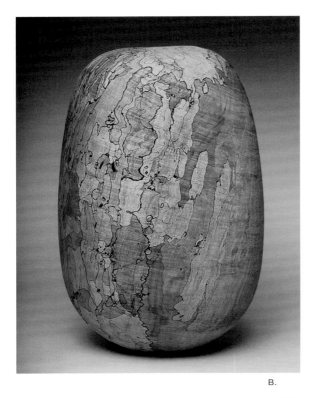

B.

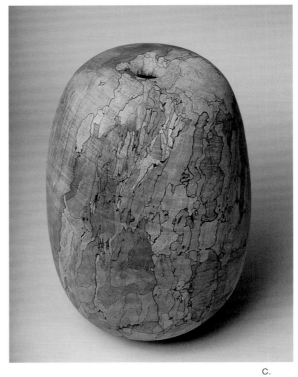

C.

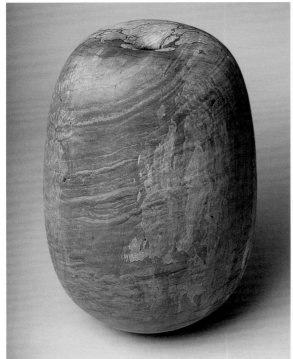

D.

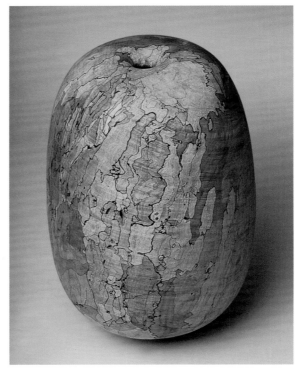

E.

B. C. D. E.
David Ellsworth
Hommage Pot #24, *1999*
spalted sugar maple
16 x 10.25
photo: courtesy of
del Mano Gallery

In Ellsworth's work, a richly varied surface conceals a fullness of absence within.

William Hunter is another major artist steeped in long-standing wood turning traditions. However, while most of his work begins to take shape on a lathe, Hunter has introduced inventive new sculptural techniques over the past thirty years that have radically transformed the contemporary wood sculpture field. While much of his work continues to refer to vessel-forming traditions, his most recent work is purely sculptural in its configuration.

The two interlocking sculptural elements comprising Hunter's *Infinity's Echo* of 2006 represent for the artist a highly evocative visual metaphor. Describing the rich layers of meaning behind this and other related forms, Hunter has said: "I want to create an interplay of both the piece within itself and between the piece and the viewer. The interactivity is underscored by the many possible relationships of the parts to each other as they are reconfigured by the viewer or as the viewer simply changes viewpoints. The elements of the sculpture can be entangled, they can rest lightly together, they can focus towards or away from each other, reflecting the emotions and scenarios of human relationships as well as the balances in the natural world. As with most of my work, I strive to express this with fluidity through a complexity of voices emerging from a pure form." [1]

In. the work of four artists included in *The Presence of Absence* – Robyn Horn, Todd Hoyer, Christophe Nancey and Hans Weissflog – positive and negative space are presented in perfect counterbalance, as solid form is opened through cutting, drilling, piercing or wood turning processes, to allow negative space to permeate solid mass.

In Endless Form, Robyn Horn has created an open, ovoid shape which, while carved from one continuous block of wood, appears to be comprised of separate interlocking sculptural elements. The oval is open in its center allowing light and space to permeate form. The concept of 'endlessness' suggested in its title, comprises both the endlessness of the ever-returning circle and the continuous interrelationship of positive and negative space, so central to the work.

Like Horn's sculpture, Todd Hoyer's *X Series* of 1995 has open space at its heart. However, unlike Horn's which appears to juxtapose solid and void in co-equal balance, Hoyer's 'X' reads as a stamp, almost as a piercing or burning through of solid form. The wood – a lateral cut from the trunk of a palm tree – appears raw and powerful as the X pierces it, seering through, leaving blackened char remains on the form's interior.

Christophe Nancey's *Empreinte* also has an opening at its center. This relatively thin vertical plane of ash has grooves that radiate out from a central circular opening like lines of force, energy emanating from a void. Cosmic metaphors were very much on Nancey's mind as he created this stunning sculpture. In describing a combination of metal and wood that characterizes much of his earlier work, he stated: "This technique suggests to me a relationship between the universe and wood-turning. As in woodturning, everything in the universe is not straight, even if it appears so. The heavenly bodies are linked by gravity… While thinking about the infinity of the universe, I have created a story…but this is not the end of the story…" [2]

Hans Weissflog created an extraordinary transparency in his work, *Big Star Bowl*, by cutting into black walnut using his virtuoso wood turning skills. Turning a single piece on multiple axes, he creates overlapping, arching grids cut through the wood. While appearing solid, Weissflog's work, when viewed closely, is comprised, in almost equal parts, of solid and void.

While several artists in *The Presence of Absence* juxtapose positive and negative space by opening solid masses to allow empty space to permeate form, others construct open forms through composite materials, using an additive rather than a reductive process.

Christian Burchard's *Torsos* – seen individually and as a whole – subtly juxtapose positive and negative space. In each element, a thin sheet of bleached madrone burl that has shaped itself in the drying process, alludes to forms the artist likens to human torsos. While suggesting solid mass, these forms are actually thin veils, skin below which there exists a void. The negative space between each figure in this expansive installation, is as central to the artist's concept as are the individual torsos.

In *Calycanthus*, fiber artist Marion Hildebrandt creates an open, basket-like form using California native spice brush branches and waxed linen twine. While her shapes suggest the possibility of containment – the containment a vessel or a basket would offer – the predominance of negative space renders containment impossible. In its open form, *Calycanthus* represents the idea, the essence, the spirit of a vessel, rather than its substance.

In *Be Away To Be* of 2003, the Japanese-born artist Hisako Sekijima creates what appears to be a mass, comprised of tiny elements of natural materials. Similarly, sculptor Dorothy Gill Barnes constructs "baskets," from natural materials that, because they lack a definable, functional interior, exist more as sculptural form than as an object for use.

Like Christian Burchard, Michael Peterson works with unseasoned, green wood, and allows it to shape itself in the drying process. For this reason, the element of chance – an abandonment of will to random forces, allowing nature to define it own course – apparent in his stunning abstract sculpture, *Earth and Stone IV*, is consistent with Peterson's Asian-influenced aesthetic.

Kay Sekimachi's *Leaf Vessel* is among the simplest and most poetic works featured in *The Presence of Absence*. Comprised of five Boda leaves, *Leaf Vessel* is like a Haiku poem, spare, yet resonating with life's fullest meaning. There is something wistful, elegiac about this vessel shaped from leaves, separated from their source. However spare, its simplicity and beauty, ultimately, reassure.

For Gyöngy Laky, an extraordinarily inventive sculptor from northern California, the concept of absence exists at multiple levels and is related to a multi-layered sense of loss, separation and even death. Her work, much of which is comprised of reclaimed natural refuse (branches, twigs, wood discarded from orchards after the winter pruning), reinstates discarded materials and finds new meaning, new beauty, in loss.

In *Globalization IV: Collateral Damage* of 2005, Laky explores compelling social and political issues related to the absence of life due to the presence of war. About this concept, she has said, "The work has to do with my opposition to the Iraq war; in a strange way it addresses absence referencing the unnecessary loss of life…both of Americans and of Iraqis. When innocent individuals are killed they leave an un-fillable and painful void within their families and communities." [3]

Just as in the pioneering work of the 20th century composer John Cage in which ambient sound – the honking of horns, people talking and dogs barking outside the orchestra hall – was viewed as a core element of the musical composition, negative space or the "presence of absence" is integral to much contemporary wood sculpture.

Over the past twenty years, artists have explored the richly evocative set of relationships – both formal and conceptual – between solid and void, positive and negative – the constantly evolving but eternally interrelated principles of presence and absence.

Hal Nelson is director of the Long Beach Museum of Art in California. Most recently he has co-authored with his partner, Bernard N. Jazzar, a book on 20th-century enamels accompanying the exhibition *Painting with Fire: Masters of Enameling in America, 1930 – 1980* which opens in Long Beach in January 2007.

Published in conjunction with the SOFA CHICAGO 2006 special exhibit *The Presence of Absence: Contemplating the Void in Contemporary Wood Sculpture*, presented by the Collectors of Wood Art.

[1] *William Hunter*, ex. cat. (Los Angeles: del Mano Gallery, 2001): n.p.

[2] Christophe Nancey as quoted in *Connections: International Turning Exchange 1995 – 2005*, ex. cat. (Philadelphia: Wood Turning Center, 2005): 112.

[3] Gyöngy Laky to Hal Nelson, April 17, 2006.

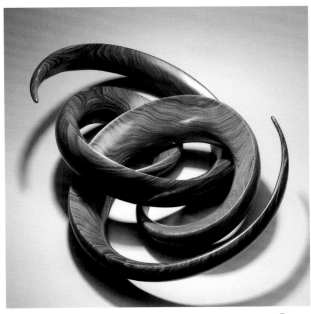

F.

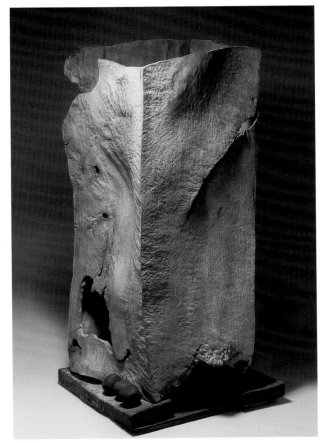

G.

F.
William Hunter
Infinity's Echo, *2006*
cocobolo, Corian,
digital prints, Perspex
10 x 21 x 16
photo: courtesy of
del Mano Gallery

G.
Michael Peterson,
Earth and Stone IV, *2006*
madrone burl, blackwood
30 x 18 x 16
photo: courtesy of
del Mano Gallery

H.
Marion Hildebrandt
Calycanthus, *2005*
California native spice branches,
waxed linen twine
30.25 x 18
photo: courtesy of
del Mano Gallery

I.
Kay Sekimachi,
Leaf Vassel, *2005*
boda leaves
6 x 5 x .5
photo: courtesy of
del Mano Gallery

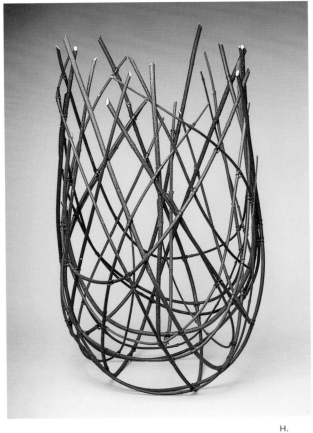

H.

I.

Confessions of Three Curators of Association of Israel's Decorative Arts (AIDA)

By Jane Adlin, Dale Anderson and Davira S. Taragin
(as told to Doug Anderson)

A.
Sergey Bunkov
Untitled #4, *2005*
sand-blasted glass
32 x 24

B.
Reddish
Yakuza, *2006*
wood
30 x 16 x 16
24 x 16 x 16

C.
Jacaranda Kori
321, *2006*
stoneware, glaze
16 x 12

B.

C.

An e-mail arrived today from Sergey Bunkov's wife, Galina. She writes in English, he does not. It began, "Sergey was very happy to get this very warm and friendly e-mail. He is very excited with what might happen in Cleveland. He treasures very much your personal care and the care of the AIDA Family about his professional life. We hope very much that the show at Tom Riley's gallery (Thomas R. Riley Galleries, Cleveland, OH) will be successful. Anyhow, this attitude helps very much to Sergey".

The timing couldn't have been better as we had just spent an hour on the phone, discussing the subject of this essay which was supposed to concern itself with the state of contemporary decorative arts in Israel four years after AIDA's start. Our conversation ranged wide and, in the end, we found ourselves using precisely the same words as Galina and Sergey.

We realized just how much a family AIDA had become when Aviva Ben-Sira, Director of Retail Operations at the Eretz Israel Museum and our Project Manager in Israel, brought us together for a cocktail party in her home with the forty artists we've chosen for SOFA CHICAGO, COLLECT and for various residencies. We were together again for the first awarding of "The Andy" at the Eretz Israel Museum, this time with 40 of our supporters who were in

Israel with us on an art/politics/history trip. We were almost 100 strong. Artists who didn't know each other have become friends. Alliances have been formed.

But it wasn't always that way.

To prepare for our special exhibit at SOFA CHICAGO 2003, Aviva came to SOFA CHICAGO 2002 to see the level of art being shown so she'd know what she was looking for in Israel. She and Rivka Saker, Director of Sotheby's Israel, put out a call for artists to participate. They received hundreds of portfolios, only 60 of which met their criteria. Of the 60, a small handful actually met the standard set by Dale, Davira and Jane and they discussed this with Aviva. Aviva told them that many of the better artists didn't want to consign their treasures to a start-up organization. We had legs in Israel because of Andy and Charles Bronfman's stature and Aviva and Rivka's reputations and connections…but our legs were wobbly.

We asked Aviva to try again, which she did. Another large box of presentations arrived at our home and Jane and Davira flew to Palm Beach for another meeting with Dale. They were joined by Jo Mett, who had agreed to run our booth at SOFA, and Andy Bronfman. Everyone was delighted by what they saw and

selections were quickly made. Andy agreed to make studio visits with Aviva and Rivka when she returned to Israel in May. Indeed, Andy decided that she would collect the work of each AIDA artist, and made it a point to buy something from each artist she visited as a way to give them much needed money to produce new work.

I'd like to say that we knew what we were doing that first year but we really didn't. We worked from the gut and from the heart. Seattle architect, Norm Sandler and his wife, well-known designer Elisabeth Sandler, created our space at SOFA and worked on the installation.

It was important that the artists come to SOFA CHICAGO. We wanted to show a face of Israel that the newspapers don't show – Israelis who make art, not in military uniform defending their country. We wanted the Israelis to see the reaction to their work so they would become energized, and we wanted them to become familiar with their international peers. As we saw it, the artists had been given an award and they needed to be there to receive it.

The artists we brought to SOFA CHICAGO 2003 came without expectations and returned home on a real high. They had given lectures and seen the full span of what was going on in the world

of contemporary decorative arts. They had filled their digital cameras with images to show their students. We learned that most of the artists covered their living expenses by teaching.

We had dinner together each night. Once the show opened, we were at the booth together the whole time. Of course, the work was well received, sold well and we were able to place several of the artists with galleries, which was the outcome we'd hoped for. The artists bonded with each other and with all of us and when they returned home, they told their friends what had happened. In Israel, a country about the size of New Jersey, word travels fast. The artists who had been to SOFA CHICAGO put AIDA on the map.

We learned from our experience and in year two, Davira went to Israel to do studio visits with Andy, Rivka and Aviva, who said that her presence, along with the reports from SOFA CHICAGO 2003 made it easier to get the best artists to work with us. Davira told everyone that she was just the eyes of a three-person curatorial committee, but reported that several artists asked her to critique their work and to suggest what they might do to make their work more attractive to the U.S. marketplace. A partnership was beginning to form. The artists began to understand that something positive could come out of a relationship with our small group. We had no agenda but to help them and they were becoming aware of that.

In June 2005, when Aviva took Jane, Dale, Andy and Rivka on a week of studio tours, they noticed that the studios had been cleaned up for their visits and work laid out the way it would be in a gallery. Tea was served and serious discussion ensued about each artist's work. As Dale put it, "gratitude had replaced attitude."

This year was bittersweet. Jane, Davira and Dale traveled to Israel to work with Aviva and Rivka. Andy was gone and it was clear that AIDA had suffered a huge loss. But the work they saw was great and the desire to be chosen and made a member of the AIDA family was palpable.

When Andy died, the artists lost a loving friend who lived in their neighborhood three months each year. They lost the joy of her visits and their ability to visit her in Jerusalem. This will never be replaced. What they've gained as AIDA has grown is a strong family in the U.S. who is working with their art dealers on their behalf.

Jane and Davira are professional curators who work for major museums where, often, their duties are administrative. Here they have been doing the work they love. As Davira put it, "it's all about the art and the artists."

You see, AIDA has opened up something for the artists and it's much more than having a dealer in the United States. As we have grown through the generosity of our supporters, we have begun to work with dealers to promote our artists' work. Jane put it best when she said "we're so happy with the results that we want to do more…which makes the artists want to do more and that makes them work on a higher level. It's a circle and it's all very positive." As we've grown, we've begun to develop a system and have tried to find the right balance that let's us help without intruding on the personal relationship an artist and their dealer needs to have. We want our artists to be successful and independent.

The form that it takes to be an AIDA artist is evolving and can assume different postures. It can mean participating in SOFA CHICAGO, COLLECT, the Philadelphia Craft Show or in programs such as those at Watershed or Corning. It can also mean having AIDA be a sponsor of a museum-organized exhibition such as the upcoming exhibition, *Women's Tales: Four Leading Israeli Jewelers*, co-organized by the Israel Museum and the Racine Art Museum (RAM). Now, the four artists featured in that exhibition will be warmly welcomed into the AIDA family when the show opens on September 17, 2006 at RAM.

Over these last four years, Aviva and Rivka, Jane, Davira and Dale have developed a curatorial standard. They see the same picture and they trust each other. Without Aviva's knowledge, hard work and relationships, none of this would have been possible.

Someone described AIDA's management style as opportunistic or, rather, management by putting yourself in the right place at the right time. We have all lived and worked in the not-for-profit world of museums, universities, summer schools and arts support groups for almost three decades and know our way around that world. Through these relationships, and the relationships of our supporters, we manage to pick up like-minded people as we keep our ears open for interesting ideas.

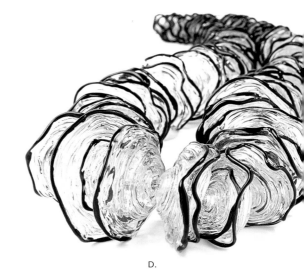

D.

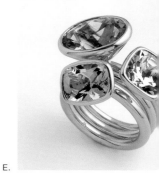

E.

F.

G.

H.

I.

D.
Nirit Dekel
Ruffles, *2006*
glass, silver
length: 31.5

E.
Nirit and Avi Berman
Spring Bouquet, *2006*
18k gold, tourmaline,
aquamarine, beryl
1.25

F.
Noa Goren-Amir
Waves Bracelet 1, *2005*
22k gold
2d

G.
Avner Singer
Untitled, *2006*
local clay, terra sigilatta,
overglaze
27.5h

H.
Tania Engelstein
Veil, *2006*
porcelain, copper wire netting
17.75 x 7.75

I.
Mikhal Gamzou
Foregin Worker, *2006*
construction net, public
telephone cards, nylon cable
ties, key markers
80 x 42 x 7

J.
Andrea and Charles Bronfman

AIDA has been the beneficiary of generous support from a wide range of people. Through the generosity of the Andrea & Charles Bronfman Philanthropies, we've been able to afford to hire Erika Vogel as AIDA's Director.

Erika has picked up the ball that started with a successful partnership with Watershed last summer. This year we repeat that experience and have formed new relationships with the Corning Museum of Glass and Haystack Mountain School of Crafts where students will have fellowships. In future years we will continue this program and seek further relationships where we can place teachers from Israel into summer programs with the goal of cultural exchange leading to opportunity for the artists. Through the generosity of several of our supporters, 14 artists from Israel have been given scholarships to Pilchuck Glass School over the last few years. Having Aviva on the ground in Israel and with the advice of well-positioned AIDA artists, we are able to pick the right people for each opportunity.

We are always pleasantly surprised by the number of hits our website, www.aidaarts.org, receives each month and where they come from. We are delighted when we hear that a tour organizer has included studio visits to AIDA artists in his trip or has asked Aviva to help make that kind of arrangement. In a word, we've helped put artists working in the decorative arts in Israel on the international map. We've given them optimism, broadened their horizons, arranged for residencies,

fellowships and teaching opportunities, given them professional advice, introduced their work to the collector community in the United States and London, connected them to galleries in the United States and Europe and driven traffic to their door. Together, we've built AIDA and it belongs to all of us.

In the end, it's about the art and the artists. How do you measure the outcome? One thing's for sure, AIDA artists present themselves more confidently than they did four years ago.

Published in conjunction with the SOFA CHICAGO 2006 special exhibit: *Progressions* presented by the Association of Israel's Decorative Arts (AIDA).

It is with extreme sadness that the Association of Israel's Decorative Arts (AIDA) mourns the loss of Andrea (Andy) Bronfman. AIDA was founded in 2003 with the goal of nurturing the careers of emerging decorative artists from Israel and was built on three key elements: a passion for the arts, working together as a team, and caring for one another.. these were all Andy's great talents.

Andy formed a particularly strong bond with AIDA's artists. Each artist became a part of an extended family and like family, Andy celebrated each artist's achievements with the pride of a mother.

J.

The Other Kind of Green
Notes Towards An Ecocriticism of Irish Art and Craft

By Marianne Mays

Inter-relationship, context, connection; matrix, symbiosis; convergence, network. Gathering, collecting. *A leaf a gourd a shell a net a bag a sling a sack a bottle a pot a box a container*: Ursula LeGuin's 'carrier bag theory' of civilisation posits the receptacle as the primary tool, before the axe, the spear or the knife, *the tool that brings energy home*. I want to gather up some different ideas about greenness and put them into the same bag.

Green is literally as well as symbolically the colour of Ireland: hardly an original observation. All the same, newcomers and even returning natives are astonished by the reality, the intensity, the wraparound completeness of green that envelopes them on arrival. Years ago, coming here for the first time from a cold brown Canadian spring, I was overwhelmed by the weirdness of the light in St. Stephen's Green, filtering down through the trees and seeming also to rise up out of the ground, a transfiguring luminescence of green.

That is Irish Green: literal and symbolic at the same time. I'll call the other kind Ecology Green. Though the two shades of meaning are distinct, they are cognate: their origins are intertwined.

Green only became the symbolic national colour of Ireland in the later eighteenth century (before that it was blue). But for centuries green in art and literature has represented the natural world of birth, growth and the cycle of the seasons. The Green Man Celtic myth was the god of fertility, whose decapitation and revival represent the annual death and rebirth of vegetation. In the mediaeval poem *Sir Gawain and the Green Knight* the Knight survives his beheading, picking up his severed head and making an appointment to fight again next year. This colour symbolism continues in the iconography of Renaissance art. To take just one example, the green dress worn by the bride in Jan Van Eyck's famous painting *Giovanni and His Bride* (1434) represents her readiness to bear children. 'Under the green-wood tree' is where the young lovers of

Shakespearean comedy find themselves and each other. Nowadays, when fir-trees and green boughs of holly are brought into the house at Christmas, they are a reminder of the times when they were the only green things to be found through the dark months of winter.

B.

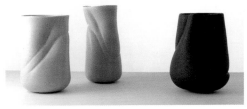

C.

A.
Angela O Kelly
Hundreds and
Thousands, *2004*
layered Financial
Times *with silver ends*
2 x 39.5

B.
Liam Flynn
Inner Rimmed Vessels
2004
carved and turned
ebonized and fumed oak
9d; 12d

C.
Sara Flynn
Untitled, *2004*
thrown and altered
porcelain, green speckle
glaze, slate speckle glaze
13.5h; 13.75h; 14h

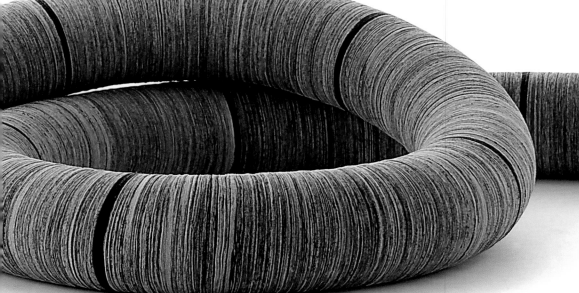

A.

These associations of the colour green underlie the poem in which the phrase 'the Emerald Isle' first occurs in *Erin*, by the United Irishman William Drennan, written in 1795. The poem opens with an account of the birth of Erin recalling both the Genesis story of Creation and the image of Venus Aphrodite rising from the waves:

> *When Erin first rose from the dark-swelling flood, God blessed the green island, and saw it was good; The emerald of Europe, it sparkled and shone, In the ring of the world, the most precious stone...*

D.

The poem celebrates the birth of an ideal of national identity. A fresh start is a return to natural innocence. Green not only replaces the red which dyed the Shannon 'with Milesian blood' but promises to 'outlive both the orange and blue' of divided causes:

> *Nor one feeling of vengeance presume to defile The cause, or the men, of the EMERALD ISLE.*

Throughout the nineteenth century, the wearing of the green dominated the iconography of Irish nationhood. Robert Emmet's flamboyant green uniform was commented upon by his contemporaries and intensified in significance as the mythology surrounding him accumulated. A colour engraving by J. D. Reigh, *Robert Emmet heads his men*, in the *Shamrock Colour Supplement* in 1890, centres on the glowing green of his jacket against the background of a crowd of non-uniformed followers, under a

banner of slightly less vivid green, the whole composition washed in greenish-grey. There are surely parallels here to be drawn with the mythical Green Man who gains new life through his own sacrificial death.

From the Renaissance on, the colour green as symbolic of Nature has included a sense of the natural world in opposition to, or vulnerable to destruction by, human activity. The seventeenth century poet Andrew Marvell repeatedly uses the word green in this sense, recognising a clash between the advances of civilisation and the integrity of Nature, and the precarious balance between them:

> *So architects do square and hew*
> *Green trees that in the forest grew*

The advances of science and the colonisation of the New World – Faust's study and Prospero's island – are reflected in Marvell's sense of 'Man' as the only creature who,

> *superfluously spread, Demands*
> *more space alive than dead*

These are the origins of what I've called Ecology Green, although the term ecology was first used in 1869 by a German zoologist, Ernst Haeckel, and it was not until the British Ecology Party changed its name to The Green Party in 1973 that the colour and its iconographic symbolism became identified with the ecological movement. Now the word green is routinely applied to any person, society, policy or idea concerned with the protection of 'nature': an inspirational usage, washing with a common hue of idealism a set of ideas ranging from rigorously scientific to New Age romantic, and from left to right of the political spectrum.

> *Is this the tide coming in or the*
> *tide going out? Do I keep silent,*
> *or do I shout?*

Hugh Maxton's poem, succinctly describing the radical uncertainty of life in general, has special resonance for ecologists. Does global warming really exist? Is it caused by humans? Can anything be done about it without paying an intolerable price in political and social terms? Or – another set of questions –

should the introduction of exotic plant species be regarded as destructive of the native environment? Current opinion thinks so: but would we really want to eradicate the fuchsia and montbretia that riot so beautifully in Connemara and West Cork? Are all environmental changes introduced by humans necessarily destructive?

The self-image of the New Ireland (post colonial, post-Tiger) as 'cool, urban and edgy' is accompanied by suburbanisation on a scale unparalleled anywhere else in Europe. Does this Ireland still think of itself as green? In 2003, for Emmet's bi-centenary, Kilmainham Gaol was the site of an exhibition entitled *Would You Die For Ireland?* to which the artist John Byrne contributed a video with the same title. A surprising number of participants when asked the question answered in the affirmative or a version of it. While it would be unwise to claim sociological authority for a work of art, the very asking of the question is culturally significant, an indication that Irish Green has more life in it still than a Bord Failte promotional gimmick.

What about the other kind of green? Anecdotal evidence indicates a degree of cynicism about ecological matters. A student suggested to me that the reason for indifference to ecocriticism here in contrast to its growth in America and to an extent in Britain is that, having got rid of the landlords and the priests, Irish people are not inclined to take on board another bunch of bosses or preachers haranguing them and telling them what to do. Post-colonial criticism is more palatable; but the two approaches are closer than is generally recognised. The defining event in post-colonial consciousness, the Famine, was as much an ecological as a political event. The two are only a side-step apart. Meanwhile on the ground the controversy rages about the building of one-off houses in rural areas, with a ground swell of popular opinion in its favour. "Let them [tourists] go to Scotland if they want the green fields" (Irish spokesperson in an interview in an American travel magazine, quoted in *The Irish Times*).

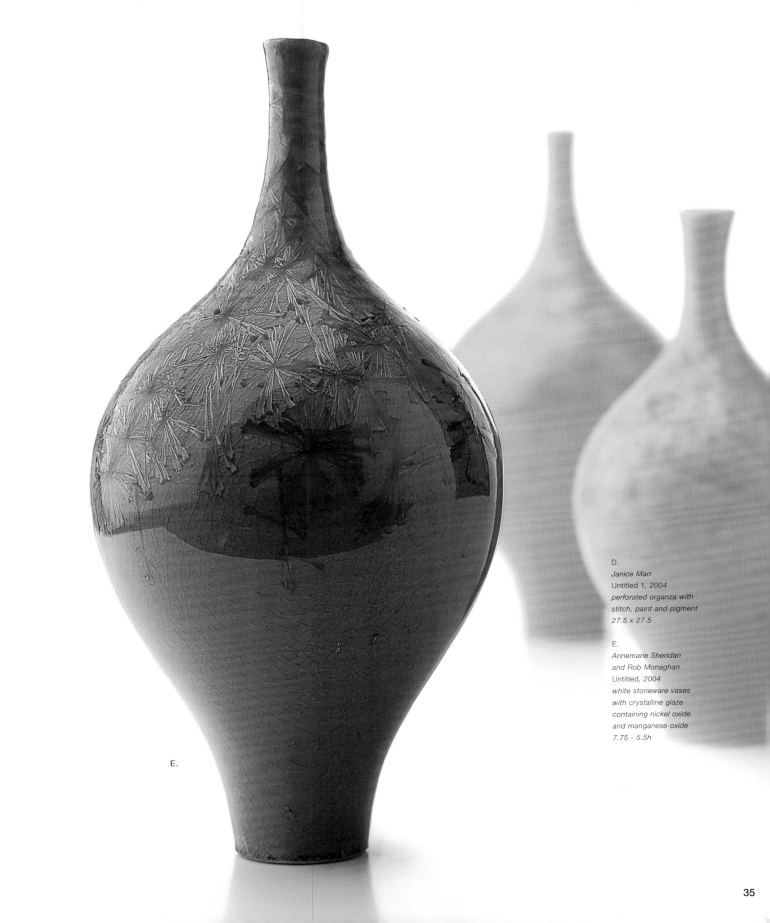

E.

D.
Janice Marr
Untitled 1, 2004
perforated organza with
stitch, paint and pigment
27.5 x 27.5

E.
Annemarie Sheridan
and Rob Monaghan
Untitled, 2004
white stoneware vases
with crystalline glaze
containing nickel oxide
and manganese oxide
7.75 - 5.5h

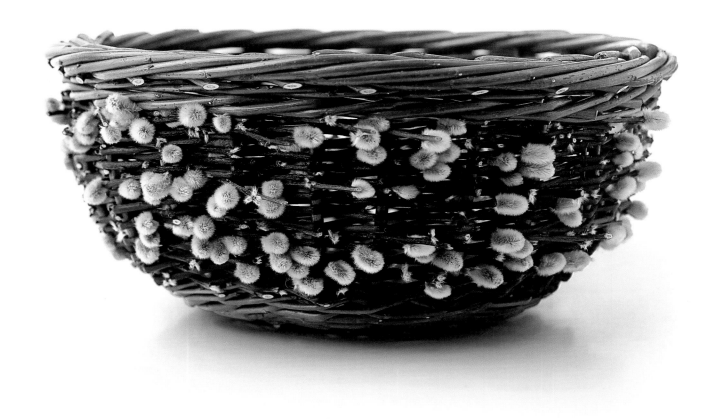

F.

F.
Joe Hogan
Bowl, 2004
Catkins, brown maul
and salix daphnoides
15 x 15 x 6

G.
Pamela Hardesty
Font, *2004*
glass, painted and
stained: stainless steel
and enamelled wire
27.5 x 27.5 x 2

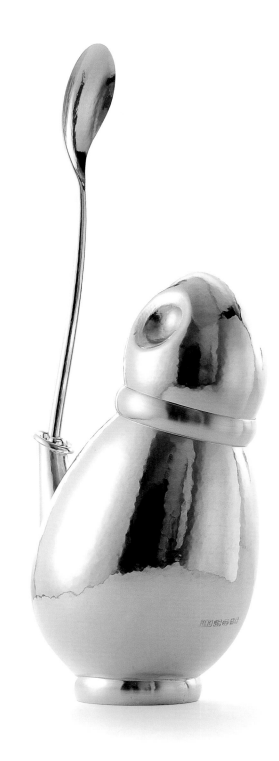

H.
Richard Kirk
Honey pot and spoon, *2004*
silver and brass detail;
raised, forged and chased
13 x 5 x 4.5

I.
Edmund McNulty
Untitled, 2004
Marino lambs wool
47.25 x 12

J.
Paul Devlin
Placid Vase 1 & 2, 2004
free-blown glass; steel
35.5 x 30

H.

You can't make an omelette without breaking eggs – an argument that has often stopped me in my ecological tracks. But something is wrong. Eggs are produced to be eaten. In spite of their aesthetic appeal, their ovoid perfection of form and eggshell finish and even their symbolism, their destiny is consumption. Besides, they are the archetypal disposable multiples. Only a mad person would want to preserve a carton of sterilised eggs. Note too that this is making omelettes we're talking about, not just eating eggs: omelette is cuisine, it's a product. But there's an essential difference between these eggs and Marvell's "green trees that in the forest grew." The bit of ancient woodland in the path of the motor way isn't eggs, nor the small local farm that goes out of business because it can't provide the multiples with sufficient regularity for the supermarket; and if these things are the price of the omelette would we rather do without? But only a Marie Antoinette would say eat steak instead. Think global, buy local. But the small local farm has gone.

I. J.

What has this dilemma to do with art or criticism? Is it not a problem for the planners, the environmental scientists, the sociologists? In an essay entitled *Beyond Ecology: Self, Place, and the Pathetic Fallacy*, the environmentalist and ecocritic Neil Evernden writes:

it seems to me that an involvement by the arts is vitally needed to emphasise [that] relatedness, and the intimate and vital involvement of self with place. Ultimately, preservation of the non-human is ... a rejection of the homogenisation of the world that threatens to diminish all, including the self. There is no such thing as an individual, only an individual-in-context, individual as a component of place, defined by place.

Only through the arts, he suggests, can there be recognition of the true depth and dimensions of ecological problems.

Artists in Ireland are way ahead of the public and of criticism (which is how it should be) when it comes to the environment. Think of Dorothy Cross's use of the Slate Quarry Grotto on Valentia Island for her multi-media staging of Pergolesi's *Stabat Mater* ("...it's all just there", she says, "There are giant machines. There are boats. There are slices of steel...."); or of Simon Cutts' wind-turbine-driven neon lines from John Clare ("I found the poems/in the fields/and only wrote them down") quietly shining in a disused pump house in the middle of a field; or Erica van Horn's *Room for Tullio*, papered with used envelope-interiors. Tim Robinson's *Folding Landscapes of the Aran Islands* combine art, craft, and design with cartography and prose to form a meticulous record of the land and culture of the islands.

Last year I visited Austin McQuinn's installation *United* in Kilmainham Gaol, his contribution to the exhibition *Would You Die For Ireland*? McQuinn had completely enveloped his cell (each artist had been allotted a cell as exhibition space) walls, ceiling and, as far as I remember, floor too, with thick soft intricately patterned hangings of creamy Aran knitting quilted from perhaps hundreds of discarded sweaters. A padded cell, of course, but also a fabulously clean and cosy haven – a room, a womb, a home – in that cold gaunt tomb of a building, itself a site of political strife and actual violence, now reinvented as tourist attraction, art gallery and symbol of nationhood. The artist inhabited his creation: his toes protruded from behind the hangings and his eyes watched the viewers through a pair of buttonholes, a presence which could be variously perceived as surveillance or genius loci. Afterwards I hurried home to dig out an old Aran sweater, which I boiled, felted, cut up and made into a cushion cover. When I have time and enough sweaters I intend to make a quilt. This bathetic incident contains an ecocritical parable. It is even possible that I wasn't the only person to react in this peculiar way. The piece seemed to demand a more involved response than a mere viewing.

In a society threatened by inundation in its own garbage, the use of discarded materials is a gesture of defiance, but more than material re-valuation is involved. "The symbol of the Aran sweater", McQuinn explains, "knitted by mothers to protect their sons from harshness, became in the late twentieth century an object of derision. Like many 'traditional' images of Irishness it became uncomfortable or unfashionable. For me it has great emotional power and political complexity." (Another reason for the Aran sweater's obsolescence is of course that nowadays it's too hot to wear. Houses, shops, cars are heated and most of us aren't exposed to harshness. The heavy sweater is a reminder of the bad old days.) Using craft skills akin to those of the original knitters, McQuinn recategorised the sweater as Art: my own activity, while I hesitate to dignify it with the name of Craft, returned it to the realm of the domestic, replete now with memory and meaning. The appropriation of material and its history for home-making purposes is clearly in the tradition of patchwork quilting, long recognised in feminist criticism as emblematic of womens' creativity. But quilting, born of necessity, combining thrift and utility with artistic self-expression and the inscribing of memory – used flour sacks and tattered wedding dresses – is equally significant in terms of ecocriticism.

Time for some definitions. The term ecocriticism was coined by and for literary criticism, my home-discipline, and is more widely used in America than on this side of the Atlantic. What

I'm attempting is a kind of double transposition from literature to art and from America to Ireland.

*Eco and critic both derive from Greek, oikos and kritis, and in tandem they mean 'house judge'....[thus] "a person who judges the merits and faults of writings [artworks] that depict the effects of culture upon nature, with a view to celebrating nature, berating its despoilers, and reversing their harm through political action." So the oikos is nature, 'our widest home', and the kritos is an arbiter of taste who wants the house kept in good order, no boots or dishes strewn about to ruin the original decor. (*William Howarth, *Some Principles of Ecocriticism)*

K.

Having quoted this definition, I immediately start to back-pedal. My own definition would be less confrontational, less judgmental and less restrictive. Critics are not necessarily evaluators of merit, much less berators or arbiters; they may be watchers of straws in the wind, guides or interpreters, pointers-out of previously unperceived meanings and different perspectives. Given the uncertainties of ecology as described above, 'bespoilers' are not always easily identified, and as for 'original decor' how far back do you go? For Americans this question may be slightly easier, since they still have a folk-memory of a home where the buffalo roam, having

destroyed it so recently. For Europeans there can be no such imaginable primal home. But the idea of home remains central to my definition.

Think of the child who writes her address in her schoolbook:

First name and Surname
House-number and Street
Suburb/Village/Town Land
Town City
County
Country
Continent
Planet Earth
Solar System
Milky Way
The Universe

Placing herself as the focal point, she asserts her right to claim any one of those widening circles as her home, her *eikos*. Knowing your address is important. Knowing where you come from is fundamental to knowing who you are. Social and environmental change has been so rapid and so radical in Ireland in the last few decades that many Irish people do not, in this sense, know their address, or where they're coming from. Even if they haven't moved, their place has changed around them, sometimes beyond recognition, sometimes more subtly – looking the same, but altered in context, in relation to other places. With the concept of *home* comes that of *not-home*, as *I* defines itself by *not-I*; someone else's home, a friend's house, a bird's nest, another country. Travel and tourism have elided this distinction. Television and mobile phones make it possible to be at home and somewhere else at the same time.

These changes are nothing but liberating to many people that the question must be asked (it is the title of an essay by Dana Philips) *Is Nature Necessary?* "We may," he says, "still feel at home in this world because we no longer know or can tell the difference between nature and culture." (Could we ever? A matter of degree.) "We don't know the difference, because memory is debased in a world where it is daily replaced by the artificial repositories of the snapshot, the video … these things

have changed the meaning and the structure of memory itself."

The function of ecocriticism is the raising of consciousness towards the way literature and art reflect this fundamental aspect of life, in the same way that feminist criticism has for gender, or Marxist criticism for material and economic conditions. So the ecocritic isn't only concerned with works that are explicitly about nature or ecology. Just as a feminist drama critic might find Shakespeare's *Henry V* (two tiny parts for women) as interesting as Carol Churchill's *Top Girls* (no parts for men), an ecocritic could be as interested in the alienated urban melancholy of Edward Hopper as in Walker Evans' dust bowl photographs or Ansel Adams' Yosemite landscapes, or in Mondrian's grids as much as Georgia O'Keeffe's flowers. Of Andy Warhol's multiples of Marilyn Monroe and Campbell's soup cans, the ecocritic asks the question: 'Celebration, lament, or satire?' There cannot be such a thing as a work of art or literature that is not in some way shaped by (and in turn helps to shape) the place of human beings on the cosmic map.

Parts of the contemporary environment, quite large parts, have retreated into near invisibility; the tracts of land on the outskirts of towns, industrial estates, car parks, waste lots, road interchanges, used car lots, commercial parks; home to nobody, no-mans-land, except that lots of people work there. Commuters drive through these areas listening to tapes; so do city dwellers on their way to the recreational facility of the countryside. Nobody really looks at them, or thinks about them. They are the underside of life, not even embarrassing, just ignored. In the opening sequence of *The Office* the TV camera sweeps across such a landscape. The bleakly hilarious comedy, in mock-documentary style, traces the distorted behavior of humans confined within it, the postures and gesture of anomie.

The business parks of the twenty-first century have a different look. Extensive landscaping, earth moving, and road making transforms the

topography: valleys filled in, green berms introduced, trees planted, maybe a rush-fringed lake. Is this the tide coming in? Perhaps the green light will filter down through those trees and rise up from that grass as Nature takes over. Or is the tide going out? Perhaps 'shallow ecology' only masks the situation that 'deep ecology' perceives; "a single planet-wide system everywhere devoted to maximum productivity and the unbridled assertion of human dominance." (Theodore Roszak in *Person/Planet*). Worse, the creation of a simulacrum of Nature itself compounds the culture of the virtual, of copies, images, representations, imitations that obfuscate a sense of the real.

Most people know most art through reproductions. Sometimes they are disappointed by the original. The *Mona Lisa* viewed from behind a protective rope in the company of other hot and tired tourists may not seem worth it. A good reproduction that you can take home with you provides a better experience. What a choice! The *Mona Lisa* itself has disappeared into its meaning, as I am using it now, as shorthand for 'great art'. Still, that the tourists are there indicates the power of the idea of 'presence'. On the other hand, when the painting was stolen in 1911, more visitors than ever came to view its empty space. Artists have devised various strategies to insist on the uniqueness, the presence of the original work. Andy Goldsworthy's ice sculptures or patterns of leaves floating on water, Christo's wrapped landscapes and monuments, celebrate the ephemeral, but only notionally or gesturally, since the photographic record is not so much the legacy as the product of the process. (I've not seen photographs of Goldsworthy's leaves dispersing and decaying, though they probably exist.) These products are then published or exhibited in galleries, thus undermining the subversive gesture against commodification.

Must all our reverence, asked the poet George Herbert, a contemporary of Marvell, be given "Not to a true, but painted chair?" Craft

answers, No. Craft offers "Not ideas about the thing but the thing itself." Presence is essential for a bowl, a chair, a woven cloth. Function or use remains essential, even when in actuality the object may be too fragile or too valuable for practical use. Van Gogh's 'painted chair' pays tribute to function, but it is not the skill of the chair maker that is cherished by the millions who cherish its image. A chair with an array of nails sticking up from the seat, or one that is much too large for human use, becomes Art by another route. A photograph of such an object could convey its point. A prime virtue of craft is its defiance of the virtual. It distances itself from function at its peril. Ecocriticism would not blur the distinction between Art and Craft. But it would question the hierarchy.

Kettle's Yard in Cambridge houses a collection in which paintings and sculpture share a home on equal terms with furniture, glass, ceramics and natural objects. It is the personal collection of Jim Ede, former curator at the Tate Gallery and his wife Helen, who lived in this house for 16 years from 1956. Ede's intention was that the place would be "not an art gallery or museum, nor ... simply a collection of works of art reflecting my taste or the taste of a given period. It is, rather, a continuing way of life from these last fifty years, in which stray objects, stones, glass, pictures, sculpture, in light and in space have been used ..." Architecturally, the space is a series of interconnected rooms on different levels with unexpected corners; light falls naturally on objects grouped on windowsills, shelves and tables rather than in posed display. It is an environment which allows the visitor to sit in the chairs and watch the light changes, a space "holding things in a particular, powerful relation to one another and to us" (Ursula Le Guin's carrier bag theory again).

The contrast between the petit bourgeoise life of my home town, the decayed grandeur and second rate provincialism of Dublin, the riches, wastefulness & utter conventionality

of upper-class London life, repelled me. By contrast ... Aran, wrenching an existence from the sea, against a background of endless labour, danger, poverty, ignorance, patience & religious belief, charming gentle manners. The amorous musical cadences of spoken Irish. The individual racial types, waking old race memories, all these things decided me that here was where I wished to live and work.

L.

K.
Zeita Scott
Platter, 2004
Limoges porcelain,
high fired slip and
earthenware glaze with
hand formed glass feet
17 x 3.5

L.
Roger Bennett
Bowl, 2004
sycamore coloured with
water-based wood stains,
inlaid with sterling silver
dots in a spiral pattern
4 x 1.25

Deep in the Russian consciousness lies the conviction that this forbidding climate, the poverty of the soil, the social violence, the lack of human rights, the coarseness and the alcoholism ... are in fact the well-spring of the resilience, energy and spirituality of the Russian people.

The first passage, from a letter by Sean Keating, is quoted in an article by S.B. Kennedy, *An Irish School of Art?* The second is quoted in a review by Zinovy Zinik of the London exhibition *Russian Landscape Painting in the Age of Tolstoy*. Both are

concerned with the relationship between literature and painting in treating themes of nationhood and nationality, and both imply that while literature (W.B. Yeats, Synge; Tolstoy, Chekhov, Turgenev) could portray the complexity of such issues, painting could not do so without sacrificing essential subtlety. Both focus on the uses of adversity in the formation of national character, or rather its perception. The Russian example introduces a further problematic dimension in sentimentalising brutality – though the idealised view of Aran in Keating's letter might equally be called sentimental. Synge by contrast never ignored the potential for violence; patricide is the dark heart of *The Playboy*.

The connections between nationalism and ecology are murky. Neither Zinik nor Kennedy mentions the word ecology, although both are concerned with the way art depicts the relationship between people and land. Ecocriticism would take the side-step from politics to ecology, to reverse the focus from place-as-nation (concept) to nation-as-place (home), and to pose a different set of questions.

An example: Jack B. Yeats' *Men of Destiny* in the National Gallery shows two male figures of heroic proportions, broad-shouldered, athletic, in a rugged western landscape of rock and water, all bathed in a lurid transfiguring light, through which they loom like emanations. They stride towards the viewer as if they are leaving home. An ideological reading would see them bringing the rugged virtues of the West to invigorate the new nation with their hardihood, independence and resilience. The portentous title drives the message home. An ecocritical reading would focus on the portrayal of the landscape itself and its relation to the human figures. The relation suggested by the brushwork is not one of figure and ground but rather of an integrated whole. The figures appear to coalesce rainbow-like from the weather conditions, dark and stormy to the right, clear and bright in the distance to the left. The background figure and small boat (wrecked? or just keeling in

the wind?) appear to be de-materialising into the landscape. The light which suffuses the whole may seem garishly apocalyptic, but virtuoso displays of son-et-lumiere are frequent where moisture-laden air and intermittent sunlight are in constant interaction. The land is apparently undomesticated and inhospitable, composed of interpenetrating rock and water in indecipherable proportions, but the Men move lightly across it, hands in pockets, heads high, at ease with the elements. Though they loom large, there is no evidence of human impact on the land.

In the light of all this, what happens to the implications of the title? Without the rhetoric of nationhood to underpin it, the title appears not less prophetic, but ominously tinged with irony. If these Men who are so much part of the land are leaving it, turning their backs on it and walking out of the frame, the concept of their destiny and that of the land itself loses definition.

Globalisation, multiculturalism, migration, displacement and rootlessness are accompanied symbiotically by a growing awareness of cultural identity and ethnic roots. Roots are fashionable. Paradoxically they are also mobile. Dance companies, theatre groups, art and craft exhibitions travel the world bringing their heritage to an international audience. This summer an exhibition of Australian Aboriginal art, an art which perhaps more than any other in the world is rooted in ecology, in long centuries of interaction between the people and their land. Irish people had the opportunity to see the art of a totally different culture, based on an intimacy with a place that has seemed to its European settlers to be alien, harsh and forbidding but which to the Aborigines has been home in the deepest sense. Is this the tide coming in? The art on display was aesthetically impressive, and there's much that our culture can learn from the message it brings about humans and nature. Or going out? The Aborigine's land is now in grave danger of terminal degradation from improvement schemes introduced by white settlers,

according to Germaine Greer, and the people themselves have been driven to the fringes of their country. Their art, however, has become a multi-million dollar industry, and subject to all the forces of western ideas about property, originality and the persona of the artist which are alien to Aboriginal culture. There is now a Label of Authenticity for which artists can apply so that tourists can be sure that when they buy they are getting the real thing and not an imitation made in Thailand or Taiwan. Can indigenous art survive such pressures? Aidan Dunne, reviewing the Carlow exhibition, says that international interest has contributed to a renaissance in Aboriginal art, enabling it "without compromising its nature and its core values...to accommodate traditional qualities and contemporary realities." Coming in, or going out? The ecocritic can't be sure.

Finally, or meanwhile, here is Claes Oldenburg on 'city-nature':

City nature is made up of streets, houses, stores, advertisements, make-up, clothing and vehicles. Make-up and clothing & the people who animate them are like trees, vehicles like animals. Stores are forests, streets plains and rivers, advertisements and goods so many creeping and crawling dreams ... What kind of nature is city nature. It's a piece of man's mind ...

Marianne Mays has taught at universities in Canada and the U.K. and is now with the Open University in Ireland. She has written on modern Irish fiction and, more recently, on aspects of craft. She lives in County Wicklow where, together with her husband, she manages a small farm-forestry project.

Published in conjunction with the SOFA CHICAGO 2006 special exhibit *40 Shades of Green* presented by the Crafts Council of Ireland.

Many of the essays quoted can be found in *The Ecocriticism Reader* ed Sheryll Glotfelty and Harold Fromm (The University of Georgia Press, 1996). S. B. Kennnedy's essay on depictions of the Irish landscape was published in *Famine, Land and Culture in Ireland* ed Carla King (University College Dublin Press, 2000). Germaine Greer's book is *Whitefella Jump Up: The Shortest Way to Nationhood* (Profile Books, 2004).

M.

M.
Laura Mays
10 drawers 3 doors, *2003*
maple, tanoak, acacia,
padouk, madrone, jarrah,
cocbolo, cherry, redheart,
pear, koa
Australian lacewood
63 x 19.5 x 15

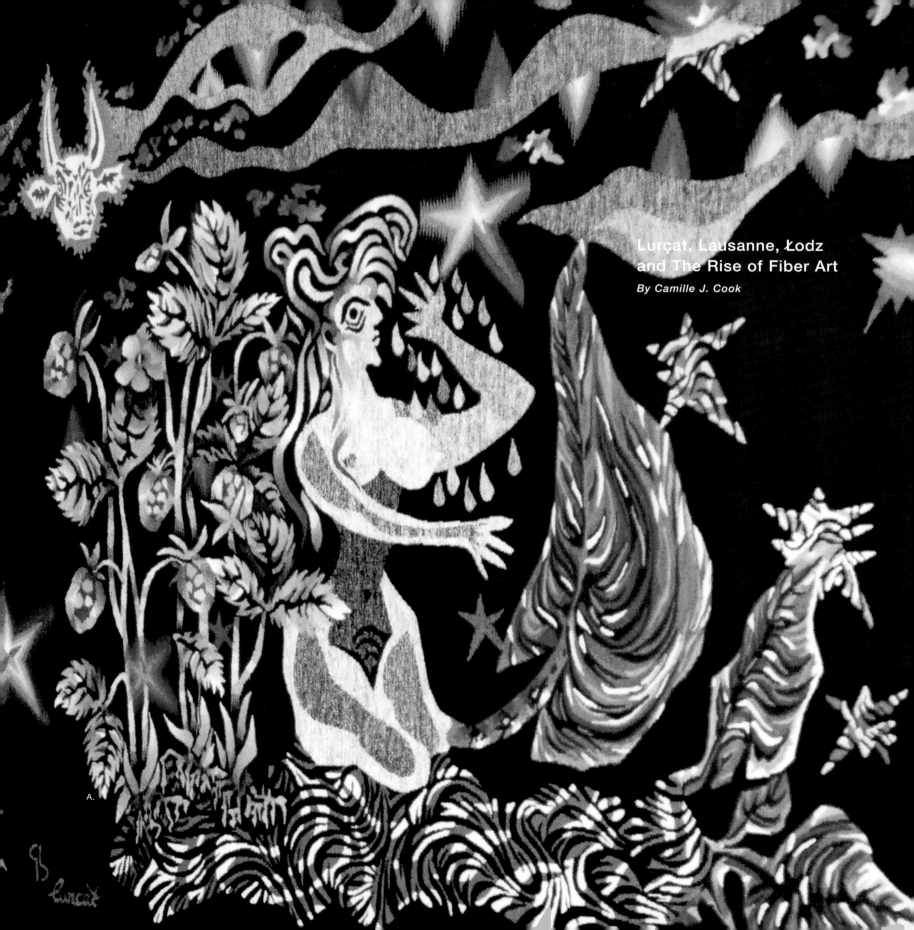

Lurçat, Lausanne, Łodz and The Rise of Fiber Art

By Camille J. Cook

A.

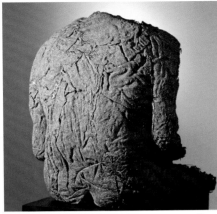

B.

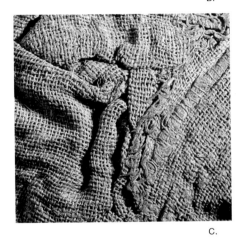

C.

A.
Jean Lurcrat
Eve, 1960-61
carton numerate;
linen warp, wool weft
Laurie Sudler collection

B. C.
Magdelena Abakanowicz
Seated Shoulder, 1981
burlap, glue
24 x 18 x 22
Mark and Sharon
Bloome collection

Friends of Fiber Art International is honored to celebrate its 15th anniversary with the exhibition, *Material Difference: Soft Sculpture and Wall Works* now on view at the Chicago Cultural Center, and a select version called *Material Difference Too* at SOFA CHICAGO 2006. Both are composed of objects lent by private and museum collections. Our organization, as part of its long term support of contemporary textile arts, has been interested in the influence of European exhibition initiatives which displayed works that extended the definition of tapestry and recognized the artists who produce it. Fourteen years ago, Friends' first international program was to attend both the Bienniale Internationale de la Tapisserie in Switzerland and the Miedzynarodowe Trienniale Tkanniny in Poland. The histories of the Biennale and Triennale chart the metamorphosis of tapestry into contemporary fiber art. The objects selected for these exhibitions are by many pioneers whose talent was recognized in these early European surveys.

In France the changes began with French tapestry designer Jean Lurçat, who set out to revive production of classical tapestry by simplifying the technical requirements. To accomplish this, in 1941-42 he invented a weave-by-number system, called carton numerate that would reduce the cost of production.

Switzerland, 1962 – Jean Lurçat was president of the Centre International de la Tapisserie Ancienne et Moderne (CITAM) which that year produced the first Biennial. Later called Lausanne Biennials, they continued until the 16th and final edition in 1995. The Biennials had a profound international effect on the advancement of art produced in flexible materials or using textile techniques.

In this first Biennial, Lurçat's own *La Poesie*, a work designed by Matisse and tapestries designed by others were displayed. Many gave their drawings to weaving studios for completion employing the carton numerote

invented by Lurçat. In addition, weavings by Polish artists Magdalena Abakanowicz and Jolanta Owidzka were shown. The Polish artists were unique in this context because they both designed and wove their pieces.

America, 1963 – *Woven Forms* at the Museum of Contemporary Crafts (MCC) showed work by artists liberated from the strict use of tapestry techniques. It was one of the earliest displays of the new freedom now defined as fiber art. This exhibition and some earlier textile solo shows were mounted by Paul J. Smith, who was then the assistant director of MCC and later became the director. Smith continued to support contemporary fiber art throughout his thirty-year career. Artists in *Material Difference* whose fiber art was in the path-breaking *Woven Forms* show include Sheila Hicks, Lenore Tawney and Claire Zeisler. It had an important international impact. Erika Billeter, then curator of the Musee Bellerive in Zurich, saw it and exhibited a variation of *Woven Forms* in Switzerland. Billeter later became the director of the beaux arts department of the Cantonal Museum in Lausanne which was host to the Biennials for most of that show's life.

For the second Lausanne Biennial in 1965, Pierre Pauli was at CITAM's helm. This edition included one work by Lurçat, pieces by Victor Vasarely and Pablo Picasso, tapestries by Abakanowicz, Owidzka, and five other Polish artists. Lurçat died the next year. The third Lausanne Biennial in 1967 presented the debut appearances by two artists in *Material Difference*: Olga de Amaral and Zofia Butrymowicz. A piece by Abakanowicz, the last work by Lurçat and others were also included. It wasn't until the fourth (1969) Biennial that real freedom from strict tapestry forms was displayed in Lausanne by Françoise Grossen and several artists whose work is in *Material Difference*.

D.

E.

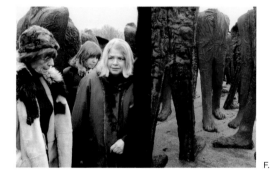

F.

G.

The same year (1969) when Mildred Constantine was a curator at the Museum of Modern Art, MoMA got on the fiber bandwagon with *Wall Hangings*. It included artists now in *Material Difference*: Magdalena Abakanowicz, Olga de Amaral, Zofia Butrymowicz, Françoise Grossen, Sheila Hicks, Jolanta Owidzka, Ed Rossbach, Kay Sekimachi, Sherri Smith, Lenore Tawney and others. This attention from a major New York fine art museum may have inspired modern art curators across the nation to investigate fiber art.

In 1971-72 *Deliberate Entanglements* was organized by Bernard Kester for the University of California, Los Angeles Art Galleries. It was the first time works by Magdalena Abakanowicz, Olga de Amaral, Françoise Grossen, Kay Sekimachi, Claire Zeisler and others were seen at most stops on the American and Canadian museum tour, setting off increased interest in fiber art. In Los Angeles, Kester's show opened with enthusiastic community support including simultaneous fiber shows at commercial and non-profit galleries. It was the first recorded commercial gallery support of fiber that we found.

In 1972, the first Triennial of Tapestry was a national show presented in Łodz, the second largest city in Poland. It featured tkaniny unikatowe (one-of-a-kind textiles) by only Polish artists including several artists in *Material Difference*. The 1972 show paved the way for the International Triennial of Tapestry which followed in 1975 and continues today. Presenting work by up to 150 artists from about 50 different countries, it is the longest-running international survey of fiber art.

Throughout the subsequent decades, artists around the globe found more ways to fashion flexible materials into expressive works of art. In America creative people utilized traditional quilting techniques to make exemplary wall hangings. Others looked to basket forms as the basis for sculpture to be seen and enjoyed, not used as vessels. Decorative textile techniques such as dyeing, embroidery and beadwork entered the artist's tool kit. Now there is no limit to what can be used to serve the urge to create. Textile materials and techniques have crossed the line between craft and fine art. Today we can enjoy the fruits of this freedom in outstanding objects seen at SOFA and collected for personal pleasure.

An artist who conspicuously crossed the fine art boundary is Magdalena Abakanowicz who is just completing a major installation in Chicago's Grant Park. The work titled *Agora* consists of 106 nine-foot-tall, cast-iron figures. She has progressed through different materials with more enthusiasm and success than any other fiber artist.

In the book, *Material Difference*, you are invited to also enjoy the views of homes of Midwest collectors who loaned important historic and new works of contemporary fiber art to the show *Material Difference*. While you're looking, consider how these beautiful objects could enhance your home environment. Several SOFA galleries are presenting an extensive display of contemporary fiber art.

Camille J. Cook is the President and Founder of Friends of Fiber Art International.

Published in conjunction with the SOFA CHICAGO 2006 special exhibit *Material Difference Too* presented by Friends of Fiber Art.

Friends of Fiber Art has been organizing tours to the Triennials since 1992. For information on the next tour, or to join Friends of Fiber Art International call 708.246.9466.

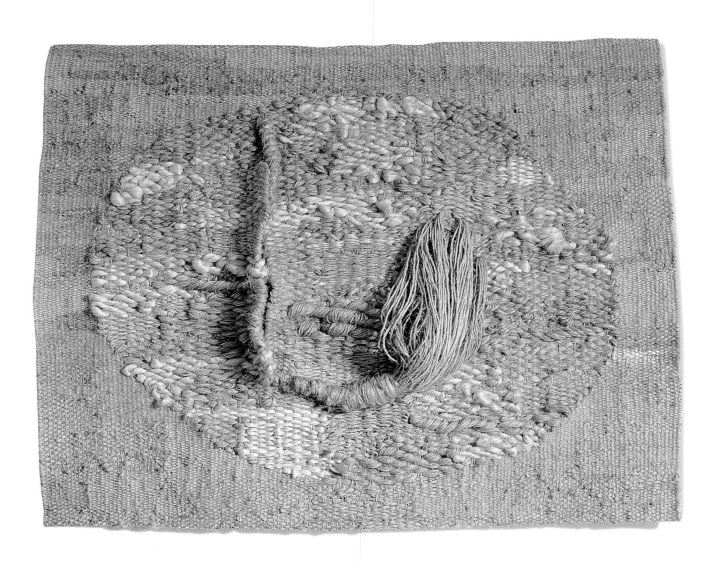

D. E. F. G.
Magdelena Abakanowicz
Agora, 2006
106 9' tall cast iron figures
Grant Park, Chicago installation
photo: Artur Starewicz

H.
Magdelena Abakanowicz
White, 1970-80
sisal, wool; woven
48 x 60

Tradition and Innovation - Spotlight on Korean Contemporary Ceramics

By Jaeyoung Kang

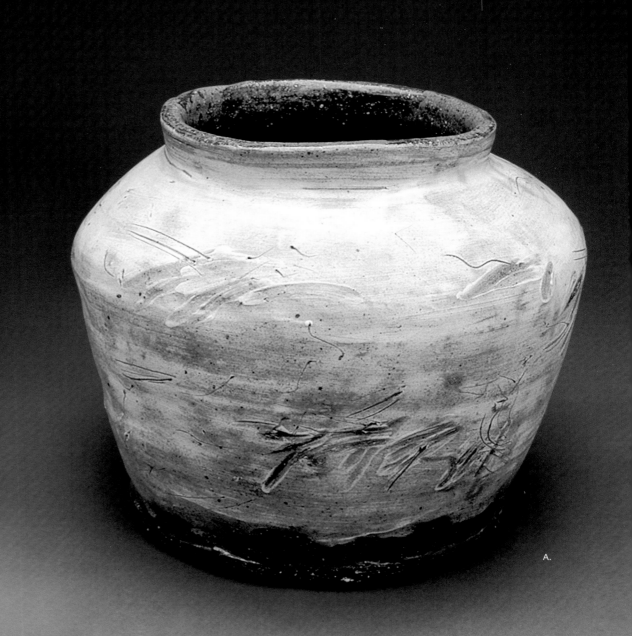

A.

What is the origin of Korean ceramics? What characteristics make Korean ceramics unique? Korean ceramic culture boasts a history of five thousand years and is primarily represented by celadon, *buncheong,* and white porcelain. Dating from the Goryeo Dynasty (918-1392), celadon is characterized by refined shapes in transparent jade green; *buncheong* by freer forms in bluish-green; and dating from the Joseon Dynasty (1392-1910), white porcelain by elegant simplicity. Although different materials were used through the ages, Korean ceramics have always had a creative and natural, modest beauty. This is the reason they have become so popular internationally in recent years.

Despite the great tradition of Korean ceramics, contemporary Korean ceramics started in an unfavorable environment. Entering the twentieth century, Korean ceramics declined abruptly as a result of extreme political instability, collapse of the national economy, and the Japanese occupation. After Korea's liberation, Koreans became aware of their proud heritage of ceramics. Since the late 1950s, Korean ceramics have entered a new phase of development.

While reproduction of traditional Korean ceramics remained the primary endeavor, ceramic art that focused on artistic expression and eliminated the functionality of ceramics emerged. Influenced by modern art in the West, the younger generation educated in figurative arts in diverse fields, began to create unique works with clay as the material of expression.

Today's mainstream Korean ceramists can be divided into two groups: those who are trying to incorporate tradition, and those who are seeking purely creative forms of expression, free from the concept of ceramics as craft.

Tradition and Innovation – Spotlight on Korean Contemporary Ceramics intends to show a wide spectrum of Korean ceramics today. Korean ceramics began with the production of vessels for daily use and is now witnessing an up-swelling of unlimited imagination as it embraces contemporary expressive language and new challenges of our times. Ten artists are presented in this exhibition in three groupings.

B.

The first group of artists seeks to incorporate tradition into contemporary vessels. Their works uphold tradition and show that the deeply-rooted process of painstaking labor and craftwork together create truly outstanding artworks. These vessels reflect the individual styles of the artists, while embracing fundamental principles of ceramic aesthetics and production.

A.
Kwangcho Yoon
Buncheong Jar, *2005*
red clay, buncheong
11 x 11 x 10

B.
Inchin Lee
House Filled with Light
installation, *2003-2005*
wood-fired stoneware

Kwangcho Yoon broke from traditional forms and modified *buncheong*, advancing its liberal and free-spirited characteristics. On the surfaces of his uniquely-shaped vessels, Yoon expresses his emotions, making impromptu lines and rough drawings.

Geejo Lee extends the boundaries of white porcelain by blending its inherent nature with aesthetic principles of modern art. Lee's white porcelain vessels are geometrically shaped with sectioned and recomposed surfaces. They look intellectual and austere, but also inviting to the touch.

Inchin Lee uses traditional firing techniques without glaze to produce contemporary vessels. The unpredictable effects of firing make jars of simple shapes look primitive and yet very appealing to the contemporary eye.

The second group of artists is progressive. These artists have led the new movement in ceramic artistic expression. Clay as basic material is handled by the creative minds of the artists, and the result is an entirely new realm of ceramic art unique to each individual.

Sangho Shin's ceramic sculptures are principally about animals in drastically transformed shapes and his tiles are brightly colored with geometric lines. His theme of "Dream of Africa" combines ceramic sculpture and painting, and represents a distant "home" in our hearts and minds.

Suku Park produces works in dark pastel colors without glaze. His works are about everyday things such as windows, wooden objects, and umbrellas, and those we readily find in nature. Park's works reflect the land-scape in his mind.

In the last group are the youngest artists of post-modern times. Their works show the dynamic and diverse aspects of Korean ceramics. Beyond the boundary of ceramics delimited by the material called clay, these artists interpret tradition and culture in new ways, attempting to transcend time, space, and genres.

Byungju Seo creates objects that embody the stories in his mind. His ceramic sculpture is filled with symbolic allegory. Horses, houses, the sky, and carriages, and other figurines in his works represent an imaginary world that commingles reality and dreams.

Paying attention to issues facing Korean ceramics and the constantly changing trends of today, Jiman Choi's ceramic vessels of traditional shapes depict a 21st century land-scape, including war, sports, and computers. His works freely address a broad range of issues from Western values to contemporary aesthetics and social concerns.

C.

D.

E.

Jinkyoung Kim challenges a conventional notion according to which clay becomes stronger when fired. Her works are about clothing as a metaphor for the fragile human body. In this way, she shows the sensitivity of clay, which can also easily be broken.

Kyungran Yeo produces works in relief. On traditional vessels such as tea pots, flower vases, and jars, she carves the kinds of flowers and birds typically seen in Korean folk paintings. Her ceramic works are brightly colored like folk paintings, and cross-over genres as well as the mediums of painting and ceramics.

A most challenging artist in the exhibition, Dongwon Shin presents conceptual ceramic sculpture in relief. The two-dimensional wall of the exhibition hall serves as a canvas for his three-dimensional expression in ceramics.

Tradition and Innovation – Spotlight on Korean Contemporary Ceramics presents a wide spectrum of Korean ceramics today, bolstered by unlimited imagination as it embraces contemporary expressive language and faces the challenges of our changing times.

Jaeyoung Kang is chief curator for the World Ceramic Exposition Foundation, Korea. She studied art theory and has organized various exhibitions, and curated the 2005 exhibition *Trans-Ceramic-Art* for the Third World Ceramic Biennale in Korea.

Published in conjunction with the SOFA CHICAGO 2006 special exhibit *Tradition and Innovation – Spotlight on Korean Contemporary Ceramics,* presented by the World Ceramic Exposition Foundation (WOCEF), Korea.

F.

G.

H.

I.

J.

C.
Geejo Lee
Vase, *2004*
white clay
10.25 x 9 x 10.25

D.
Sangho Shin
Dream of Africa, *2004*
ceramic
23.5 x 22.5 x 21 front
98.5 x 79 back

E.
Suku Park
Rainy Day
wood-fired stoneware
27.5 x 13.75 x 29.5

F.
Byungju Seo
Play Riddles, *2004*
stoneware, music box,
leather strap, glaze,
terra sigillata
24.5 x 8.5 x 21.5

G.
Jiman Choi
21st Century Jar and
Stand of Goguryeo, *2004*
31 x 13.25

H.
Jinkyoung Kim
Netting Clay 952, *2006*
super white clay,
copper, fabric
31.5 x 13.75 x 10

I.
Dongwon Shin
Wish, *2005*
porcelain, plywood, paint
31 x 27.5

J.
Kyungran Yeo
Untitled, *2005*

hibitors

Tom Munsteiner, **Brooch/Necklace,** *2006*
rock crystal, with pyrite crystal, lapis lazuli, 18k yellow gold, 3.75 x 3

Aaron Faber Gallery

Modern Jewelry Design and Style: A Personal Collection

Staff: Edward Faber; Patricia Kiley Faber; Jackie Wax; Jerri Wellisch; Erika Rosenbaum; Claudia Andrada; Sara Fendley

666 Fifth Avenue
New York, NY 10103
voice 212.586.8411
fax 212.582.0205
info@aaronfaber.com
aaronfaber.com

Representing:
Marianne Anderson
Glenda Arentzen
Margaret Barnaby
Marco Borghesi
Claude Chavent
Françoise Chavent
Brooke Marks-Swanson
Bernd Munsteiner
Tom Munsteiner
Earl Pardon
Tod Pardon
Linda Kindler Priest
Kim Rawdin
Susan Kasson Sloan
Jeff Wise
Susan Wise
Michael Zobel

Earl Pardon, **Paint, Circle Brooch,** *1989*
sterling silver, 14k and 24k gold, painted enamel, shell, blue topaz, rhodolite garnet, amethyst, 2d

Klaus Spies, **Coral Necklace**, *2006*
18k yellow gold, 14mm coral beads, length: 18

Aaron Faber Gallery

Special SOFA CHICAGO Exhibition: *History Repeating Itself: Millennia BC*

Yoshiko Yamamoto, **Pillar Amulet Brooch,** *2006*
20 and 18k gold, carnelian, Egyptian Djet faience, 2.5 x 1.5

Representing:
Glenda Arentzen
Cecilia Bauer
Lisa Black
Petra Class
Margot Di Cono
Devta Doolan
Jordan Fretz
Anat Gelbard
Gurhan
Barbara Heinrich
Janis Kerman
Enric Majoral
Dawn Nakanishi
Harold O'Connor
Wiebke Peper
Linda Kindler Priest
Alyssa Reiner
Eva Seid
Klaus Spies
Brigitta Sueters
Noriko Sugawara
Yoshiko Yamamoto
Michael Zobel

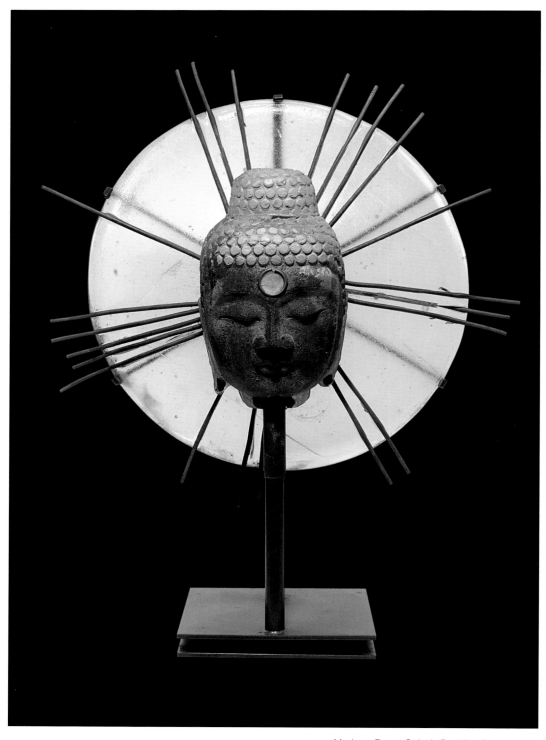

Marlene Rose, **Cobalt Buddha Burst,** *2006*
sand-cast glass, metal, 32 x 25 x 10
photo: David Monroe

Adamar Fine Arts

Contemporary original paintings and sculpture by recognized national and international artists
Staff: Tamar Erdberg, owner/director; Adam Erdberg, owner; Olga Cartaya, director

358 San Lorenzo Avenue
Suite 3210
Miami, FL 33146
voice 305.576.1355
fax 305.448.5538
adamargal@aol.com
adamargallery.com

Henry Richardson, **Precipitation**, *2006*
chiseled glass, 20 x 20 x 14
photo: Andrew Swaine

Representing:
Brad Howe
Tolla Inbar
Niso Maman
Gretchen Minnhaar
Henry Richardson
Marlene Rose
Donald Sultan

Czeslaw Zuber, **Untitled***, 2006*
crystal, 19 x 9.5 x 6.75
photo: Czeslaw Zuber

AKTUARYUS - Galerie Daniel Guidat

Contemporary sculptures in crystal, glass and bronze; paintings available
Staff: Daniel Guidat, proprietor; Albert Feix, III, proprietor

23 Rue de la Nueè Bleue
Strasbourg 67000
France
voice 33.3.8822.4444
fax 33.6.0821.9308
albertfeix3@earthlink.net
galeriedanielguidat.com

Representing:
Alain Bègou
Marisa Bègou
Gilles Chabrier
Yves Trucchi
Yan Zoritchak
Czeslaw Zuber

Yan Zoritchak, **Reflection,** *1999*
glass, 27.5 x 28 x 5.25
photo: Michele Wirth

Luis Fernando Uribe, **Encuentro I,** *2006*
ink on paper, 29 x 20
photo: Ana Fernatt

Aldo Castillo Gallery

International fine arts — specializing in Latin American art
Staff: Aldo Castillo, director; Rafael Castro, manager

675 North Franklin Street
Chicago, IL 60610
voice 312.337.2536
fax 312.337.3627
info@artaldo.com
artaldo.com

Oswaldo Vigas, **Centaura**, *1990*
bronze, 23.75 x 11 x 12.25

Representing:
Salvador Calvo
Adriana Carvalho
Salvador Dalí
Magdalena Fernández-Merino
Eladio González
Esperanza González
Luis López Cruz
Lorna Marsh
Manuel Mendive
Rosa Segura Sanz
Luis Fernando Uribe
Oswaldo Vigas

Jesus Curia Perez, **David** IV
bronze, metal, 20.5 x 6.5 x 5

Ann Nathan Gallery

Established and emerging contemporary realist painters, artist-made furniture,
famed ceramic and bronze sculptors, visionaries and selective African art
Staff: Ann Nathan, director; Victor Armendariz, assistant director;
Layla Bermeo, associate; Justin Hemmingson; Chris Strano

212 West Superior Street
Chicago, IL 60610
voice 312.664.6622
fax 312.664.9392
nathangall@aol.com
annnathangallery.com

Representing:
Pavel Amromin
Mary Bero
Mary Borgman
Gordon Chandler
Cristina Cordova
Gerard Ferrari
Krista Grecco
Michael Gross
Chris Hill
Sangram Majumdar
Jesus Curia Perez
Jim Rose
John Tuccillo
James Tyler
Jerilyn Virden

Jim Rose, **Five Drawer Table with Shelf**
steel, natural rust patina, 31 x 72 x 16

Sangram Majumdar, **Procession #2**
oil on linen, 120 x 50

Cristina Cordova, **Temporal**
ceramic, mixed media, 23.5 x 14.5 x 10.5

Stephen Benwell, **Large Vase (in Arcadia)**, *2006*
hand-built earthenware, underglaze painting, 19.5 x 19.5 x 19.5
photo: David McArthur

Australian Contemporary

Presenting the finest Australian contemporary craft and design. Australia Council and JamFactory International Craft Initiative is a strategy of the Visual Arts Board of the Australia Council, the Federal Government's arts funding body.
Staff: Stephen Bowers, managing director; Pauline Griffin, sales director; Margaret Hancock, project coordinator

19 Morphett Street
Adelaide, South Australia 5000
Australia
voice 61.8.8410.0727
fax 61.8.8231.0434
stephen.bowers@jamfactory.com.au
jamfactory.com.au

Representing:
Stephen Benwell
Stephen Bird
Bev Hogg
Jenny Orchard

Stephen Bird, **Figure This,** *2005*
glazed earthenware, 22 x 8 x 6
photo: Greg Piper

Bev Hogg, **Conversations with Country - Horizon,** *2005*
clay, slip glaze, slip cast bottles, 55.25 x 17.5 x 12
photo: David Paterson

Jenny Orchard, Elegirl, 2006
earthenware, 28 x 14 x 14
photo: Greg Piper

Avital Sheffer, **Mistor VI & Mistor VII,** *2006*
hand-built earthenware, 29 x 8 x 4; 27.5 x 8 x 4

Beaver Galleries

Contemporary Australian glass, ceramics, jewelry, wood, paintings and sculpture
Staff: Martin Beaver

81 Denison Street, Deakin
Canberra, ACT 2600
Australia
voice 61.2.6282.5294
fax 61.2.6281.1315
mail@beavergalleries.com.au
beavergalleries.com.au

Representing:
Clare Belfrage
Mel Douglas
Tim Edwards
Avital Sheffer

Tim Edwards, **Diffuse #6,** *2006*
blown and wheel-cut glass, 14.75 x 17 x 2.75

Juan Ripollés, **Totem de los Brazos,** *2006*
hand-shaped Murano glass, 37 x 11.5 x 9
photo: F. Ferruzzi

Berengo Fine Arts

Modern and contemporary art and glass art
Staff: Adriano Berengo, director; Hans van Enckevort, fair manager

Fondamenta Vetrai 109/A
Murano, Venice 30141
Italy
voice 39.041.739453
39.041.5276364
fax 39.041.527.6588
adberen@berengo.com
berengo.com

Berengo Collection
Calle Larga San Marco 412/413
Venice 30124
Italy
voice 39.041.241.0763
fax 39.041.241.9456

Kortestraat 7
Arnhem 6811 EN
The Netherlands
voice 31.26.370.2114
31.61.707.4402
fax 31.26.370.3362
berengo@hetnet.nl

Dusciana Bravura, **Tartarughe,** *2006*
Murano glass mosaic, resin, 7 x 22.5 x 15.75
photo: F. Ferruzzi

Representing:
Luigi Benzoni
Dusciana Bravura
James Coignard
Juan Ripollés
Jan Van Oost
Koen Vanmechelen
Silvio Vigliaturo

Edward Teasdale, **Chest with 7 Lids,** *2005*
tulip and reclaimed wood, 18 x 85 x 18
photo: Graham Edwards

Bluecoat Display Centre

Inspirational British applied art
Staff: Maureen Bampton, director; Samantha Rhodes, assistant director

Bluecoat Chambers
College Lane
Liverpool L1 3BZ
England
voice 44.151.709.4014
fax 44.151.707.8106
crafts@bluecoatdisplaycentre.com
bluecoatdisplaycentre.com

Representing:
Laura Baxter
Halima Cassell
Stephen Dixon
Rebecca Gouldson
Thomas Hill
Pauline Hughes
Alice Kettle
Cathy Miles
Junko Mori
Kate Moult
Kazuhito Takadoi
Edward Teasdale

Kazuhito Takadoi, **Happa (Leaves),** *2005*
mixed media, oak frame, 30 x 43 x 2.5
photo: Kazuhito Takadoi

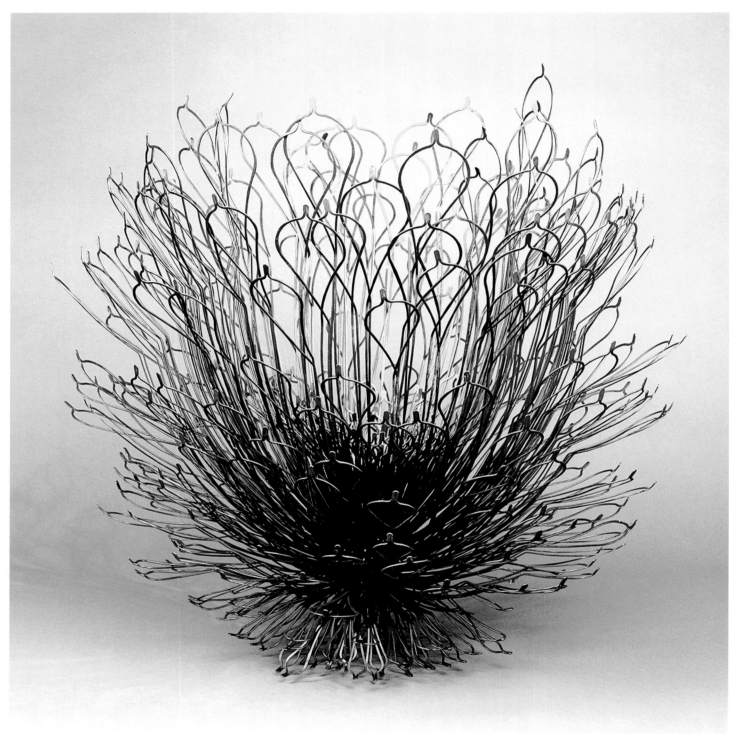

Junko Mori, #09 Blossom, 2006
wax-coated, forged mild steel, 22.75 x 22.75 x 22
photo: Matthew Hollow

Bluecoat Display Centre

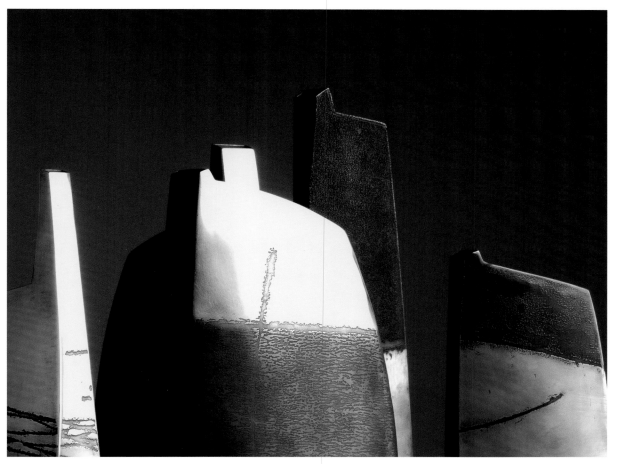

Rebecca Gouldson, **Skyline**, *2004*
sterling silver, copper, tallest: 11.75
photo: Tas Kyprianou

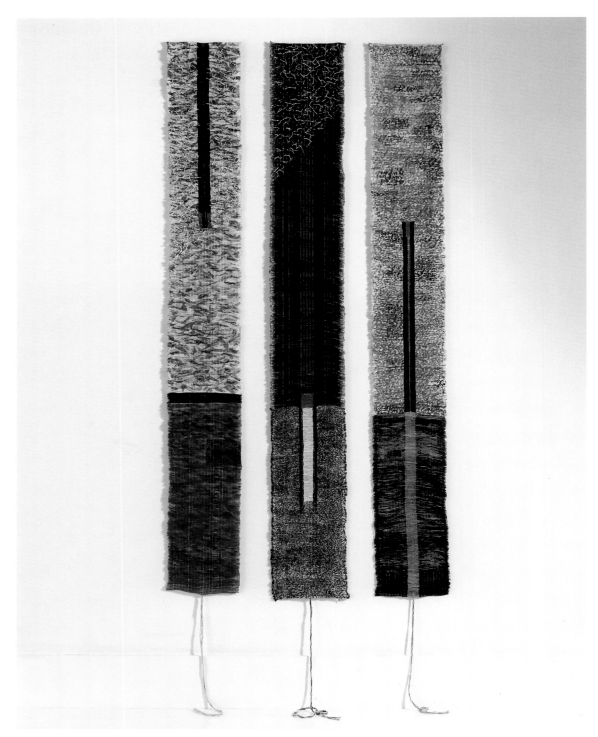

*Caroline Bartlett, **Trace**, 2002*
linen, pigment, 90 x 37
photo: Tom Grotta

browngrotta arts

Focusing on art textiles and fiber sculpture for 19 years
Staff: Rhonda Brown and Tom Grotta, co-curators; Roberta Condos, associate

Wilton, CT
voice 203.834.0623
fax 203.762.5981
art@browngrotta.com
browngrotta.com

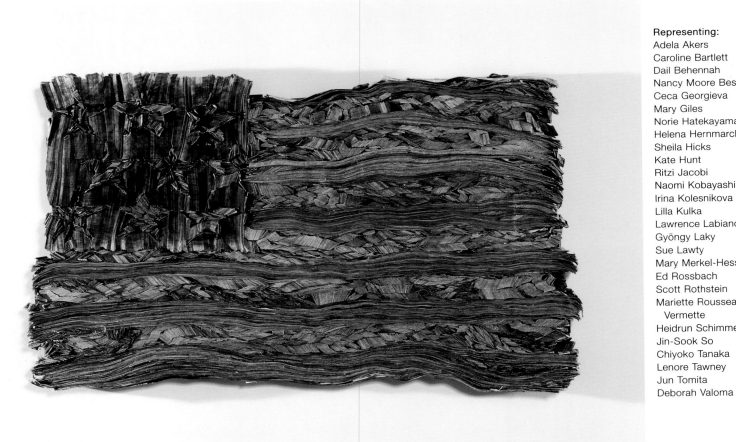

Representing:
Adela Akers
Caroline Bartlett
Dail Behennah
Nancy Moore Bess
Ceca Georgieva
Mary Giles
Norie Hatekayama
Helena Hernmarck
Sheila Hicks
Kate Hunt
Ritzi Jacobi
Naomi Kobayashi
Irina Kolesnikova
Lilla Kulka
Lawrence Labianca
Gyöngy Laky
Sue Lawty
Mary Merkel-Hess
Ed Rossbach
Scott Rothstein
Mariette Rousseau-
 Vermette
Heidrun Schimmel
Jin-Sook So
Chiyoko Tanaka
Lenore Tawney
Jun Tomita
Deborah Valoma

Kate Hunt, **Simple Flag #3,** *2006*
newspaper, steel, 20 x 35 x 2.5
photo: Tom Grotta

Kevin Perkins, **Cape Barren Goose Hutch,** *2005*
Tasmanian oak, huon pine, 50 x 48 x 14
photo: TRG Studios

Brushings, LTD.

Exquisite, classic and contemporary, museum-quality pieces for the home
Staff: Martha Hackett; William Parke; Stuart Meeking

By Appointment Only
16165 Thompson Road
Thompson, OH 44086
voice 440.488.0687
fax 440.298.3782
brushings@gmail.com
brushings.com

Representing:
Rex Heathcote
Marian Larner
Kevin Perkins
Paccy Stronach

Kevin Perkins, **Purple Hen Cabinet,** *2005*
Tasmanian oak, 60 x 12 x 12
photo: TRG Studios

Richard Marquis, **Stars and Stripes Pyramid with Reddy Kilowatt,** *2006*
glass; hot slab technique, found object, 6.25 x 12.75 x 9
photo: R. Marquis

The Bullseye Gallery

Contemporary works in Bullseye glass by established and emerging artists
Staff: Dan Schwoerer, CEO; Lani McGregor, executive director; Rebecca Rockom, sales; Chris McNelly, office manager

300 NW Thirteenth Avenue
Portland, OR 97209
voice 503.227.0222
fax 503.227.0008
gallery@bullseyeglass.com
bullseyeconnectiongallery.com

Representing:
Jane Bruce
Tessa Clegg
Mel George
Steve Klein
Silvia Levenson
Jessica Loughlin
Dante Marioni
Richard Marquis
Klaus Moje
Catharine Newell
Kirstie Rea
Ted Sawyer
April Surgent
Richard Whiteley
Mark Zirpel

Klaus Moje, **Object 12,** *2005*
kiln-formed and cold-worked glass, 11.75 x 23.5 x 2.75
photo: R. Watson

Silvia Levenson, **Be Happy** *installation, 2006*
furniture, glass, copper wire, 8' x 5' x 3'
photo: Natalia Saurin

Caterina Tognon Arte Contemporanea

Contemporary glass sculpture by European and American artists
Staff: Caterina Tognon, owner and director; Sergio Gallozzi, assistant

San Marco 2671
Campo San Maurizio
Venice 30124
Italy
voice 39.041.520.7859
fax 39.041.520.7859
info@caterinatognon.com
caterinatognon.com

Representing:
Václav Cigler
Maurizio Donzelli
Silvia Levenson
Maria Grazia Rosin

Václav Cigler, **Untitled Double Form,** *2005*
cut, matted optical glass, 11.5 x 10.5 x 11.5
photo: Francesco Allegretto

Toshio Iezumi, **M060402,** *2006*
laminated plate glass, ground and polished, 78 x 11.75 x 4.75
photo: Toshio Iezumi

Chappell Gallery

Contemporary glass sculpture
Staff: Richard L. Chappell, chairman; Alice M. Chappell, director;
Kathleen M. Pullan, gallery manager; Carol L. Chappell, direct marketing manager

526 West 26th Street
Suite 317
New York, NY 10001
voice 212.414.2673
fax 212.414.2678
amchappell@aol.com
chappellgallery.com

Naomi Shioya, **The Galactic Collection**
cast glass, 7.5 x 18.5 x 17.25
photo: Naomi Shioya

Representing:
Ruth Allen
Mary Ann Babula
Alex Gabriel Bernstein
Tomas Brzon
Sydney Cash
Christie Cathie
Hilary Crawford
Kathleen Holmes
Toshio Iezumi
Laurie Korowitz-Coutu
Pipaluk Lake
Melissa Misoda
Kait Rhoads
Youko Sano
Gale Scott
Ben Sewell
Naomi Shioya
Ethan Stern
Sasha Zhitneva

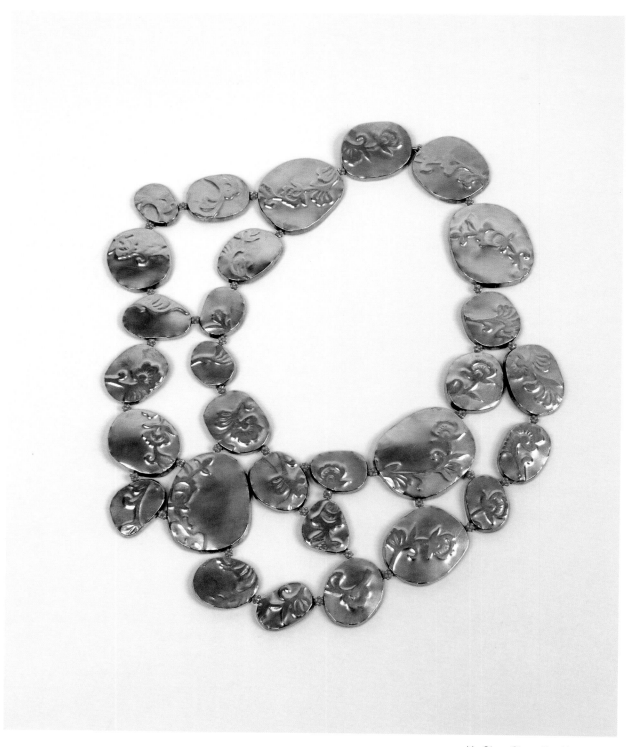

Yu-Chun Chen, **Necklace,** *2006*
oxidized silver, coral beads

Charon Kransen Arts

Contemporary innovative jewelry from around the world
Staff: Ciel Bannenberg; Adam Brown; Lisa Granovsky; Charon Kransen

By Appointment Only
456 West 25th Street
New York, NY 10001
voice 212.627.5073
fax 212.633.9026
charon@charonkransenarts.com
charonkransenarts.com

Natalya Pinchuk, **Growth Series brooch,** *2006*
wool, copper, enamel, plastic, thread

Representing:

Efharis Alepedis	Meiri Ishida	Barbara Paganin
Kirsten Bak	Reiko Ishiyama	Anya Pinchuk
Ralph Bakker	Hiroki Iwata	Natalya Pinchuk
Rike Bartels	Hilde Janich	Beverley Price
Roseanne Bartley	Mette Jensen	Kaire Rannik
Nicholas Bastin	Karin Johansson	Jackie Ryan
Carola Bauer	Machteld van Joolingen	Lucy Sarneel
Ela Bauer	Ike Juenger	Sylvia Schlatter
Michael Becker	Karin Kato	Claude Schmitz
Toril Bjorg	Martin Kaufmann	Frederike
Liv Blavarp	Ulla Kaufmann	Schuerenkaemper
Celio Braga	Jeong Yoon Kim	Biba Schutz
Sebastian Buescher	Judith Kinghorn	Karin Seufert
Shannon Carney	Stefanie Klemp	Verena Sieber Fuchs
Anton Cepka	Yael Krakowski	Charlotte Sinding
Yu Chun Chen	Deborah Krupenia	Evelien Sipkes
Annemie de Corte	Dongchun Lee	Elena Spano
Giovanni Corvaja	Felieke van der Leest	Claudia Stebler
Simon Cottrell	Hilde Leiss	Dorothee Striffler
Claudia Cucchi	Nel Linssen	Barbara Stutman
Saskia Detering	Susanna Loew	Hye-Young Suh
Babette von Dohnanyi	Friederike Maltz	Janna Syvanoja
Corinna Dolderer	Piotr Malysz	Salima Thakker
Hilde Foks	Stefano Marchetti	Ketli Tiitsar
Ford/Forlano	Lucia Massei	Terhi Tolvanen
Peter Frank	Christine Matthias	Silke Trekel
Martina Frejd	Elizabeth McDevitt	Catherine Truman
Marijke de Goey	Bruce Metcalf	Flora Vagi
Ursula Gnaedinger	Naoka Nakamura	Manuel Vilhena
Sophie Hanagarth	Evert Nijland	Karin Wagner
Mirjam Hiller	Carla Nuis	Yasunori Watanuki
Yasuki Hiramatsu	Sean O'Connell	Irene Wolf
Linda Hughes	Daniela Osterrieder	Annamaria Zanella

Gérald Vatrin, **L'oiseau Gagua,** *2005*
engraved and enameled glass, 6.75 x 11

Collection-Ateliers d'Art de France

Work by contemporary artists in a variety of media
Staff: Marie-Armelle de Bouteiller; Anne-Laure Roussille

4 Rue de Thorigny
Paris 75003
France
voice 33.1.4401.0830
fax 33.1.4401.0835
galerie@ateliersdart.com
ateliersdart.com

Representing:
Catherine Farge
Agnés His
Christophe Nancey
Simone Perrotte
Marc Ricourt
Isabelle Roux
Gérald Vatrin
Jean-Pierre Viot

Marc Ricourt, **Untitled,** *2005*
oak, ferrous oxide, 19.75 x 7.75

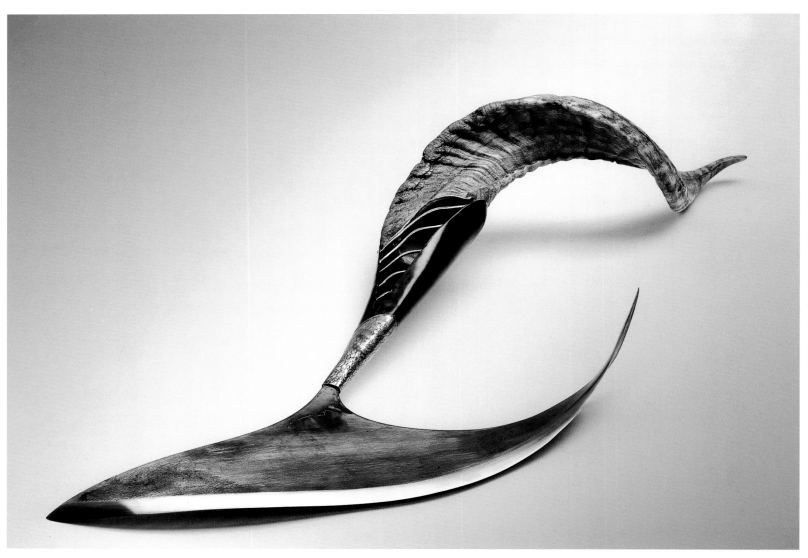

Chantal Gilbert, **La Montagne/The Mountain**, *2003*
mountain goat horn, bronze, sterling silver, stainless steel blade, 29 x 10
photo: Lucien Lisabelle

CREA, Galerie des Métiers d'Art du Québec

Select works contemporary Québec artists in a variety of media

Staff: Serge Demers, executive director; Linda Tremblay, marketing and export director

350 St. Paul Street East
Suite 400
Montréal, Québec H2Y 1H2
Canada
voice 514.861.2787, ext. 2
fax 514.861.9191
cmaq@metiers-d-art.qc.ca
metiers-d-art.qc.ca

Representing:
Louise Lemieux
 Bérubé
Maude Bussières
Mitsuru Cope
Laurent Craste
Nadine Fenton
Carole Frève
Bruno Gérard
Chantal Gilbert
Antoine Lamarche
Eva Lapka
Paula Murray
Francesc Peich
Patrick Primeau
John Paul Robinson
Natasha St. Michael
Luci Veilleux

Luci Veilleux, **Oscillation,** *2006*
sterling silver, 18k gold, 1.75 x 2.5
photo: Kedl

Yuriko Matsuda, **Slip Out,** *1990s*
polychrome porcelain, 15 x 17.5 x 11

Dai Ichi Arts, Ltd.

Modern and contemporary Japanese ceramics
Staff: Beatrice Chang, director

249 East 48th Street
New York, NY 10017
voice 212.230.1680
fax 212.230.1618
daiichiarts@yahoo.com
daiichiarts.com

Representing:
Shoji Hamada
Yasuo Hayashi
Shigemasa Higashida
Takashi Hinoda
Toshimi Imura
Kosuke Kaneshige
Tsubusa Kato
Yuriko Matsuda
Harumi Nakashima
Goro Suzuki
Izuru Yamamoto

*Izuru Yamamoto, **Embracing**, 2006*
wood-fired stoneware with ash glaze, 23.5 x 18 x 11
photo: Alexandra Negoita

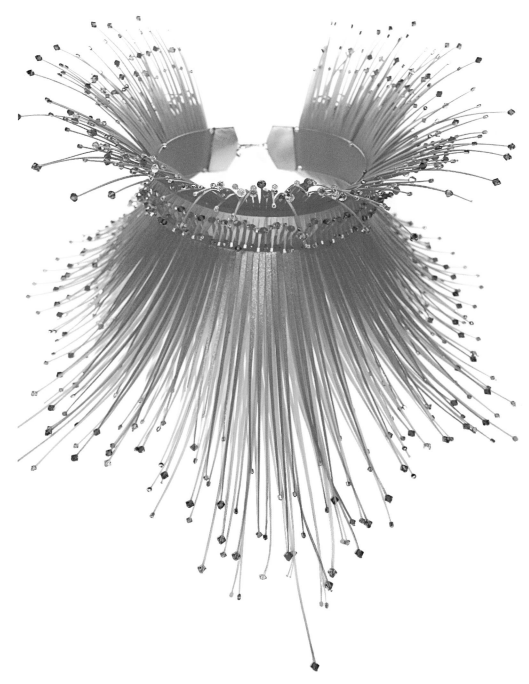

Anoush Waddington, **Sun Necklace**, *2006*
polypropylene, Swarovski crystal beads, silver fittings
photo: Jennifer David

The David Collection

International fine arts with a specialty in contemporary studio jewelry
Staff: Jennifer David; Robin David; Yuki Ishi

44 Black Spring Road
Pound Ridge, NY 10576
voice 914.764.4674
fax 914.764.5274
jkdavid@optonline.net
thedavidcollection.com

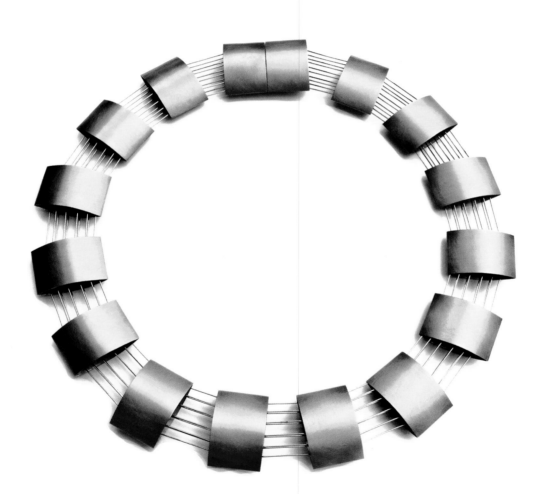

Representing:
Sara Basch
Silje Bergsvik
Alexander Blank
Babette Boucher
Elisa Deval
Joachim Dombrowski
Valentine Dubois
Nina Ehmck
Jürgen Eickhoff
Katje Fischer
Jantje Fleischhut
Kyoko Fukuchi
Ursula Gnaedinger
Michael Good
Ulrike Hamm
Michael Hamma
Marion Helig
Mari Ishikawa
Melanie Isverding
Yoko Izawa
Constantinos Kyriacou
Ingrid Larssen
Ruth Marques
Tasso Mattar
Jesse Mattes
Maria Phillips
Gitta Pielcke
Alexandra Pimental
Julia Reymann
Claudia Rinneberg
Kayo Saito
Marianne Schliwinski
Graziano Visintin
Anoush Waddington
Mona Wallström
Erich Zimmermann

Claudia Rinneberg, **Necklace***, 2005*
18k gold, stainless steel wire
photo: Berhard Rinneberg

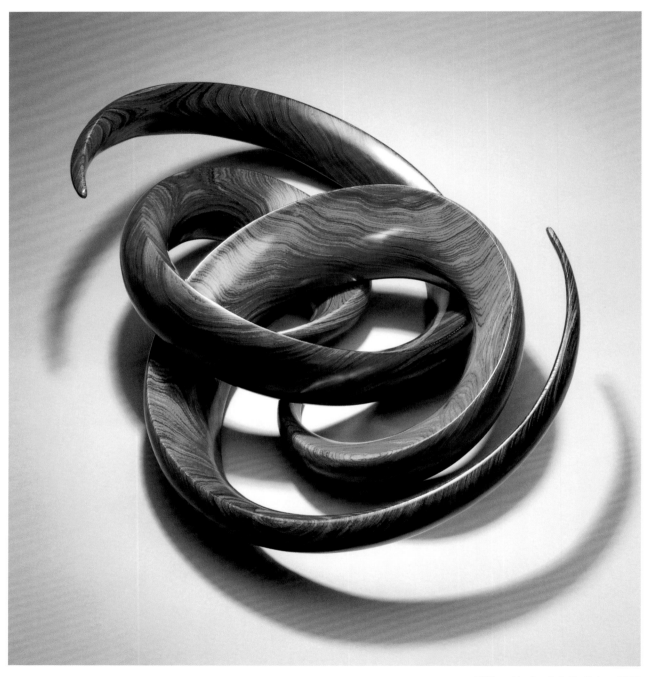

William Hunter, **Infinity Echo,** *2006*
cocobolo, 10 x 21 x 16
photo: Alan Shaffer

del Mano Gallery

Turned and sculptured wood, fiber, teapots and jewelry
Staff: Jan Peters; Ray Leier; Kirsten Muenster

11981 San Vicente Boulevard
Los Angeles, CA 90049
voice 310.476.8508
fax 310.471.0897
gallery@delmano.com
delmano.com

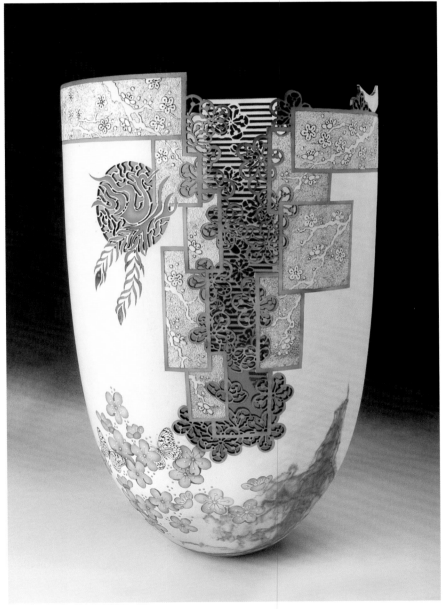

Binh Pho, **Amor Renovation (Rebirth of Love)***, 2006*
box elder, acrylic paint, dye, 15 x 10

Representing:

Gianfranco Angelino	Debora Muhl
Jerry Bleem	Judy Mulford
Mark Bressler	Dennis Nahabetian
Michael Brolly	David Nittmann
Christian Burchard	Nikolai Ossipov
David Carlin	George Peterson
M. Dale Chase	Michael Peterson
Jean-Christophe	Binh Pho
Couradin	Harry Pollitt
Robert Cutler	Jill Powers
Leah Danberg	Graeme Priddle
J. Kelly Dunn	Vaughn Richmond
David Ellsworth	Merryll Saylan
Harvey Fein	Siegfried Schreiber
J. Paul Fennell	Elizabeth Whyte
Ron Fleming	Schulze
Marion Hildebrandt	Neil Scobie
Robyn Horn	Kay Sekimachi
William Hunter	Michael Shuler
John Jordan	Steve Sinner
Steven Kennard	Fraser Smith
Ron Kent	William Smith
Stoney Lamar	Butch Smuts
Bud Latven	Alan Stirt
Ron Layport	Holly Tornheim
Art Liestman	Neil Turner
Jennifer Falck Linssen	Joël Urruty
John Macnab	Grant Vaughan
Alain Mailland	Jacques Vesery
Thierry Martenon	Hans Weissflog
Matt Moulthrop	Andi Wolfe
Philip Moulthrop	Malcolm Zander

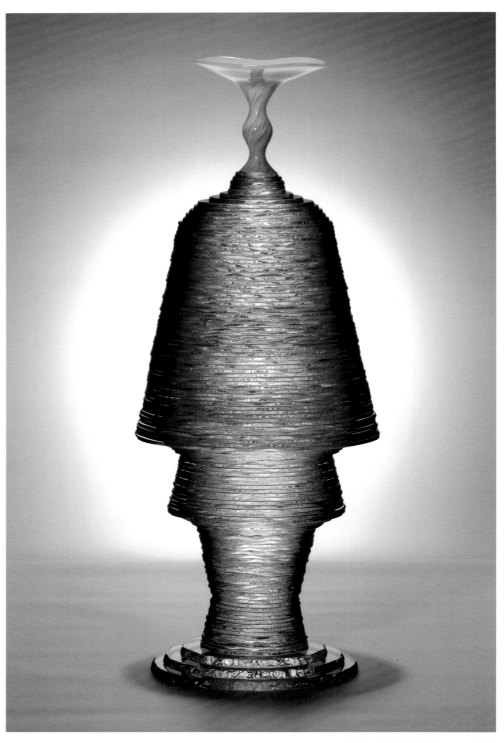

Satoshi Nishizaki, **Agora***, 2006*
cut and blown glass, 29 x 11 x 6.5

DF ARTS INTERNATIONAL

Contemporary fine sculpture focusing on site specific installation
Staff: Kikuko Izumi, owner; Toshinori Izumi, manager; Toshio Mochizuki, director

1-7-3 Hozumi
Toyonaka-shi
Osaka 561-0856
Japan
voice 81.6.6866.1400
fax 81.6.6866.2104
art@watouki.com
watouki.com

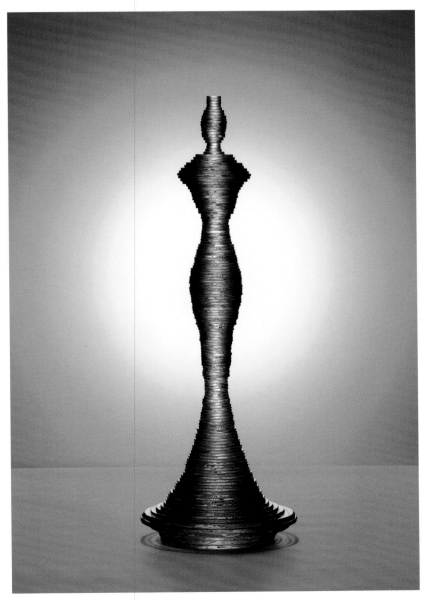

Representing:
Satoshi Nishizaki

Satoshi Nishizaki, **Miroku,** *2006*
cut glass, 18.5 x 4 x 4

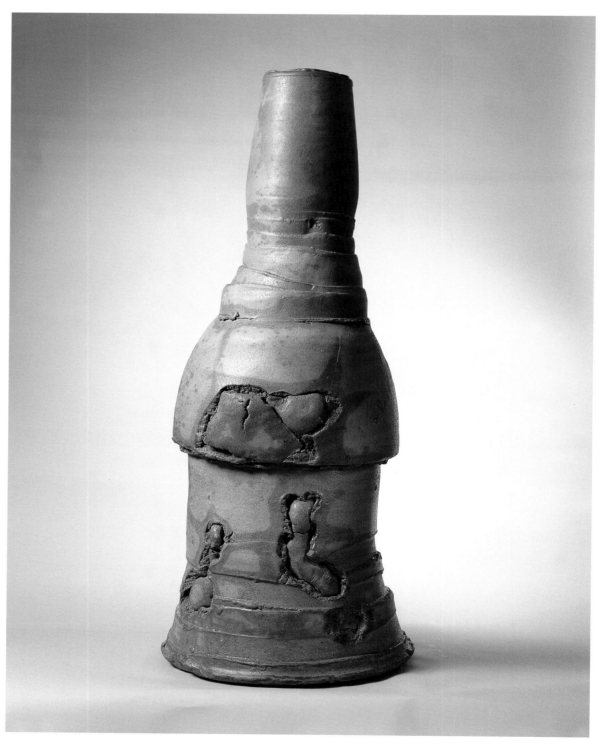

Peter Voulkos, **Stack,** *1979*
gas-fired stoneware, 40 x 16 x 16
photo: Goodbody

Donna Schneier Fine Arts

Modern masters in ceramic, glass, fiber, metal and wood
Staff: Donna Schneier; Leonard Goldberg; Jesse Sadia

By Appointment Only
910 Fifth Avenue
New York, NY 10021
voice 212.472.9175
fax 212.472.6939
dnnaschneier@mhcable.com

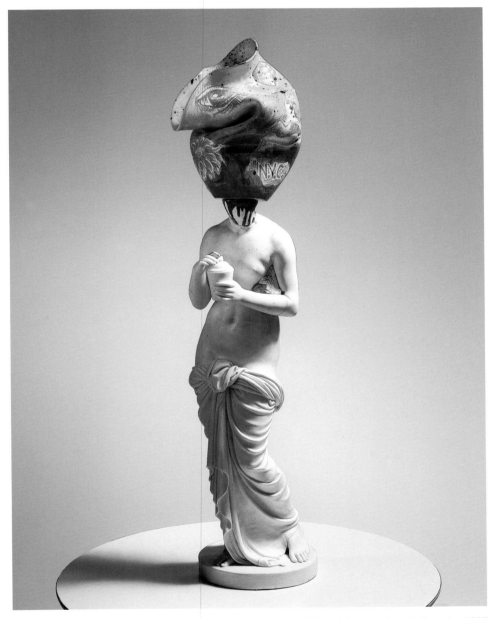

Michael Lucero, **French Female**, *1997*
porcelain, earthenware, glazes, 23 x 5 x 6
photo: Goodbody

Representing:
Jacob Agam
Dale Chihuly
Richard DeVore
Rick Dillingham
Viola Frey
Harvey K. Littleton
Michael Lucero
Sam Maloof
William Morris
Toshiko Takaezu
Bertil Vallien
František Vízner
Peter Voulkos
Beatrice Wood
Betty Woodman

Grethe Wittrock, **Little Peace***, 2004*
fiber, 59 x 12
photo: Anders Sune Berg

Drud & Køppe Gallery

Contemporary objects

Staff: Birgitte Drud and Bettina Køppe, directors; Marie T. Hermann, assistant

Bredgade 66
Copenhagen 1260
Denmark
voice 45.3333.0087
info@drud-koppe.com
drud-koppe.com

Cecilie Manz, A Slightly Disabled Chair, One of A Kind, *2004*
ash, string, paint, 27.5 x 20 x 20
photo: Jeppe Gudmundsen-Holmgren

Representing:
Louise Campbell
Michael Geertsen
Ditte Hammerstrøm
Castello Hansen
Louise Hindsgavl
Steen Ipsen
Mia Lerssi
Cecilie Manz
Anne Fabricius Møller
Stig Persson
Anders Ruhwald
Mette Saabye
Grethe Wittrock

Michael Geertsen, **Wall Object**, *2006*
earthenware, decals, gold, 6 x 10 x 12
photo: Søren Nielsen

Drud & Køppe Gallery

Castello Hansen, **Untitled**, *2003*
cibatool, reconstructed coral, paint, 18k gold, 2 x 1.25 x 1.25
photo: Lars Gundersen

Jenny Pohlman and Sabrina Knowles, **Aditi of Twilight**, *2006*
blown and hot-sculpted glass, mixed media, 45 x 23 x 23
photo: Russell Johnson

Duane Reed Gallery

Contemporary painting, sculpture, ceramics, glass and fiber by internationally recognized artists
Staff: Duane Reed; Glenn Scrivner; Merrill Strauss; Gaby Schaefer

7513 Forsyth Boulevard
St. Louis, MO 63105
voice 314.862.2333
fax 314.862.8557
info@duanereedgallery.com
duanereedgallery.com

Representing:
Rudy Autio
Cassandria Blackmore
Laura Donefer
Michael Eastman
Mary Giles
Sabrina Knowles
Marvin Lipofsky
Mari Meszaros
Danny Perkins
Jenny Pohlman
Ross Richmond
Michal Zehavi

Ross Richmond, **Garden of Earthly Delights,** *2006
blown and hot-sculpted glass, 11.5 x 18 x 6.5*

Erin Furimsky, **Burgeon,** *2006*
earthenware, glaze, 21 x 15 x 3
photo: Erin Furimsky

Dubhe Carreño Gallery

Contemporary ceramics by emerging and international artists
Staff: Dubhe Carreño, director; Barbara Wakefield, assistant

1841 South Halsted Street
Chicago, IL 60608
voice 312.666.3150
fax 312.577.0988
info@dubhecarrenogallery.com
dubhecarrenogallery.com

Michaelene Walsh, **Elegy,** *2006*
earthenware, glaze, various dimensions
photo: Eric Smith

Representing:
Meredith Brickell
Cynthia Consentino
Erin Furimsky
Tyler Lotz
Dennis Lee Mitchell
Machiko Munakata
Scott Rench
Thomas Schmidt
Karen Swyler
Michaelene Walsh

David Gerstein, **Brush Strokes Long**
hand-painted wall sculpture, 71 x 23.75

Eden Gallery

Contemporary art by leading Israeli artists featuring bronze, painting, metal and glass
Staff: Mickey Klimovsky; Cathia Klimovsky; Danny Herman

10 King David Street
Jerusalem 94101
Israel
voice 972.2.624.4831
fax 972.2.624.4832
info@eden-gallery.com
eden-gallery.com

Representing:
Yoel Benharrouche
Dganit Blechner
David Gerstein
Sarit Hefetz
Menashe Kadishman
Dorit Levinstein
Mark Tochilkin

Dorit Levinstein, **The Wave Fish**
hand-painted bronze, 27.5 x 15.75

Mayme Kratz, **Knots**, *2005*
resin on board, weeds, 11 x 50 x 2
photo: Tim Lanterman

Elliott Brown Gallery

Primary and secondary market contemporary decorative and sculptural glass; mixed media
Staff: Kate Elliott; Charlotte Webb; Ellen Hartwell

By Appointment Only
Mailing address: PO Box 1489
North Bend, WA 98045
voice 206.660.0923
fax 425.831.3709
kate@elliottbrowngallery.com
elliottbrowngallery.com

Representing:
Hank Murta Adams
Dale Chihuly
Mayme Kratz
Richard Marquis
Ann Robinson
Laura de Santillana
Toots Zynsky

Richard Marquis, **Zanfirico Teapot,** *2001*
blown glass, 4.25 x 6.75 x 6.75
photo: Richard Marquis

Jason Walker, **Sittin' Duck**, *2006*
porcelain, 15 x 14 x 10
photo: Jason Walker

Ferrin Gallery

Two and three dimensional art, ceramic sculpture and studio pottery
Staff: Leslie Ferrin; Donald Clark; Michael McCarthy; Giselle Hicks

69 Church Street
Lenox, MA 01240
voice 413.637.4414
fax 413.637.4232
info@ferringallery.com
ferringallery.com

Sergei Isupov, **Group of Heads**, *2006*
porcelain, tallest: 13h
photo: John Polak

Representing:
Russell Biles
Paul Dresang
Lucy Feller
Giselle Hicks
Sergei Isupov
Dana Major
Michael McCarthy
Keisuke Mizuno
Richard T. Notkin
Mark Shapiro
Micah Sherrill
Michael Sherrill
Randy Shull
Susan Thayer
Sandra Trujillo
Baba Diakate Wague
Jason Walker
Red Weldon-Sandlin
Irina Zaytceva

Carlos Mata, **Toro Panthelio,** *2006*
bronze, 24.5 x 22.75

Frederic Got Fine Art

Contemporary art, original sculptures and painting
Staff: Frederic Got, owner; Gabriel Eid, general manager; Sébastien Pronovost, manager

64 Rue Saint Louis en l'Île
Paris 75004
France
33.14.326.1033
got3@wanadoo.fr
artchic.com

Representing:
Ruth Bloch
Rémi Bourquin
Gonzales Bravo
Pierre Jean Couarraze
Alain Gazier
Annette Jalilova
Odile Kinart
Jacques Lebescond
Carlos Mata
Ranucci
Vittoria Tessaro
Tolla
Cris Vell
Andrei Zadorine
Roman Zaslonov

Jacques Lebescond, **Norma,** *2005*
bronze, 50h

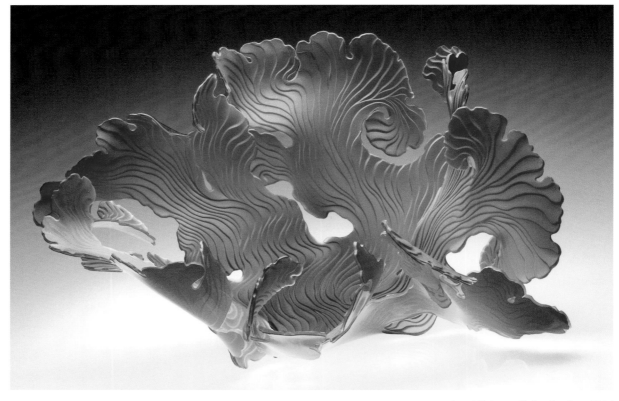

Janet Kelman, **Ruby Seafan**, *2004*
blown, sand-carved, slumped glass, 12 x 21 x 18.5
photo: JB Spector

Function + Art/PRISM Contemporary Glass

Excellence in objects: furniture, ceramics, glass, wood and metal
Staff: D. Scott Patria, director; Amy Hajdas, communications

1046-1048 West Fulton Market
Chicago, IL 60607
voice 312.243.2780
312.243.4885
info@functionart.com
info@prismcontemporary.com
functionart.com
prismcontemporary.com

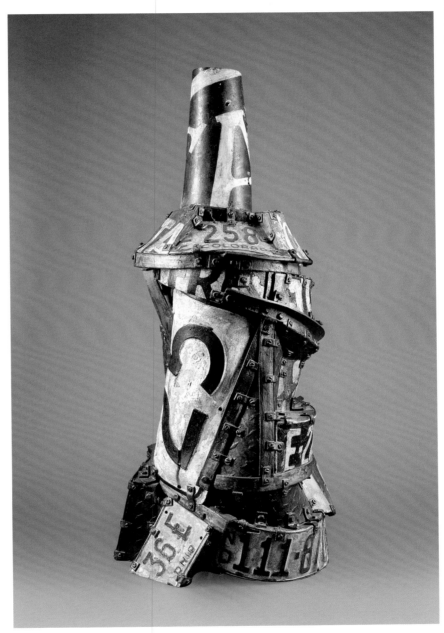

Steve Hansen, **Speed Limit 25,** *2006*
ceramic, 42 x 18
photo: JB Spector

Representing:
Brian Benchek
Bonnie Bishoff
Afro Celotto
Kathleen Elliot
Alex Fekete
Steve Hansen
Kimberly Haugh
Janet Kelman
Christopher J. Martin
John Medwedeff
Martin Rosol
Scott Schroeder
JM Syron
Jeffrey Wallin

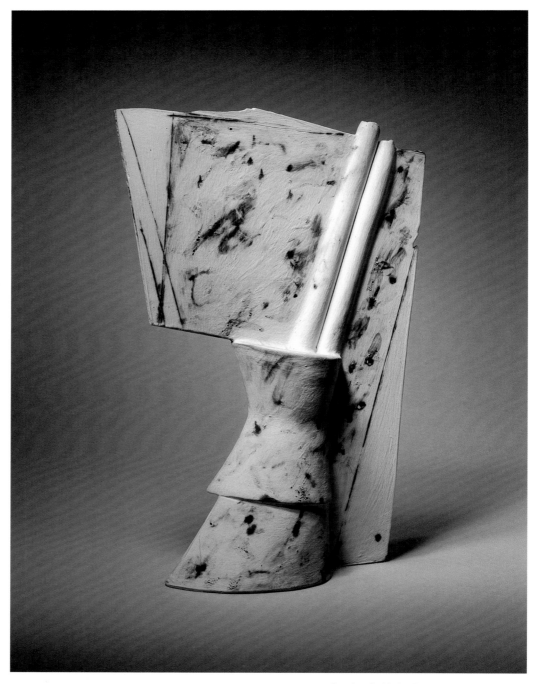

Gordon Baldwin, **Developed bottle***, 1982*
earthenware, matte white glaze, 13.75h
photo: Alan Tabor

Galerie Besson

International contemporary ceramics
Staff: Anita Besson, owner; Matthew Hall; Louisa Vowles

15 Royal Arcade
28 Old Bond Street
London W1S 4SP
England
voice 44.20.7491.1706
fax 44.20.7495.3203
enquiries@galeriebesson.co.uk
galeriebesson.co.uk

Representing:
Gordon Baldwin
Claudi Casanovas
Hans Coper
David Garland
Shoji Hamada
Jane Hamlyn
Jennifer Lee
Lucie Rie
Prue Venables

Claudi Casanovas, **Block no. 40,** *2001*
stoneware, mixed clays, 10.25 x 14.5 x 10.5
photo: Alan Tabor

Prue Venables, **White bowl, scoop, bottle and spoon,** *2005*
porcelain, bottle: 9.25h; bowl: 12.75w
photo: Alan Tabor

Jennifer Lee, Dark olive, metallic haloed band, shadowed rim, *2006*
hand-built colored stoneware, 5.75 x 5
photo: Alan Tabor

*Caroline Ouellette, **Goutte de Miel***, *2006*
blown glass, carved, pâte de verre with flame-worked elements, 15.5 x 8.5 x 7
photo: Michel Dubreuil

Galerie Elena Lee

New directions of contemporary art glass and mixed media for over 30 years
Staff: Elena Lee; Joanne Guimond; Matthew Morein; Sol Ines Peca; Sylvia Lee

1460 Sherbrooke West
Suite A
Montréal, Québec H3G 1K4
Canada
voice 514.844.6009
info@galerieelenalee.com
galerieelenalee.com

Carole Pilon, **Les Corps Étrangers 6**, *2006*
lost wax cast crystal, paper pulp, pigments, 42 x 5.5 x 6.75
photo: Michel Dubreuil

Representing:
Annie Cantin
Brad Copping
Tanya Lyons
Caroline Ouellette
Carole Pilon
Cathy Strokowsky

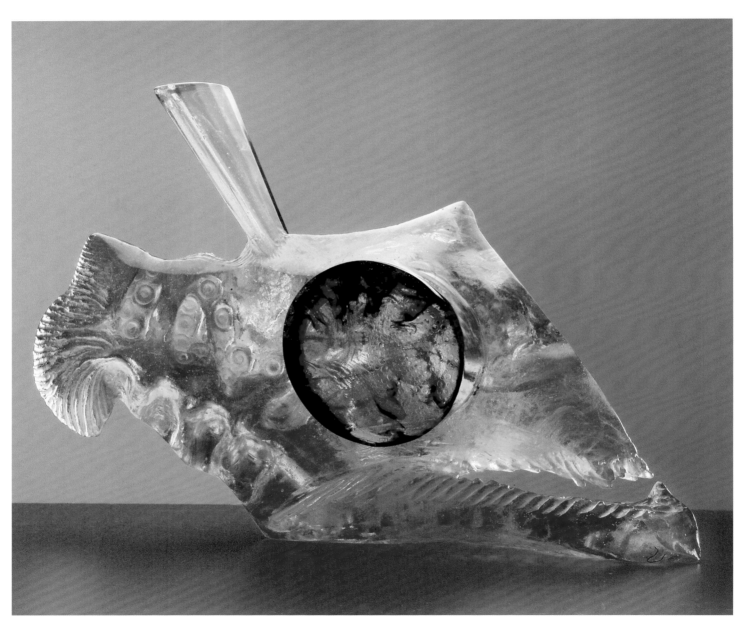

Jaromír Rybák, **Japanese Fish,** *2005*
cast glass; cut, etched and engraved

Galerie Meridian

Collection of contemporary works of Czech artists representing traditional art glass
Staff: Zdenka Pfauserová, owner; Alena Sebránková

Široká 8
Prague 1, 110 00
Czech Republic
voice 420.2.2481.9154
fax 420.2.24815759
galeriemeridian@volny.cz
galeriemeridian.cz

Representing:
Blanka Adensamová
Bohumil Eliáš
Josef Marek
Jaroslav Matouš
Jaromir Rybák
Dana Vachtová
František Vízner
Jaroslav Wasserbauer

Bohumil Eliáš, **Theatre***, 2001*
painted sheet glued and cut glass, 20 x 4

*Štěpán Pala, **Lines**, 2004*
drawing, 36 x 24
photo: courtesy of the artist archive

Galerie Pokorná

Contemporary and modern art
Staff: Jitka Pokorná, director

Janský Vrsek 15
Prague 1, 11800
Czech Republic
voice 420.222.518635
fax 420.222.518635
office@galeriepokorna.cz
galeriepokorna.cz

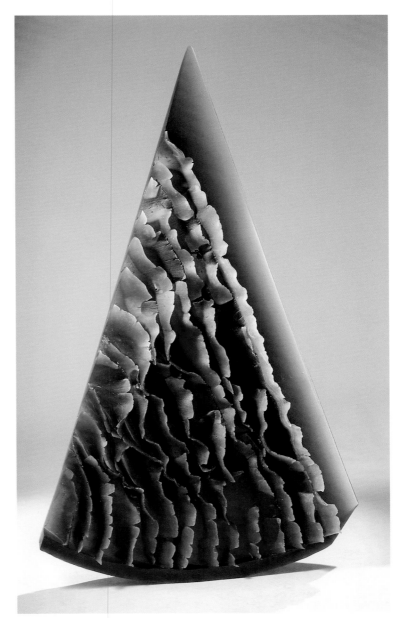

Representing:
Vladimír Bachorík
Richard Čermák
Lenka Čermákova
Václav Cígler
Jan Frydrych
Štépán Pala
Zora Palová

Zora Palová, **Remembrance of the Sea,** *2005*
cast glass, 38 x 24 x 6
photo: courtesy of the artist archive

Zhuang Xiao Wei, **Nude with Chinese Ink,** *2006*
glass, 19.75 x 9.75 x 4
photo: Warren So

Galerie Vee

Sculpture in glass from American and Asian artists

Staff: Vanessa Lee Taub, director; Cora Lee, gallery manager; Paul Yip, gallery associate; Monica Tai, exhibition coordinator

Shop 225, 2/F
Prince's Building
Central, Hong Kong
voice 852.2522.3166
fax 852.2522.1677
vanessa@galerievee.com
interiors@galerievee.com
galerievee.com

Representing:
Lam Laam Jaffa
Wang Qin
Yang Mei Hua
Zhuang Xiao Wei

Wang Qin, **Calligraphy 2,** *2006*
glass, 9.5 x 32.5 x 2.75
photo: Wang Qin

Arman, Violon Phoenix
golden bronze, bronze, 25.5 x 11.75 x 11.75

Galerie Vivendi

International contemporary art with emphasis on optic art
Staff: Alex Hachem, director; Paola Cancian and Rachel Pavie, assistants

28 Place des Vosges
Paris 75003
France
voice 33.1.4276.9076
fax 33.1.4276.9547
vivendi@vivendi-gallery.com
vivendi-gallery.com

Carlos Cruz-Diez, **Physichromie 1407**, *2004*
mixed media, 47.25 x 23.5

Representing:
Arman
Carlos Cruz-Diez
Dirk De Keyzer
Park Kwang-Jin
Alexandra Lazareff
Dario Perez-Flores
Seock Son

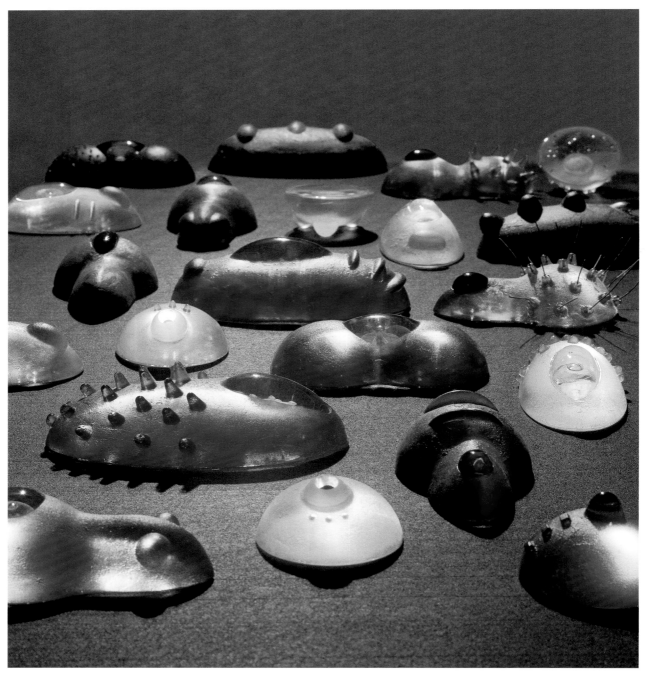

Micha Karlslund, **Cells***, 2003*
glass, length: 5.5-12.5
photo: Sten Afd. Fem

Galleri Grønlund

Representing the very best Danish glass artists

Staff: Anne Merete Grønlund, gallery owner; Kirstine Grønlund; Jørgen Grønlund

Birketoften 16a
Copenhagen 3500
Denmark
voice 45.44.442798
fax 45.44.442798
groenlund@get2net.dk
glassart.dk

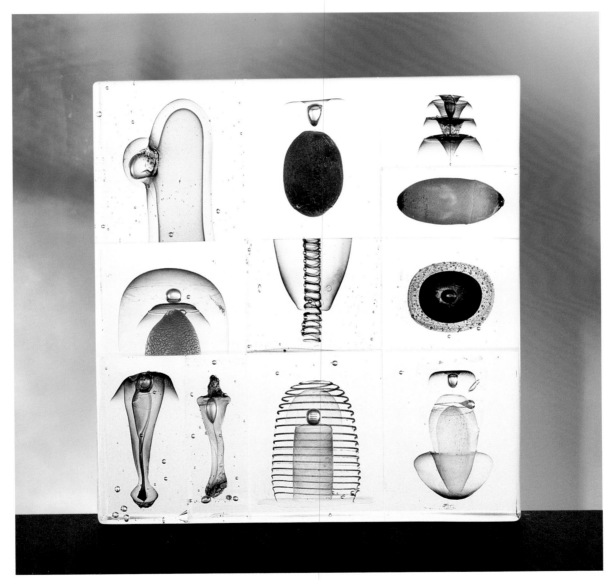

Representing:
Lene Bødker
Marianne Buus
Steffen Dam
Trine Drivsholm
Rikke Hagen
Micha Karlslund
Tobias Møhl

Steffen Dam, **11 Small Inventions**, *2006*
glass, 10.25 x 9.5 x 2
photo: Sten Afd. Fem

Martin Bodilsen Kaldahl, **Knot Pot #4,** *2004*
ceramic, 17 x 18 x 11.5
photo: Ole Akhøj

Galleri Nørby

Contemporary Danish ceramics

Staff: Susanne Pouline Svendsen, director; Gurli Elbaekgaard, assistant; Martin Bodilsen Kaldahl

Vestergade 8
Copenhagen 1456
Denmark
voice 45.33.151920
fax 45.33.151963
info@galleri-noerby.dk
galleri-noerby.dk

Representing:
Barbro Åberg
Per Ahlmann
Morten Løbner Espersen
Bente Hansen
Gitte Jungersen
Martin Bodilsen Kaldahl
Lone Skov Madsen
Bodil Manz
Bente Skjøttgaard

*Bodil Manz, **Untitled**, 2006*
ceramic, 4 x 4.5
photo: Ole Akhøj

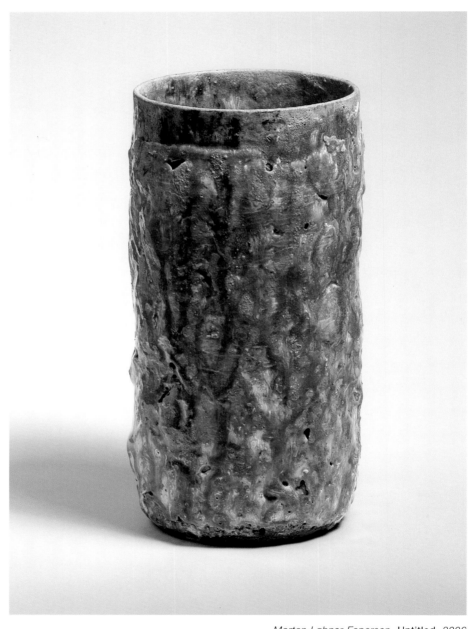

Morten Løbner Espersen, **Untitled,** *2006*
ceramic, 12 x 6
photo: Ole Akhøj

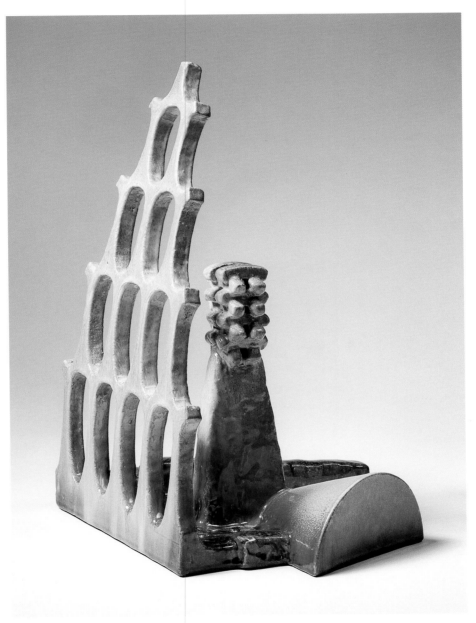

Per Ahlmann, **Tomorrow,** *2006*
ceramic, 14 x 9.5
photo: Ole Akhøj

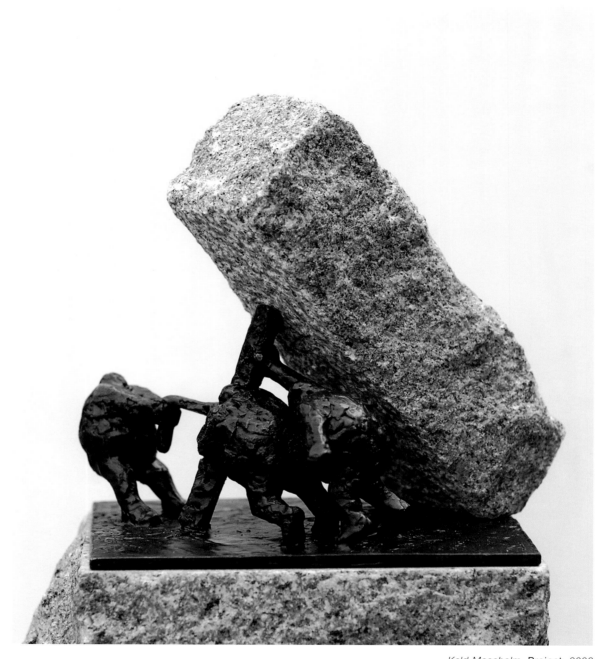

Keld Moseholm, **Project**, *2006*
bronze, granite, 9 x 9 x 7
photo: Keld Moseholm

Galleri Udengaard

Contemporary fine art Vester Allé 9
Staff: Lotte Udengaard; Bruno Dahl Aarhus C 8000
Denmark
voice 45.8625.9594
udengaard@c.dk
galleriudengaard.com

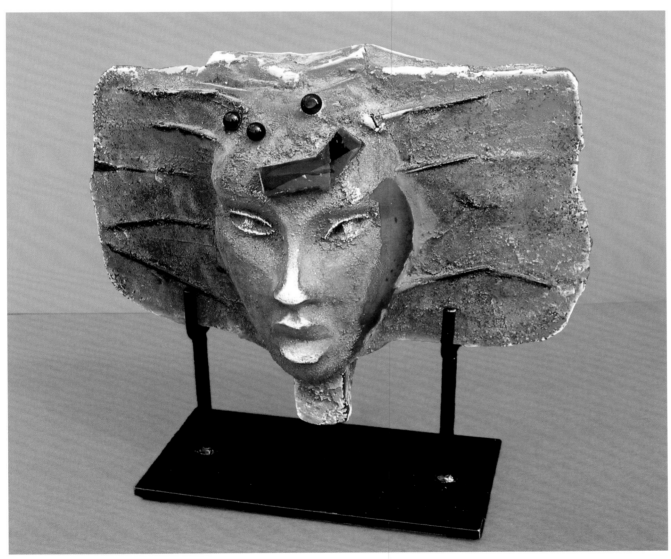

Representing:
Björn Ekegren
Keld Moseholm

Björn Ekegren, **Tigre,** *2005*
sand-cast glass, 15 x 17 x 3
photo: Lotte Udengaard

Mark Chatterley, **3 Levels,** *2006*
clay, 68 x 36 x 18
photo: Mark Chatterley

Gallery 500 Consulting

Promoting excellence and creativity in all media
Staff: Rita Greenfield, owner

3502 Scotts Lane
Philadelphia, PA 19129
voice 215.849.9116
610.420.9626
fax 610.277.1733
gallery500@hotmail.com
gallery500.com

Representing:
Mark Chatterley
Sherrie Fehr
Debra Fritts
Cornelia Goldsmith
Dale Gottlieb
Ayesha Mayadas
Marion Robinson
Philip Soosloff
Gretchen Wachs

Debra Fritts, **Silent Language***, 2006*
terra cotta clay, 38 x 15 x 13
photo: David Gulisano

Yoshiaki Yuki, Usagi (Rabbit), *2006*
ceramic lamp, silver glaze, 9 x 7 x 7
photo: Tamotsu Kawaguchi

gallery gen

A broad spectrum of contemporary art from Japan
Staff: Chizuko Go; Shinya Ueda; Mio Takahashi; Nicholas Rucka

158 Franklin Street
New York, NY 10013
voice 212.226.7717
fax 212.226.3722
info@gallerygen.com
gallerygen.com

Representing:
Junichi Arai
Kazuko Mitsushima
Yoshiaki Yuki

Yoshiaki Yuki, **Mori (Forest)***, 2006*
Japanese pigments and charcoal ink on paper, mounted on wood, 70 x 70 x .5
photo: Tamotsu Kawaguchi

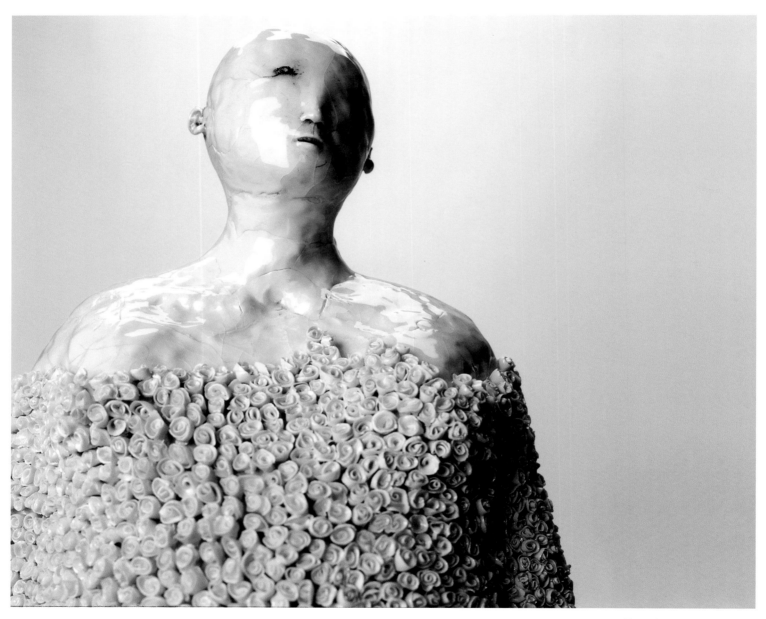

Claire Curneen, **Feast***, 2003*
porcelain, 19h
photo: Dewi Tannatt Lloyd

The Gallery, Ruthin Craft Centre

Contemporary craft and applied art from Wales

Staff: Philip Hughes, director; Jane Gerrard, deputy director; Gwenno Jones, Wales Art International

Park Road
Ruthin, Denbighshire
Wales LL15 1BB
United Kingdom
voice 44.1824.704774
fax 44.1824.702060
thegallery@rccentre.org.uk

Representing:
Beverley Bell-Hughes
Melanie Brown
Claire Curneen
Lowri Davies
Ann Catrin Evans
Virginia Graham
Catrin Howell
Caitlin Jenkins
Christine Jones
Walter Keeler
Wendy Lawrence
Audrey Walker

Lowri Davies, **Welsh Stereotype Collection - In the Kitchen,** *2006
slip-cast, white earthenware, 7 x 7
photo: Dewi Tannatt Lloyd*

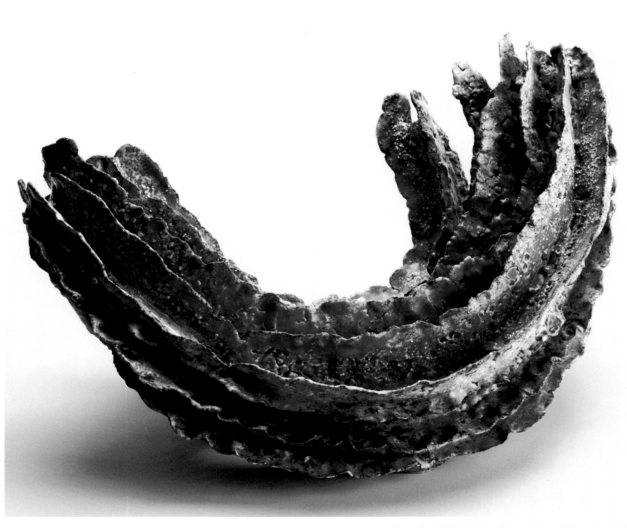

Beverley Bell-Hughes, **Razor Wave (Series)**, *2005*
reduced-fired stoneware, barium glaze, oxide washes, 7 x 11
photo: Dewi Tannatt Lloyd

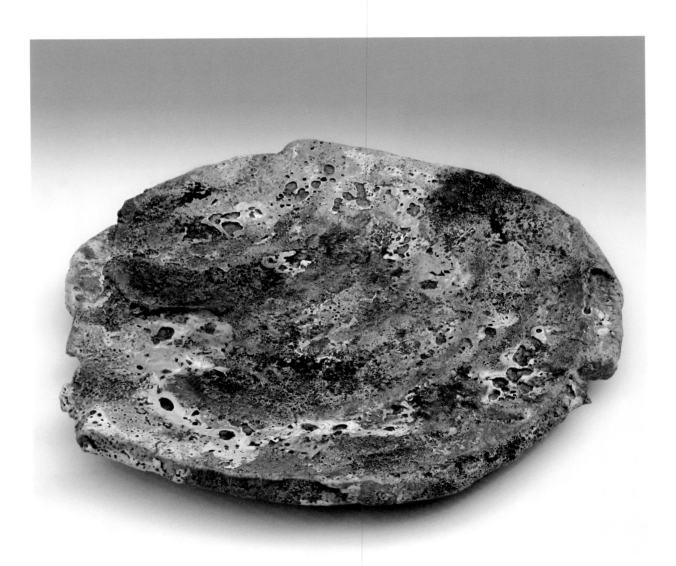

Wendy Lawrence, **Large Platter,** *2005*
stoneware, eruptive glazes, 19d
photo: Wendy Lawrence

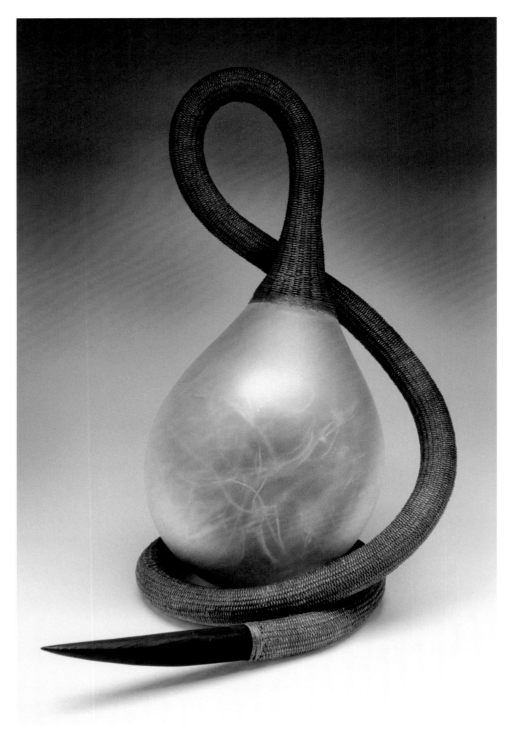

Tevita Havea, **Hina,** *2006*
blown glass, wood, twine, 19.5 x 16 x 10
photo: Stuart Hay

Glass Artists' Gallery

Australia's foremost contemporary glass gallery promoting emerging and established artists since 1982
Staff: Maureen Cahill, director

70 Glebe Point Road
Glebe, Sydney, NSW 2037
Australia
voice 61.2.9552.1552
fax 61.2.9552.1552
mail@glassartistsgallery.com.au
glassartistsgallery.com.au

Representing:
Nicole Ayliffe
Tali Dalton
Holly Grace
Tevita Havea
Sam Juparulla

Tali Dalton, **Enthralled,** *2006*
blown, sand-blasted and polished glass, 6 x 19 x 9
photo: Greg Piper

Jung-Sil Hong, **Traces of Time,** *2003*
gold, silver, steel, Korean lacquer, 12.75 x 8.75 x 8.75
photo: Heun-Man Hwang

Guil-Guem Metal Arts Research Center

Korean metal arts with an emphasis on craft-based pieces and jewelry
Staff: Jung-Sil Hong, director; Sun-Jung Kim, assistant director; Moon-Jung Kim; Hong-Yong Kim

112-2 Samsung-dong
Gangnam-gu
Seoul 135-090
Korea
voice 82.2.556.5376
fax 82.2.556.5395
ipsa78@hanmail.net
guilguemcraft.org

Representing:
In-Suk Hong
Jung-Sil Hong
Kyung-A Hong
Ji-Young Hwang Bo
Hong-Yong Kim
Moon-Jung Kim
Sun-Jung Kim
Komelia Hongja Okim
Soo-Ryeon Park
Hye-Won Yun

Jung-Sil Hong, **Time Composition,** *2005*
gold, silver, copper, steel, Korean lacquer, 7 x 15.5 x 14.25
photo: Heun-Man Hwang

David Bennett, **The Tumbler in Purple,** *2006*
blown glass, bronze, 16 x 16 x 12

Habatat Galleries

Representing the finest artists in the international realm of contemporary glass since 1971
Staff: Linda J. Boone; Lindsey Scott; Sonny Stewart

608 Banyan Trail
Boca Raton, FL 33431
voice 561.241.4544
fax 561.241.5793
info@habatatgalleries.com
habatatgalleries.com

Representing:
David Bennett
Robert Carlson
Deanna Clayton
Keith Clayton

Deanna Clayton, **Red Net Vessel,** *2002*
cast pâte de verre and electroplated copper, 12 x 24 x 24

Martin Blank, **Syncopated Red,** *2006*
hot-worked glass, 32 x 16 x 16
photo: Doug Schaible

Habatat Galleries

Developing significant collections around the world

Staff: Ferdinand Hampson; Kathy Hampson; John Lawson; Corey Hampson; Aaron Schey; Debbie Clason; Rickey Keulen; Robert Bamborough; Robert Shimell

4400 Fernlee Avenue
Royal Oak, MI 48073
voice 248.554.0590
fax 248.554.0594
info@habatat.com
habatatglass.com
habatat.com

222 West Superior Street
Chicago, IL 60610
voice 312.440.0288
fax 312.440.0207
karen@habatatchicago.com
habatatchicago.com

Margit Toth, **Agreement-Peace-Rest-Silence**
pâte de verre, 21.25 x 8.25 x 8.25

Representing:
Herb Babcock
Martin Blank
Stanislaw Borowski
Emily Brock
Daniel Clayman
Irene Frolic
Eric Hilton
Petr Hora
David Huchthausen
Bill LeQuier
Debora Moore
Jack Schmidt
Margit Toth
Leah Wingfield
Ann Wolff

Christopher Ries, **Spring,** *2006*
sculpted optical crystal, 41 x 20.25 x 6
photo: Jim Kane

Hawk Galleries

Modern masters who create contemporary glass, metal, and wood sculptures
Staff: Tom Hawk; Susan Janowicz

153 East Main Street
Columbus, OH 43215
voice 614.225.9595
fax 614.225.9550
tom@hawkgalleries.com
hawkgalleries.com

Representing:
Albert Paley
Christopher Ries

Albert Paley, **Animal Sculptures, Elephants,** *2006*
steel, various sizes
photo: Bruce Miller

Vladimira Klumpar, **Look Out,** *2006*
cast glass, 53.5 x 21.25 x 13.75
photo: Martin Polak

Heller Gallery

Exhibiting sculpture using glass as a fine art medium since 1973
Staff: Douglas Heller; Michael Heller; Katya Heller

420 West 14th Street
New York, NY 10014
voice 212.414.4014
fax 212.414.2636
info@hellergallery.com
hellergallery.com

Representing:
Nicole Chesney
Susan Taylor Glasgow
Anja Isphording
Vladimira Klumpar
Thérèsè Lahaie
Ivana Šrámková

Nicole Chesney, **Rising 11,** *2006*
glass, oil paint, 36 x 36 x 1
photo: Scott Lapham

Mary Bero, **Mountain Garden,** *2006*
hand embroidery, 16 x 15.75 x 1

Hibberd McGrath Gallery

Contemporary American ceramics, fiber, and jewelry
Staff: Martha Hibberd, partner; Terry McGrath Craig, partner

101 North Main Street
PO Box 7638
Breckenridge, CO 80424-7638
voice 970.453.6391
fax 970.453.6391
terry@hibberdmcgrath.com
hibberdmcgrath.com

Representing:
Mical Aloni
Mary Bero
Jean Cacicedo
Olga D. Cinnamon
Laurie Hall
Tom Lundberg
Amy Clarke Moore
Beth Nobles
Sang Roberson
Jim Romberg
Carol Shinn
Missy Stevens

Beth Nobles, **Border People Series: Querida Mama***, 2006*
hand embroidery, piecework, 16 x 14 x 1.25
photo: Gary Soles

*Lino Tagliapietra, **Fenice**, 2006*
blown glass, 18.75 x 21.5 x 8.5
photo: Russell Johnson

Holsten Galleries

Contemporary art glass

Staff: Kenn Holsten, owner/director; Jim Schantz, art director; Mary Childs, co-director; Stanley Wooley, associate director; Joe Rogers, preparator

3 Elm Street
Stockbridge, MA 01262
voice 413.298.3044
fax 413.298.3275
artglass@holstengalleries.com
holstengalleries.com

Representing:
Lino Tagliapietra

Lino Tagliapietra, **Concerto di Primavera***, 2000*
blown glass, 82.5 x 96 x 22
photo: Russell Johnson

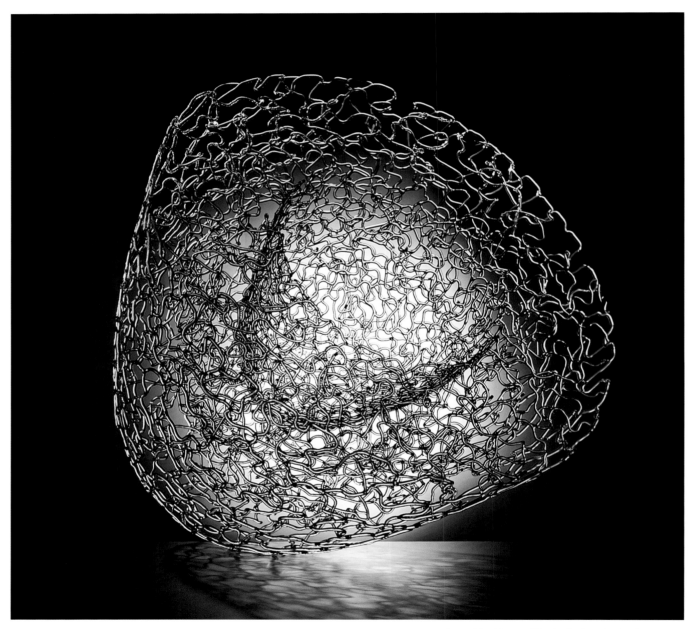

Brent Kee Young, **Matrix Series:** *Jay's Folly, 2006*
flame-worked Pyrex glass, 30 x 30 x 30
photo: Dan Fox, Lumina Studio

Jane Sauer Thirteen Moons Gallery

Innovative work by internationally recognized artists in a variety of media
Staff: Jane Sauer; Adrian Murphy; Edward Oliphant

652 Canyon Road
Santa Fe, NM 87501
voice 505.995.8513
fax 505.995.8507
jsauer@thirteenmoonsgallery.com
thirteenmoonsgallery.com

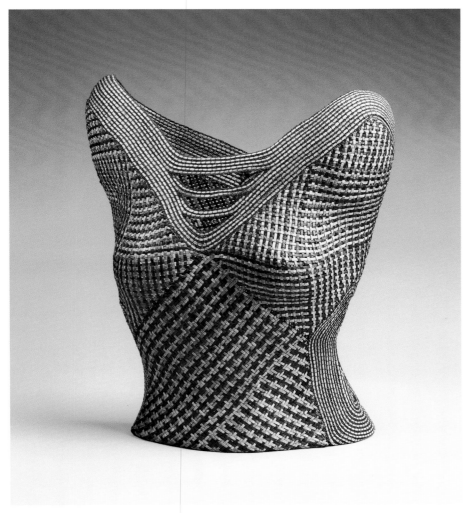

Representing:
Adela Akers
Adrian Arleo
James Bassler
Giles Bettison
Carol Eckert
Lindsay Ketter Gates
Tim Harding
Cindy Hickok
Jan Hopkins
Lissa Hunter
Christine Joy
Kay Khan
Jon Riis
Joseph Shuldiner
Polly Sutton
Cheryl Ann Thomas
Dawn Walden
Brent Kee Young

Jan Hopkins, **NEITH,** *2006*
woven cedar bark, 17 x 15 x 9
photo: Wendy McEahern

Jodi Bova, **Seems Like Yesterday,** *2005*
acrylic and solder on canvas, 12 x 12

Jean Albano Gallery

Contemporary painting, sculpture and construction
Staff: Jean Albano Broday; Sarah Kaliski; Lindsey Walton

215 West Superior Street
Chicago, IL 60610
voice 312.440.0770
fax 312.440.3103
jeanalbano@aol.com
jeanalbanogallery.com

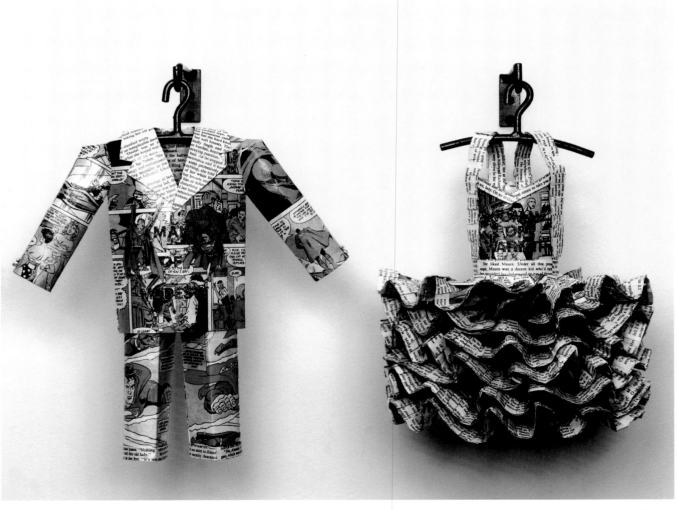

Representing:
Luciana Abait
Jodi Bova
Diane Cooper
Claudia DeMonte
John Geldersma
Donna Rosenthal
Robert Walker
Mindy Weisel

Donna Rosenthal, **He Said ... She Said (Superheroes)**, *2006*
vintage print material, shellac, text, steel, 13.5 x 11 x 11; 14.5 x 3 x 13
photo: Bill Orcutt

173

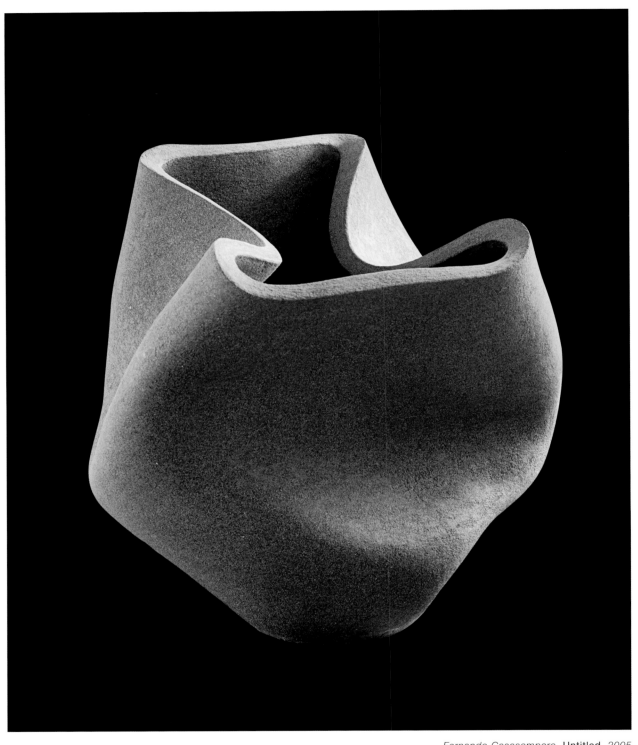

Fernando Casasempere, **Untitled**, *2005*
stoneware with industrial waste from copper mining, 29.5 x 30.75
photo: Michael Harvey

Joanna Bird Pottery

Studio pottery by contemporary artists and past masters
Staff: Joanna Bird, owner; Helen Beard, assistant

By Appointment
19 Grove Park Terrace
London W4 3QE
England
voice 44.208.995.9960
fax 44.208.742.7752
joanna.bird@btinternet.com
joannabirdpottery.com

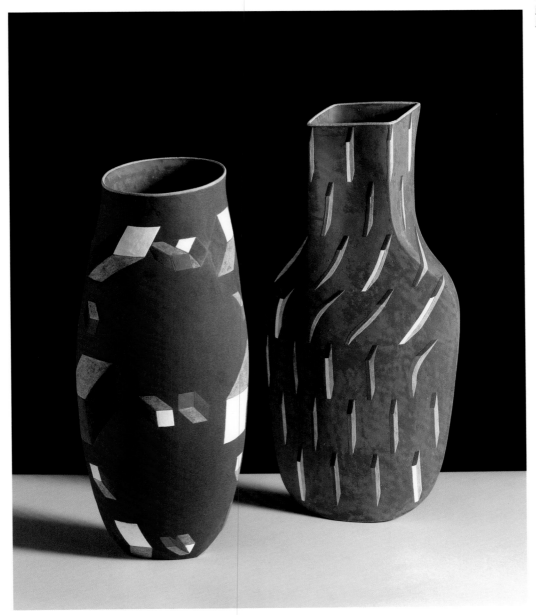

Representing:
Jacob van der Beugel
Michael Cardew
Fernando Casasempere
Thiébaut Chagué
Carina Ciscato
Hans Coper
Daniel Fisher
Elizabeth Fritsch
Shoji Hamada
Bernard Leach
David Leach
John Maltby
Lucie Rie
Tatsuzo Shimaoka
Julian Stair
Edmund de Waal

Elizabeth Fritsch, **A Collision of Particles vase; Blown Away vase Firework XI,** *2006*
hand-built stoneware, applied colored slips, 13.5 x 4; 15.5 x 7.25 x 2.5
photo: Todd White

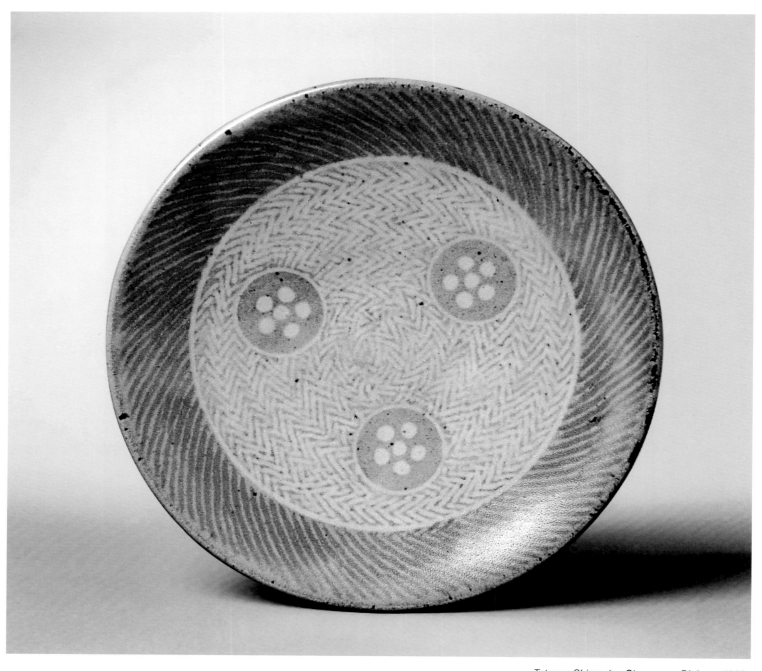

Tatsuzo Shimaoka, **Stoneware Dish**, *c. 1980s*
white slip rope inlay with blue slip rope inlay border and granite glaze, three rounded motifs, impressed potter's seal, 8.5 d
photo: Todd White

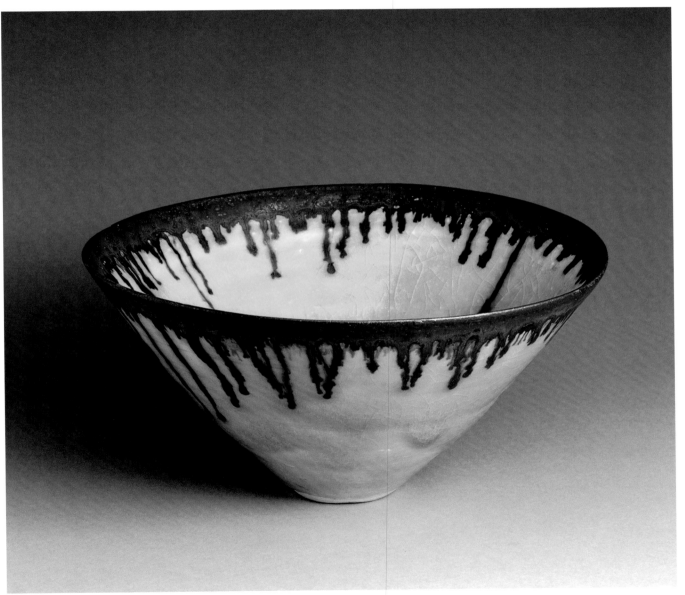

Lucie Rie, **Yellow Bowl**
porcelain with bronze manganese rim, 4.75 x 9.5
photo: Todd White

Peter VandenBerge, **Lindy,** *1991*
ceramic, 39 x 16 x 16
photo: Michael Trask

John Natsoulas Gallery

West Coast figurative ceramics, California funk and beat art movements
Staff: John Natsoulas; Steve Rosenzweig; Sonja Burgal

521 First Street
Davis, CA 95616
voice 530.756.3938
fax 530.756.3961
art@natsoulas.com
natsoulas.com

Esther Shimazu, **Say That Again,** *2006*
stoneware, 15.5 x 12 x 15.5
photo: Paul Kodama

Representing:
Wesley Anderegg
Robert Arneson
Clayton Bailey
Robert Brady
Lisa Clague
Arthur Gonzalez
Richard T. Notkin
Lucian Pompili
Richard Shaw
Esther Shimazu
Shalene Valenzuela
Peter VandenBerge
Peter Voulkos

Tom Rauschke and Kaaren Wiken, **Deer Forest Swan Pond,** *2006*
various hardwoods, glass, 13 x 9 x 9
photo: Tom Rauschke

Katie Gingrass Gallery

Fine art and contemporary craft

Staff: Katie Gingrass, owner; Christine Anderson, manager; Jeffrey Kenney, associate

241 North Broadway
Milwaukee, WI 53202
voice 414.289.0855
fax 414.289.2855
gingrassgallery@tds.net
gingrassgallery.com

Representing:
Ken Anderson
Darryl Arawjo
Karen Arawjo
Seth Barrett
Eric Bladholm
Joan Brink
Michael Brolly
Leslie Emery
Jack Fifield
Linda Fifield
Tom Galbraith
John Garrett
Polly Jacobs Giacchina
Stephan Goetschius
Herman Guetersloh
Mary Hettmansperger
Ron Isaacs
Susan kavicky
Linda Leviton
Sally Metcalf
Farraday Newsome
Laura Foster Nicholson
Tom Rauschke
Michael Rohde
John Skau
Fraser Smith
Kaaren Wiken
Jiro Yonezawa

Jiro Yonezawa, **Man With No Name,** *2006*
bamboo, cane, wood, urushi lacquer, 11 x 7 x 7
photo: Jiro Yonezawa

Nishimura Yuko, **Stir II,** *2006*
paper, 40 x 40
photo: Yosuke Ohtomo

KEIKO Gallery

Contemporary Japanese arts and crafts
Staff: Keiko Fukai, director; Yumi Nagasawa

121 Charles Street
Boston, MA 02114
voice 617.725.2888
fax 617.725.2888
keiko.fukai@verizon.net
keikogallery.com

Representing:
Fukumoto Shigeki
Hiroi Nobuko
Hoshi Mitsue
Iida Michihisa
Ito Hirotoshi
Nishimura Yuko
Sakamoto Madoka
Sakamoto Rie
Takeda Asayo
Takeuchi Kozo
Yoshimura Toshiharu
Yamazaki Fumi

Takeuchi Kozo, **Modern Remains D-II,** *2006*
glazed porcelain, 21 x 22 x 9
photo: Kenji Narumi

Marcus Dillon, Entwinement, *2006*
blown, cut glass with fabricated metal stand, 13.5 x 16.5 x 14
photo: Marcus Dillon

Kirra Galleries

Leaders in the Australian contemporary glass movement supporting established and emerging artists
Staff: Peter Kolliner, gallery director; Suzanne Brett, gallery manager; Vicki Winter, administration manager

Shop M11 (Mid Level)
Southgate Arts & Leisure Precinct
Southbank, Victoria 3006
Australia
voice 61.3.9682.7923
fax 61.3.9682.7923
kirra@kirra.com
kirra.com

Federation Square
Cnr Swanston and Flinders Streets
Melbourne, Victoria 3000
Australia
voice 61.3.9639.6388
fax 61.3.9639.8522

George Aslanis, **Exvoli (Estuary),** *2006*
cast furnace glass, 13 x 13 x 4
photo: Andrew Barcham

Representing:
George Aslanis
Annette Blair
Lisa Cahill
Marcus Dillon
Tony Hanning
Noel Hart
Simon Maberley
Kristin McFarlane
Crystal Stubbs
Patrick Wong

185

Tim Rowan, **Object 13,** *2006*
wood-fired stoneware, 12 x 22 x 14
photo: John Lenz

Lacoste Gallery

Contemporary ceramics: sculpture and vessel
Staff: Lucy Lacoste; Alinda Zawierucha

25 Main Street
Concord, MA 01742
voice 978.369.0278
fax 978.369.3375
info@lacostegallery.com
lacostegallery.com

Representing:
Ruth Borgenicht
Bill Brouillard
Margaret Keelan
Jim Lawton
Mark Pharis
Annabeth Rosen
Tim Rowan
Rob Sieminski

Margaret Keelan, **House 2,** *2006*
earthenware, 23 x 7 x 7
photo: Scott McCue

Dan Dailey, **Birds with Topaz,** *2006*
glass, metal, 22.5 x 26.5 x 8
photo: Bill Truslow

Leo Kaplan Modern

Established artists in contemporary glass sculpture and studio art furniture
Staff: Scott Jacobson; Terry Davidson; Lynn Leff; Dawn Russell

41 East 57th Street
7th floor
New York, NY 10022
voice 212.872.1616
fax 212.872.1617
lkm@lkmodern.com
lkmodern.com

Representing:
Garry Knox Bennett
Greg Bloomfield
Yves Boucard
William Carlson
José Chardiet
Scott Chaseling
KéKé Cribbs
Dan Dailey
David Huchthausen
Richard Jolley
John Lewis
Thomas Loeser
Linda MacNeil
Seth Randal
Paul Seide
Tommy Simpson
Jay Stanger
Michael Taylor
Gianni Toso
Mary Van Cline
Steven Weinberg
Jiřina Žertová

Michael Taylor, **Probing for Innovative Clarity, Bright Angle,** *2006*
optical glass, 18 x 20 x 8
photo: Bruce Miller

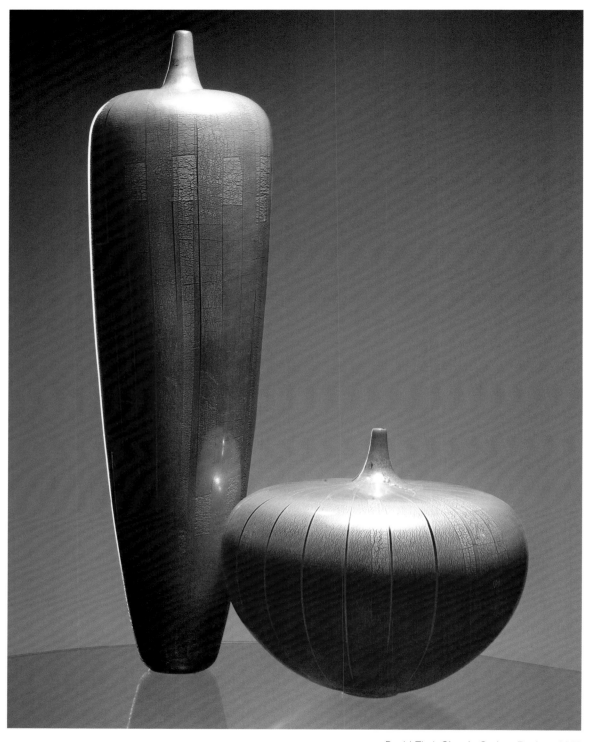

David Thai, **Classic Series, Basket,** *2006*
blown glass, Japanese silver foil, 28.5 x 6.5 x 6.5; 12 x 12 x 12
photo: Kevin Hedley

Living Arts Centre

Contemporary Canadian glass
Staff: Ben Goedhart, director; Kerry Lackie, associate director

4141 Living Arts Drive
Mississauga, Ontario L5B 4B8
Canada
voice 519.596.2900
boncoeur68@amtelecom.net
livingartscentre.ca

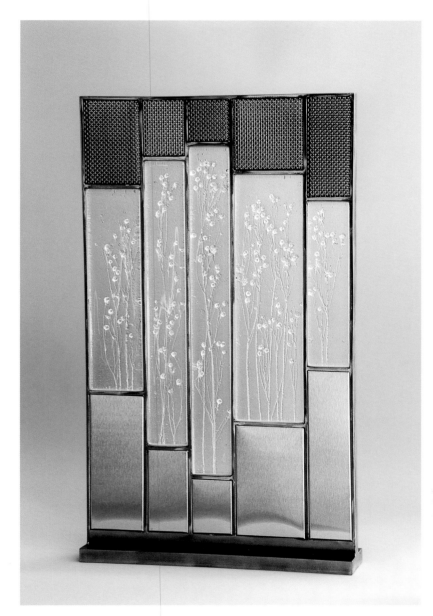

Representing:
Alex Anagnostou
Cali Balles
Stopher Christensen
Carolyn Prowse-Fainmel
Lucy Roussel
David Thai

Lucy Roussel, **Flax Field**, *2006*
sand-cast glass, steel, 36 x 19 x 4

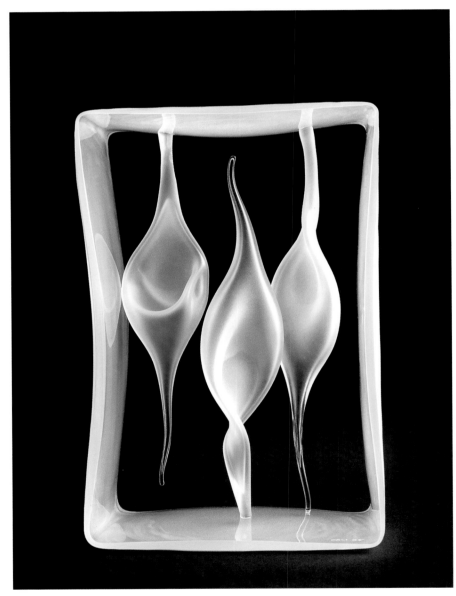

Cali Balles, **Sketch***, 2005*
blown glass, 9 x 6 x 3
photo: Aarin MacKay

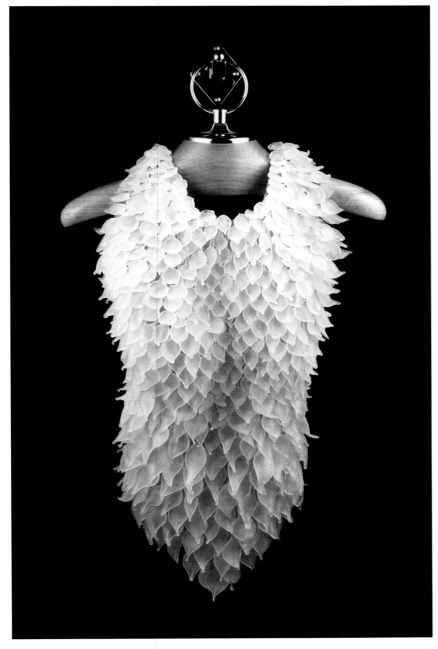

Carolyn Prowse-Fainmel, **Breastplate,** *2005*
glass, brass, wood, stainless steel, 32 x 16.5 x 10.5

Stopher Christensen, **Nestling - Guardian Series,** *2006*
blown glass, silicon bronze, 42 x 23.5 x 8

Alex Anagnostou, **Ovoid Form***, 2006*
blown glass, aluminum, 7.5 x 15 x 6

Chris Boger, **Offshore,** *2004*
glazed ceramic with china paint and luster, 32 x 22 x 20
photo: Chris Boger

Longstreth-Goldberg ART

Painting and sculpture by tomorrow's masters today
Staff: Peg Goldberg Longstreth, director; Gerry Kincheloe, gallery associate

5640 Taylor Road
Naples, FL 34109
voice 239.514.2773
fax 239.514.3890
jlongstreth@plgart.com
plgart.com

Linda Stein, **Knight of Rhythm 551,** *2005*
wood, metal, stone, 80 x 24 x 17
photo: Stein Studios

Representing:
Chris Boger
Mark Chatterley
Linda Stein
Paul Tamanian

Paul Tamanian, **Meridian**, *2005*
mixed media on fabricated aluminum, 60 x 60
photo: Peg Longstreth

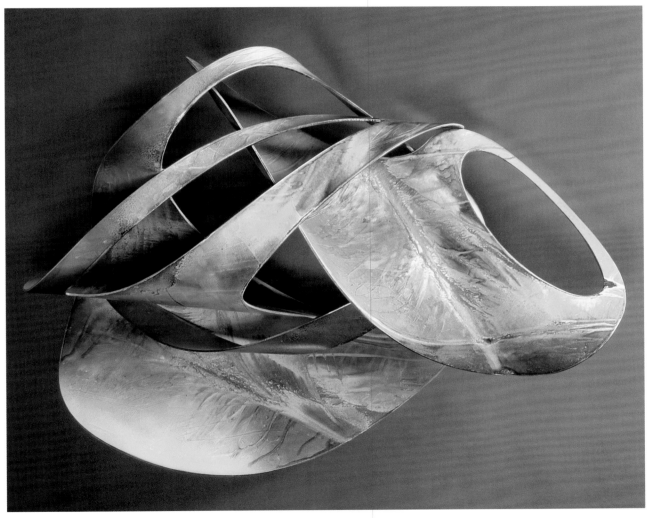

Paul Tamanian, **Humped Back Baby,** *2005*
mixed media on fabricated aluminum, 36 x 28 x 8
photo: Richard Brunck

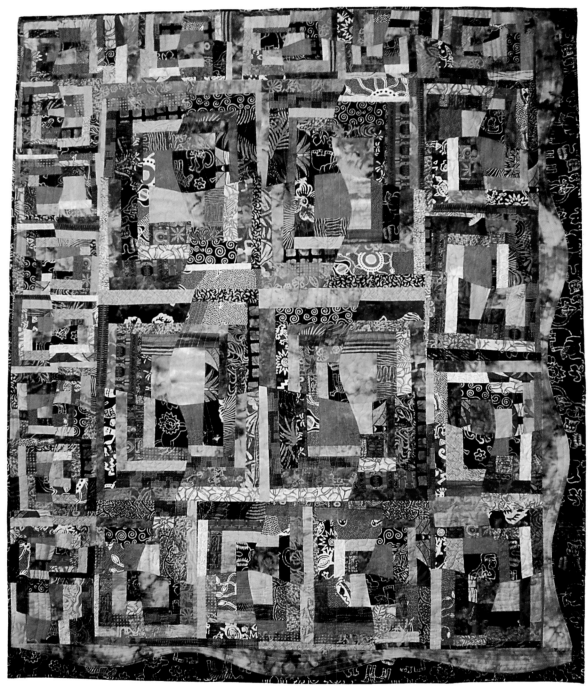

Hilde Morin, **Back Roads**, *2002*
pieced and quilted cotton fabrics, 52 x 63

María Elena Kravetz

Contemporary emerging and mid-career artists with an emphasis in Latin American expressions
Staff: María Elena Kravetz, director; Raul Nisman; Matias Alvarez, assistant

San Jeronimo 448
Cordoba X5000AGJ
Argentina
voice 54.351.422.1290
fax 54.351.422.4430
mek@mariaelenakravetzgallery.com
mariaelenakravetzgallery.com

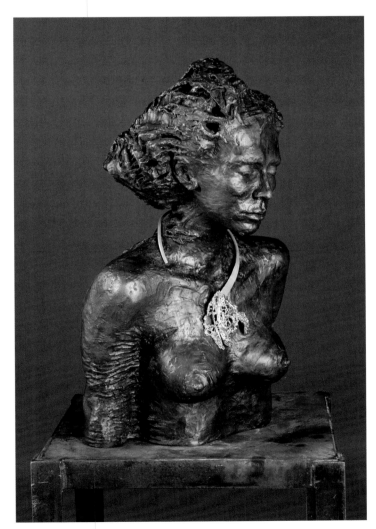

Representing:
Luis Bernardi
Faba
Elizabeth Gavotti
Sol Halabi
Ana Mazzoni
Hilde Morin
Cristina Nuñez
Jolanta Pawlak
Gabriela Perez Guaita
Daniel Pezzi
Teo San Jose
Margarita Selva
Polimnia Sepulveda
Elias Toro
Marcelo Wong

Jolanta Pawlak, **Natural Wonder,** *2005*
cast bronze with patina and removable fine silver open wire necklace, 28 x 18 x 11

Elizabeth Gavotti, **Mea Culpa**, *2006*
casting bronze, 21 x 8.75 x 4.75

María Elena Kravetz

Marcelo Wong, **Business Man,** *2006*
alabaster, wood, metal, 10 x 8 x 15

Cristina Nuñez, **Clavichord,** *2006*
oil on canvas, 60 x 35

María Elena Kravetz

Daniel Pezzi, **Torso NN,** *2005*
mixed media, foam, cement, 36 x 32 x 24

José Chardiet, **Le Dame,** *2006*
glass, 25 x 12.25 x 4.5
photo: Marty Doyle

Marx-Saunders Gallery, Ltd.

The most innovative and important artists working in glass in the world
Staff: Bonita Marx and Ken Saunders, directors; Donna Davies; Dan Miller; James Geisen; Jo-Nell Koelsch

230 West Superior Street
Chicago, IL 60610
voice 312.573.1400
fax 312.573.0575
marxsaunders@earthlink.net
marxsaunders.com

Representing:
Hank Murta Adams
Rick Beck
William Carlson
José Chardiet
KéKé Cribbs
Sidney Hutter
Jon Kuhn
Dante Marioni
Jay Musler
Stephen Powell
Richard Ritter
David Schwarz
Thomas Scoon
Paul Stankard
Janusz Walentynowicz
Steven Weinberg

William Carlson, **Luctor**
cast glass, pigment, 84 x 59 x 1.5
photo: Ignacio Gurruchaga

Maciej Zaborski, **Chair III,** *2006*
glass, 23 x 8 x 8
photo: Stanislaw Sielicki

Mattson's Fine Art

Contemporary Polish glass
Staff: Greg Mattson, director; Walter Mattson; Skippy Mattson

2579 Cove Circle
Atlanta, GA 30319
voice 404.636.0342
fax 404.636.0342
sundew@mindspring.com
mattsonsfineart.com

Representing:
Rafal Galazka
Miroslaw Stankiewicz
Maciej Zaborski

Miroslaw Stankiewicz and Rafal Galazka, **Gem of the Ocean,** *2006
glass, 13.5 x 10.5*

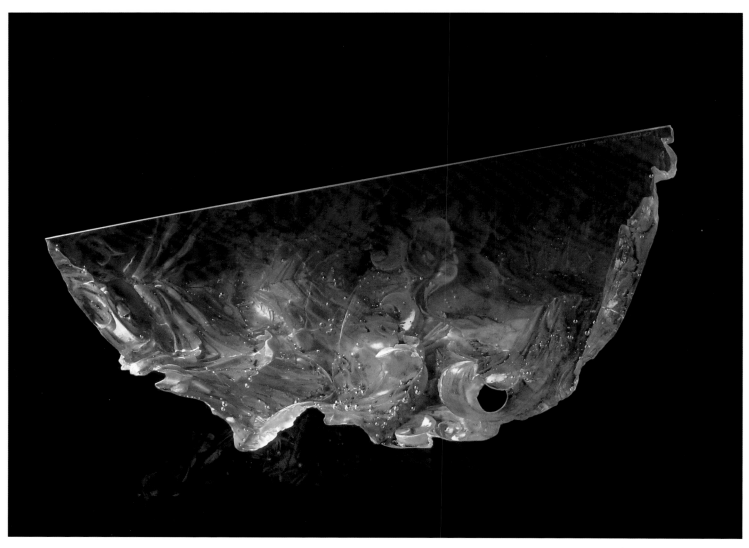

*Colin Reid, **Untitled**, 2006*
cast optic glass, 13 x 23 x 6
photo: Zach Vaughn

Maurine Littleton Gallery

Sculptural work of contemporary masters in glass and ceramics
Staff: Maurine Littleton, director; Seth Campbell; Zach Vaughn

1667 Wisconsin Avenue NW
Washington, DC 20007
voice 202.333.9307
fax 202.342.2004
info@littletongallery.com
littletongallery.com

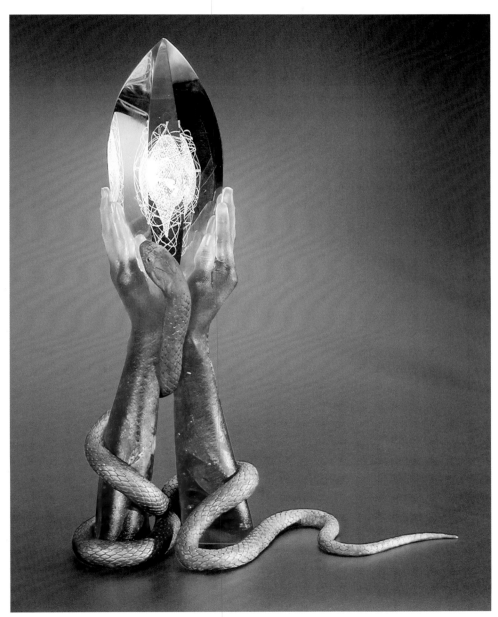

John Littleton and Kate Vogel, **Shield**, 2006
cast glass, gold leaf, mica, fiberglass, electroformed copper, 24 x 17.5 x 7
photo: John Littleton

Representing:
Mark Bokesch-Parsons
Carol Cohen
Judith La Scola
Harvey K. Littleton
John Littleton
Colin Reid
Don Reitz
Ginny Ruffner
Therman Statom
James Tanner
Kate Vogel

Rosita Johanson, **Adios Frida,** *2005*
Igolochkoy needle punch, 12.5 x 12
photo: Logan Hufford

Mobilia Gallery

Contemporary decorative arts and studio jewelry
Staff: Libby Cooper; Jo Anne Cooper; Susan Cooper; Cristina Dias;
Hanne Behrens; Logan Hufford; Dwaine Best; Lucy Robinson

358 Huron Avenue
Cambridge, MA 02138
voice 617.876.2109
fax 617.876.2110
mobiliaart@verizon.net
mobilia-gallery.com

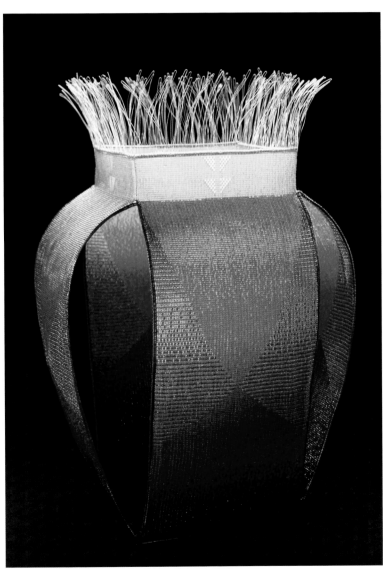

Jeanette Ahlgren, **Balancing Act,** *2006*
woven glass beads, copper wire, 19.75 x 12.5 x 12.5
photo: Jeanette Ahlgren

Representing:

Renie Breskin Adams
Jeanette Ahlgren
Sue Amendolara
Tomomi Arata
Donna Barry
Linda Behar
Hanne Behrens
Harriete Estel Berman
Mary Bero
Ingrid Goldbloom
 Bloch
Flora Book
Michael Boyd
Klaus Burgel
David K. Chatt
Kirsten Clausager
Lia Cook
Jack Da Silva
Marilyn Da Silva
Linda Dolack
Joan Dulla
Dorothy Feibleman
Arline Fisch
Gerda Flockinger, CBE
Nora Fok
Elizabeth Fritsch CBE
John Garrett
Lydia Gerbig-Fast
Kandy Hawley
Tina Fung Holder
Jan Hopkins

Mary Lee Hu
Daniel Jocz
Rosita Johanson
Dina Kahana-Gueler
Hannah Keefe
Okinari Kurokawa
Mariko Kusumoto
Jennifer Falck Linssen
Asagi Maeda
Jennifer Maestre
Donna Rhae Marder
Catherine Martin
Tomomi Maruyama
Jesse Mathes
John McQueen
Nancy Michel
Anne Mondro
Ellen Moon
Merrill Morrison
Judy Mulford
Kazumi Nagano
Harold O'Connor
Kyoko Okubo
Sarah Perkins
Antastacia Pesce
Gugger Petter
Janet Prip
Robin Quigley
Wendy Ramshaw,
 CBE RDI
Fran Reed

Suzan Rezac
Sarah Richardson
Scott Rothstein
Zuzana Rudavsky
Yuka Saito
Marjorie Schick
Annegret Schmid
Elizabeth Whyte
 Schulze
June Schwarcz
Joyce Scott
Lilo Sermol
Richard Shaw
Yoko Shimizu
Karyl Sisson
Christina Smith
Etsuko Sonobe
Brandon Sullivan
Billie Jean Theide
Jennifer Trask
Andrea Uravitch
Wim van Doorschodt
Alexandra Watkins
Heather White
Ellen Wieske
Joe Wood
Mizuko Yamada
Yoshiko Yamamoto

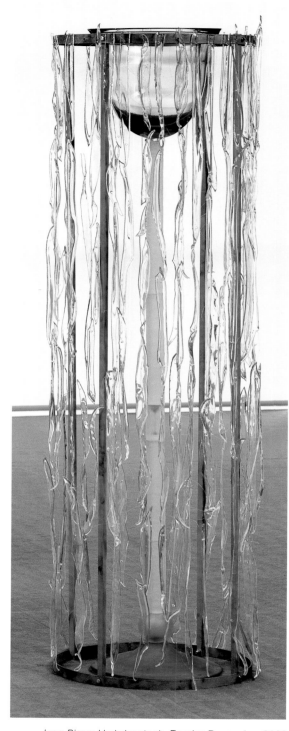

Jean Pierre Umbdenstock, **Encrier Revanche**, *2006*
glass, 120 x 45 x 45

Modus Art Gallery

23 Place des Vosges
Paris 75003
France
voice 33.1.4278.1010
fax 33.1.4278.1400
modus@galerie-modus.com
galerie-modus.com

An emphasis on contemporary original works of art, excellence of execution and genuineness of style and content

Staff: Karl Yeya, owner; Mana Asselli, manager; Joseph Kedi; Richard Elmir; Stan Mink; Veronique Botineau; Sophie Montcarat

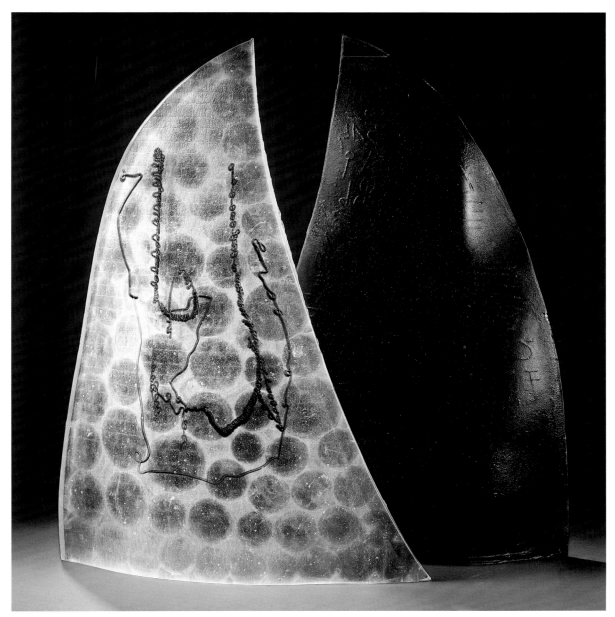

Representing:
Jean Pierre Umbdenstock

Jean Pierre Umbdenstock, **Voiles,** *2006*
glass, 55 x 32 x 2

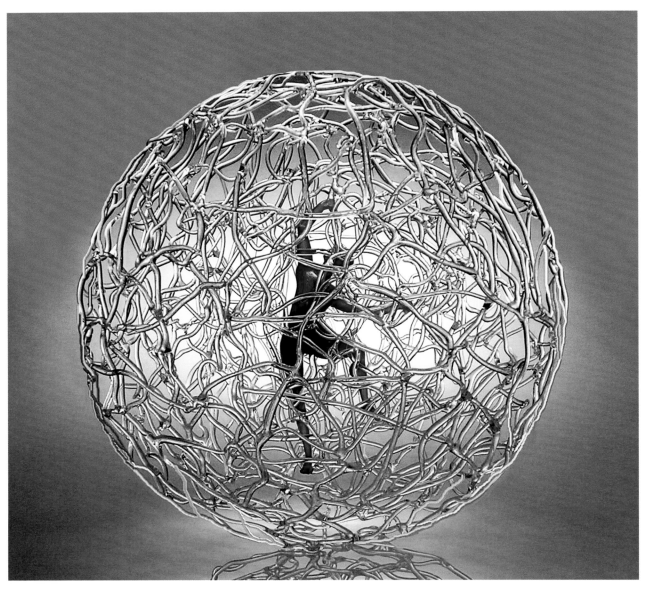

Mauro Bonaventura, **White Sphere**, *2006*
lamp-worked glass, 20d

Mostly Glass Gallery

Innovative art, technically challenging

Staff: Sami Harawi; Charles Reinhardt; Marcia LePore; Joyce Simon

34 Hidden Ledge Road
Englewood, NJ 07631
voice 201.816.1222
fax 201.503.9522
info@mostlyglass.com
mostlyglass.com

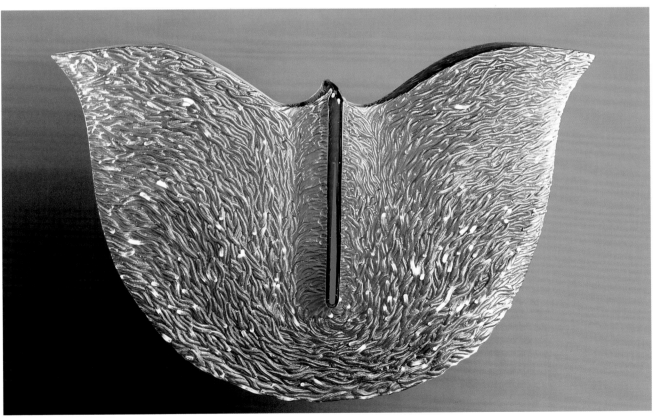

Representing:
Khalid Assakr
Mauro Bonaventurá
Jaroslava Brychtová
Fabio d'Aroma
Miriam Di Fiore
Recko Gateson
Ivana Houserova
Vlastislav Janacek
Missy Kaolin
Sandy Kaolin
Emma Luna
Madelyn Ricks
Eric Rubinstein
Jaroslav Wasserbauer
Alexandra Zonis

Ivana Houserova, **Butterfly,** *2006*
cast glass, 16.5 x 25 x 4

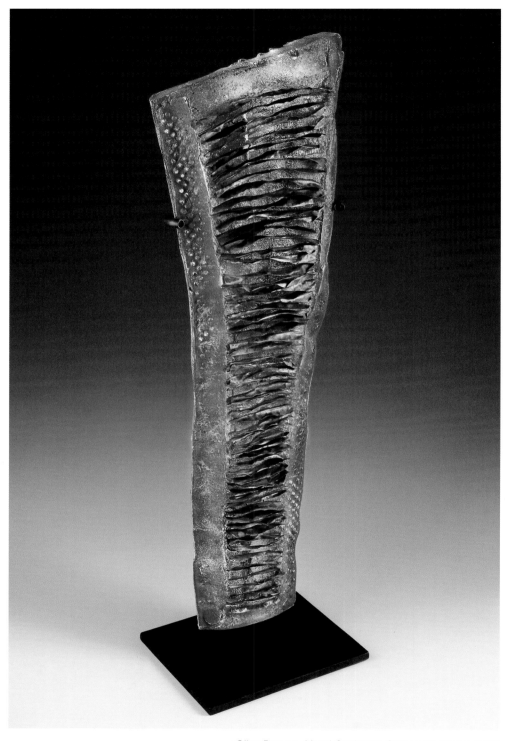

Giles Payette, Mural Sculpture Glass with Stand, *2006*
glass, 34 x 12 x 8
photo: Steve Solinsky

Mowen Solinsky Gallery

An exceptional collection by established and emerging artists
Staff: John Mowen and Steve Solinsky, owners; Franceska Alexander, manager; Yvon Dokter, assistant manager

225 Broad Street
Nevada City, CA 95959
voice 530.265.4682
fax 530.265.8469
info@mowensolinskygallery.com
mowensolinskygallery.com

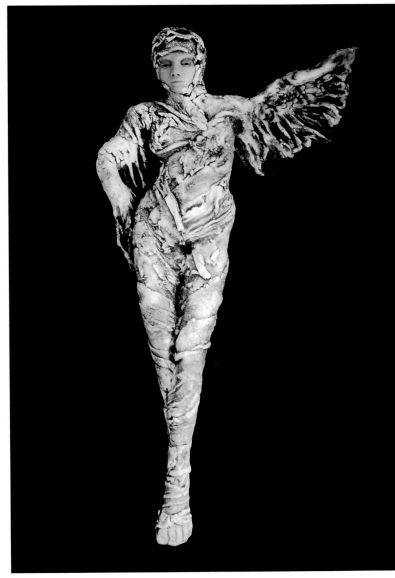

Representing:
Scott Amrhein
Ernest Caballero
Charles Cobb
Tami Dean
Robert Erickson
Jacquline Hurlbert
Bob Kliss
Laurie Kliss
David Kuraoka
Pasqual LaCroix
Jim Martin
John Mowen
Rick Nicholson
Mark Oldland
Gilles Payette
Kent Raible
Florian Roeper
Gail Rushmore
Steve Solinsky
Sharon Spencer
Kenneth Standhardt
Gary Upton

Jacquline Hurlbert, **Wrapped Winged Figure,** *2006*
ceramic, 27 x 12
photo: Steve Solinsky

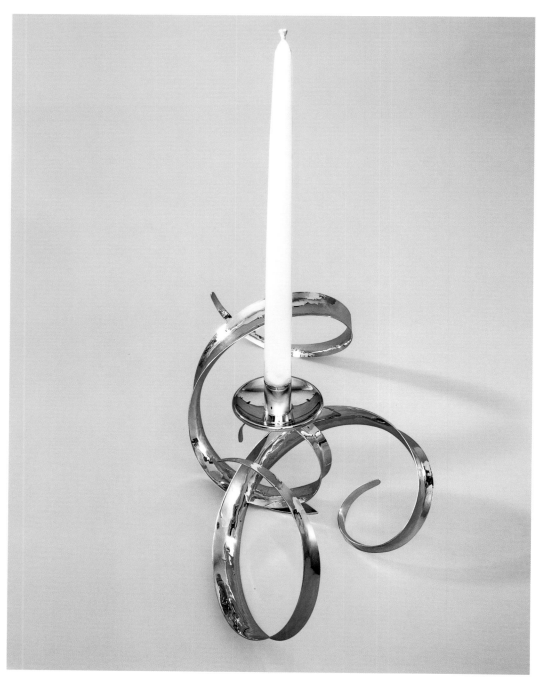

Kevin O'Dwyer, **Candelabra***, 2006*
hand-forged and fabricated sterling silver, 10 x 18 x 11
photo: Trevor Hart

The National Craft Gallery Ireland

The best of contemporary Irish craft

Staff: Vincent O'Shea, exhibition programme manager; Brian Kennedy, curator; Brian Byrne, gallery assistant; Anne Kennedy; Peter Ting

Castle Yard
Kilkenny
Ireland
voice 353.56.776.1804
fax 353.56.776.3754
ncg@ccoi.ie
ccoi.ie

Representing:
Alan Ardiff
Roger Bennett
Cormac Boydell
Denis Brown
Liam Flynn
Seamus Gill
Joe Hogan
Richard Kirk
Sonja Landweer
Glenn Lucas
Laura Mays
Kevin O'Dwyer
Angela O'Kelly
Inga Reed
Joseph Walsh

Angela O'Kelly, **Striped Arm Piece,** *2006*
layered paper, fabric, felt, plastic, elastic, 3 x 7 x 7
photo: Trevor Hart

Tom Phardel, **Inner Core***, 2005*
steel, 108 x 16

Next Step Studio & Gallery

Promoting and focusing on young talent and emerging artists
Staff: Kaiser Suidan; Rebecca Myers

530 Hilton Road
Ferndale, MI 48220
voice 248.414.7050
248.342.5074
fax 248.414.7038
nextstepstudio@aol.com
nextstepstudio.com

Craig Paul Nowak, **Piece of Me,** *2006*
painting, 4 x 4 cubes, 51 x 68 overall

Representing:
John Gargano
Rebecca Myers
Craig Paul Nowak
Tom Phardel
Sharon Que
Katrina Ruby
Kaiser Suidan
Albert Young

Bruce A. Niemi, **In the Beginning II,** *2006*
stainless steel, bronze, 61 x 33 x 7.5

Niemi Sculpture Gallery & Garden

Contemporary sculpture
Staff: Bruce A. Niemi, owner; Susan Niemi, director

13300 116th Street
Kenosha, WI 53142
voice 262.857.3456
fax 262.857.4567
gallery@bruceniemi.com
bruceniemi.com

Representing:
Theodore Gall
Bruce A. Niemi

Theodore Gall, **Morning Run,** *2006*
cast bronze, 13 x 5 x 6
photo: Wayne Smith

225

David Samplonius, **Shelf,** *2006*
walnut, aluminum, paint, 20 x 40 x 16

Option Art

Excellence in Canadian contemporary ceramics, glass, jewelry, mixed media sculpture, and wood
Staff: Barbara Silverberg, director; Philip Silverberg, assistant; Dale Barrett, assistant

4216 de Maisonneuve Blvd. West
Suite 302
Montréal, Québec H3Z 1K4
Canada
voice 514.932.3987
info@option-art.ca
option-art.ca

Janis Kerman, **Bracelet**, 2006
sterling silver, 18k yellow gold, Chinese freshwater pearls

Representing:
Jorge Aguilar
Gary Bolt
Dorothy Caldwell
Norah Deacon
John Glendinning
Rosie Godbout
Anioclès Grégoire
Janis Kerman
Ronald Labelle
Sylvie Lupien
Claudio Pino
Gilbert Poissant
Susan Rankin
David Samplonius
Andrée Wejsmann

Bahram Shabahang, **When Movements Create,** *2006*
wool pile, cotton wrap, wool weft, 72 x 48 x 1

Orley & Shabahang

Contemporary Persian carpets
Staff: Bahram Shabahang; Geoffrey Orley; Ashleigh Gersh; Obed Rochez

520 West 23rd Street
New York, NY 10011
voice 646.383.7511
fax 646.383.7954
orleyshabahang@gmail.com
shabahangcarpets.com

240 South County Road
Palm Beach, FL 33480
voice 561.655.3371
shabahangorley@adelphia.net

Shabahang Persian Carpets
223 East Silver Spring Drive
Whitefish Bay, WI 53217
voice 414.332.2486
shabahangcarpets@gmail.com

By Appointment Only
5841 Wing Lake Road
Bloomfield Hills, MI 48301
voice 586.996.5800
geoffreyorley@aol.com
shabahangcarpets.com

Representing:
Bahram Shabahang

Bahram Shabahang, **Tree of Life,** *2006*
fiber, 72 x 48 x 1

*Sergey Jivetin, **Cupola #5**, 2006*
nitinol, hypodermic needles, 4.5 x 1.5 x .25
photo: Sergey Jivetin

Ornamentum

Contemporary international jewelry
Staff: Laura Lapachin; Stefan Friedemann

506.5 Warren Street
Hudson, NY 12534
voice 518.671.6770
fax 518.822.9819
info@ornamentumgallery.com
ornamentumgallery.com

Representing:
Body Politics
Juliane Brandes
Johanna Dahm
Sam Tho Duong
Iris Eichenberg
Ute Eitzenhoefer
Maria Rosa Franzin
Thomas Gentille
Lisa Gralnick
Rebecca Hannon
Sabine Hauss
Hanna Hedman
Ineke Heerkens
Elisabeth Heine
Sergey Jivetin
Jiro Kamata
You Ra Kim
Jutta Klingebiel
Helena Lehtinen
Wolli Lieglein
Marc Monzo
Eija Mustonen
Ted Noten
Ruudt Peters
Mary Preston
Gerd Rothmann
Silke Spitzer
Julia Turner
Tarja Tuupanen
Luzia Vogt
Beate Weiss

Mary Preston, **Black & Red Tangle***, 2006*
silver, beads, 4.25 x 2.75 x 1.25
photo: Stefan Friedemann

Lesley Nolan, **Dressed in Their Finery,** *2006*
fused glass wall panel, 24 x 40 x 3
photo: Dave Nufer

Palette Contemporary Art & Craft

Contemporary offerings with colorful edges and clean looks
Staff: Kurt Nelson; Elisa Phillips; Meg Nelson

7400 Montgomery Blvd. NE
Albuquerque, NM 87109
voice 505.855.7777
fax 505.855.7778
palette@qwest.net
palettecontemporary.com

Jackie Beckman, **Roof Garden**, *2006*
kiln-formed glass wall panel, 19 x 19 x 4
photo: Dave Nufer

Representing:
Jeffrey Alan
Catherine Aldrete-Morris
Jackie Beckman
Nell Devitt
Erika Kohr
Yukako Kojima
Karen Korobow-Main
Lesley Nolan
Emi Ozawa
Andrew Van Assche
Nick Wirdnam
Karel Wuensch

John McQueen, **Another Wheelbarrow,** *2004*
sticks, string, 108 x 120
photo: Art Evans

Perimeter Gallery

Contemporary painting, sculpture, works on paper, and the masters in fiber and ceramic art
Staff: Frank Paluch, director; Scott Ashley, assistant director; Holly Sabin, registrar

210 West Superior Street
Chicago, IL 60610
voice 312.266.9473
fax 312.266.7984
perimeterchicago@
 perimetergallery.com
perimetergallery.com

Representing:
Lia Cook
Jack Earl
Edward Eberle
Bean Finneran
Kiyomi Iwata
Dona Look
John Mason
Karen Thuesen Massaro
Beverly Mayeri
John McQueen
Jeffrey Mongrain
Jay Strommen
Toshiko Takaezu
Julie York

Julie York, **Untitled,** *2006*
porcelain, plastic, glass, 15 x 4.5 x 4

Housi Knecht, **New Beginning,** *2006*
steel, 335 x 315 x 220

Persterer Art Gallery

Contemporary art gallery featuring original oil paintings and sculpture
Staff: Guido Persterer director; Ursula Rutishauser sales; Karin Fischer sales

Persterer Art Gallery
Bahnhofstrasse 37
Zurich, 8001
Switzerland
voice 41.44.212.5292
fax 41.44.212.5294
art@persterer.com
perstererart.com

Representing:
Travis Conrad Erion
Housi Knecht
Luc Leestemaker
Antonio Maro
Marcus Messmer
Kurt Laurenz Metzler
Rafael Ramirez
Stehpan Schmidlin
John Stockwell

John Stockwell, **Red Field with Clouds,** *2005*
oil on canvas, 40 x 60

Suzanne Thiel, **Big Yellow Silver and Vigorite Necklace,** *2005*
antique plastic, silver, length: 17

Pistachios

Broadening awareness of contemporary art jewelry
Staff: Yann Woolley, owner; Alexandra Jamroz; Sione LaPointe

55 East Grand Avenue
Chicago, IL 60611
voice 312.595.9437
fax 312.595.9439
pistachi@ameritech.net
pistachiosonline.com

Representing:
Talya Baharal
Dieter Dill
Fullerton & Bahr
Gudrun Meyer
Norbert Muerrle
Ben Neubauer
Niessing
Suzanne Thiel

Talya Baharal, **UL #33***, 2006*
silver, steel, iron

Vladimir Zbynovsky, **Spirit of Stone,** *2005*
optical glass, granite, 9 x 20 x 8
photo: Daniel Barillot

Plateaux Gallery

Contemporary sculptural glass, ceramics and unique furniture from Europe and beyond
Staff: Leo Duval, director; Graham Coombs-Hoar

1 Brewery Square
Tower Bridge Piazza
London SE1 2LF
England
voice 44.20.7357.6880
fax 44.20.7357.8265
gallery@plateaux.co.uk
plateaux.co.uk

Representing:
Milos Balgavy
Stephanie Carlton-Smith
Pavol Hloska
Oliver Lesso
Gareth Neal
Vladimir Zbynovsky

Gareth Neal, **GMF (Genetically Modified Furniture)**
sycamore, stainless steel, 29 x 26 x 26
photo: Damian Chapman

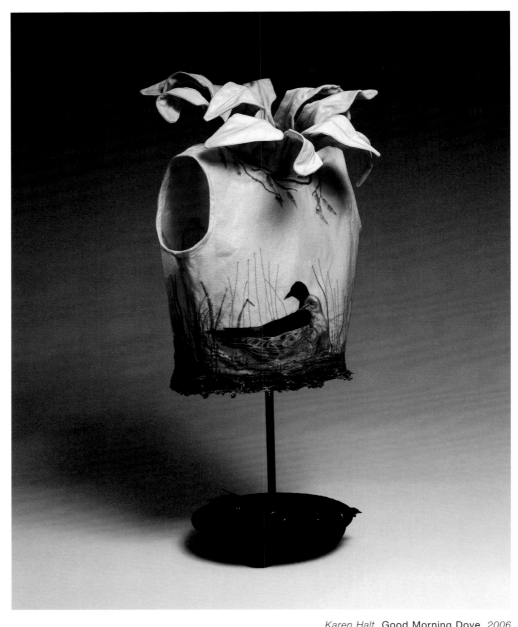

Karen Halt, **Good Morning Dove,** *2006*
hand-painted fiber dipped in beeswax and resin, metal stand, 25 x 8.5 x 12.25
photo: James Prinz

Portals Ltd.

Contemporary art of diverse media by national and international artists
Staff: William B. and Nancy McIlvaine, gallery owners; Claudia Kleiner, gallery director; Maria Antonieta Oquendo, show coordinator

742 North Wells Street
Chicago, IL 60610
voice 312.642.1066
fax 312.642.2991
artisnow@aol.com
portalsgallery.com

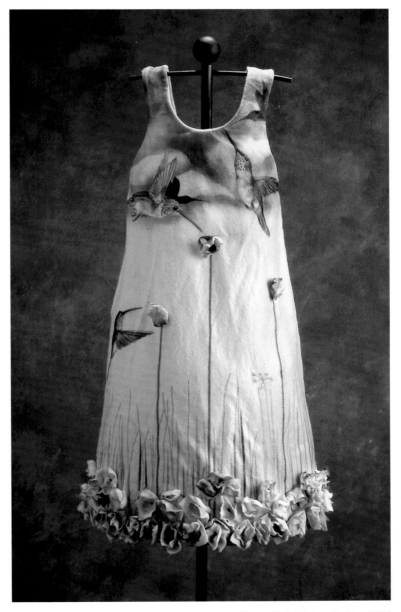

Karen Halt, **Dining Fields**, 2006
hand-painted cotton, beeswax, graphite and embroidery, 26.5 x 16 x 12
photo: Fred Fischer

Representing:
Karen Halt
Barbara Kohl-Spiro
Cheryl Malone
Constance Roberts
David Williamson
Roberta Williamson

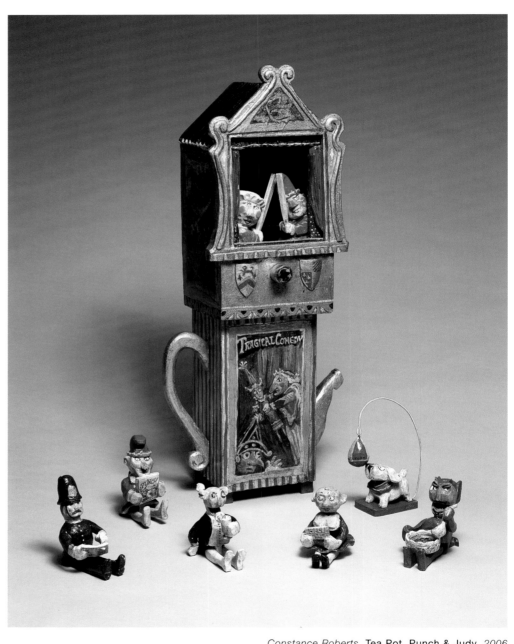

Constance Roberts, **Tea Pot, Punch & Judy,** *2006*
uniquely carved and hand-painted kinetic wooden sculpture, 24 x 10 x 7
photo: James Prinz

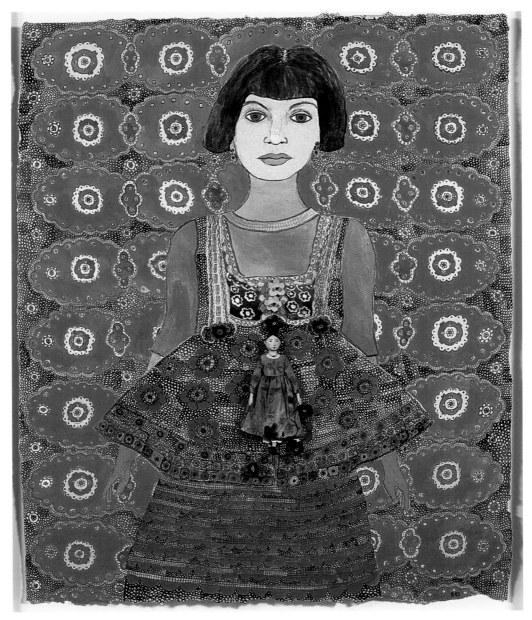

Barbara Kohl-Spiro, **Splendor**, 2006
mixed media, 42.5 x 34
photo: James Prinz

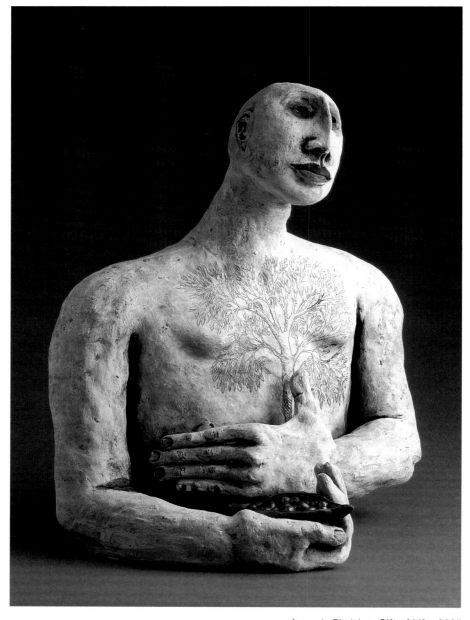

Amanda Shelsher, **Gift of Life***, 2005*
ceramic, 15 x 9.5 x 12
photo: Bill Shaylor

Raglan Gallery

Contemporary Australian glass, ceramics, sculpture, painting and Aboriginal art
Staff: Jan Karras, director; John Karras

5-7 Raglan Street
Sydney, NSW 2095
Australia
voice 61.2.9977.0906
fax 61.2.9977.0906
jan@raglangallery.com.au
raglangallery.com.au

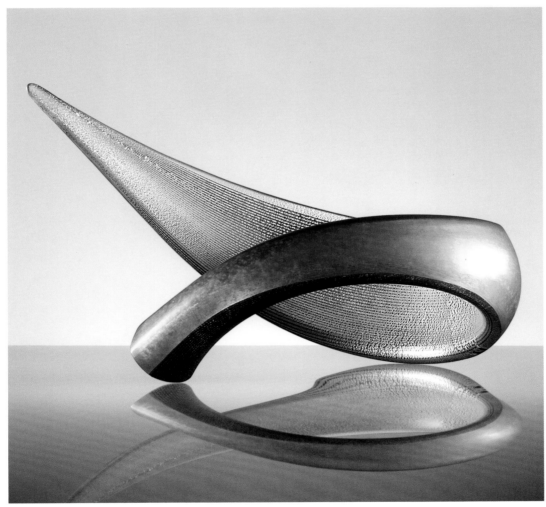

Representing:
Sandra Black
Louise Boscacci
Ben Edols
Kathy Elliott
Victor Greenaway
Virginia Kaiser
Warren Langley
Jeff Mincham
Sallie Portnoy
Amanda Shelsher
Mark Thiele

Ben Edols and Kathy Elliott, **Gold Curled Leaf,** *2006*
glass, 8 x 13 x 5
photo: Greg Piper

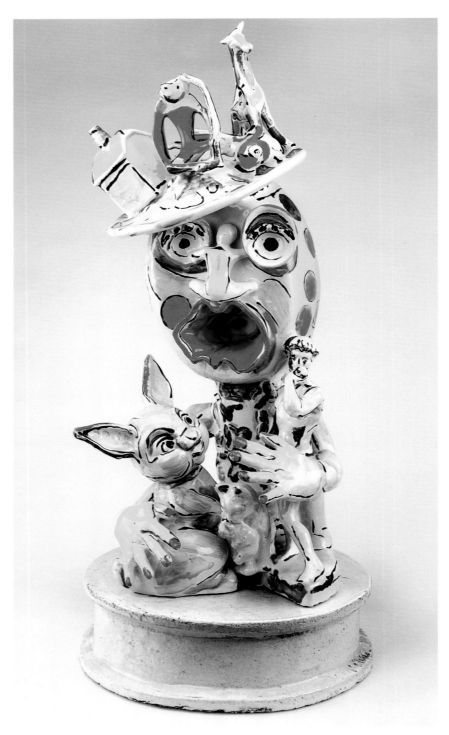

Viola Frey, **Untitled,** *2001*
ceramic, 42 x 19 x 25
photo: John Wilson White

Rena Bransten Gallery

Contemporary painting, sculpture and photography by national and international artists
Staff: Rena Bransten, owner; Leigh Markopoulos, director; Jenny Baie; Calvert Barron; Trish Bransten

77 Geary Street
San Francisco, CA 94108
voice 415.982.3292
fax 415.982.1807
info@renabranstengallery.com
renabranstengallery.com

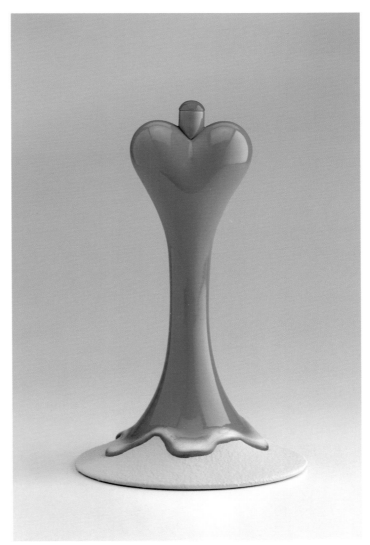

Representing:
Ann Agee
Ruth Asawa
Viola Frey
Dennis Gallagher
Hung Liu
Ron Nagle
Sam Perry
Henry Turmon

*Ron Nagle, **B.B.B.**, 2003*
ceramic, 9.75 x 6 x 6
photo: John Wilson White

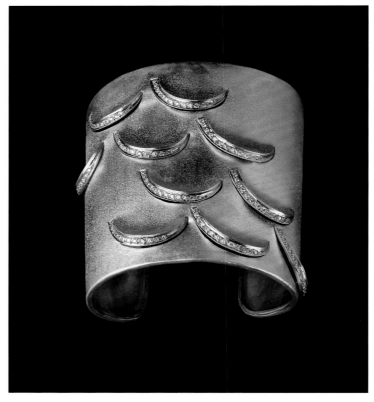

Lina Fanourakis, **Gold and Diamond Cuff Bracelet**
22k yellow gold, diamonds

Sabbia

Elegant and imaginative jewelry; a blend of modern designs with classic motifs
Staff: Deborah Friedmann; Tina Vasiliauskaite

66 East Walton Street
2nd floor
Chicago, IL 60611
voice 312.440.0044
fax 312.440.0007
sabbiafinejewelry@hotmail.com
sabbiafinejewelry.com

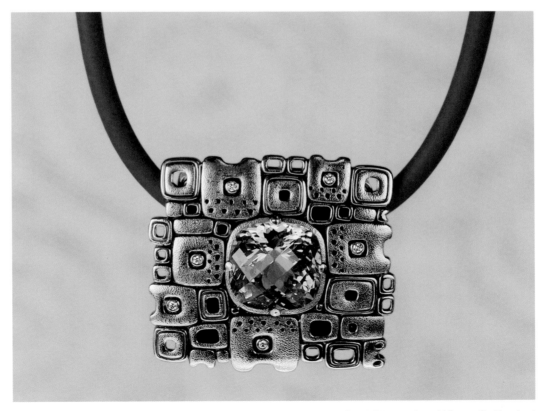

Representing:
Lina Fanourakis
Yossi Harari
Alex Sepkus
Catherine M. Zadeh
Michael Zobel

Alex Sepkus, **Rose Gold, Diamond and Morganite Pendant**
18k rose gold, diamonds, morganite

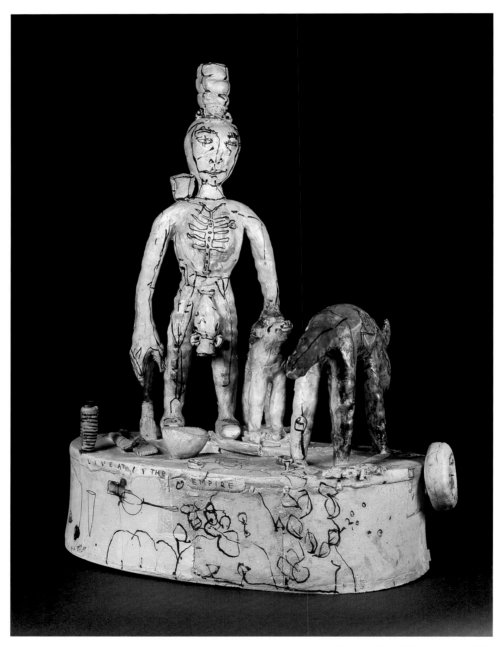

Ted Saupe, **Live at the Empire,** *2006*
salt-fired stoneware, 23 x 17 x 10
photo: Elizabeth Hunt

Santa Fe Clay

Contemporary ceramics
Staff: Avra Leodas; Triesch Voelker

1615 Paseo de Peralta
Santa Fe, NM 87501
voice 505.984.1122
fax 505.984.1706
sfc@santafeclay.com
santafeclay.com

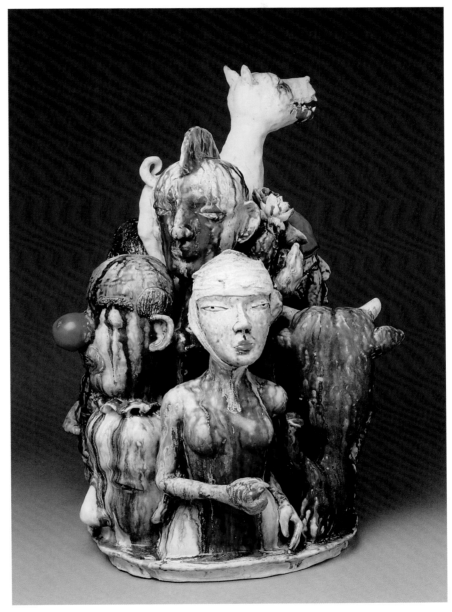

Representing:
Peter Beasecker
Gina Bobrowski
Michael Corney
John Gill
Kathy King
Beth Lo
Andy Nasisse
Mary Roehm
Annabeth Rosen
Ted Saupe
Bonnie Seeman
Kevin Snipes
Chris Staley
Maryann Webster
Janis Mars Wunderlich
SunKoo Yuh

SunKoo Yuh, **Marriage,** *2005*
porcelain, 24.5 x 17 x 15

Tom Bartel, **Fifty-5 Figure,** *2002*
ceramic, wood, 28 x 12 x 10
photo: Joe Imel

Sherrie Gallerie

Contemporary ceramics, sculpture, art jewelry and fine art
Staff: Sherrie Riley Hawk, owner; Tyler Steele; Markane Raleigh; Pam Beeler

694 North High Street
Columbus, OH 43215
voice 614.221.8580
fax 614.221.8550
sherriegallerie@sbcglobal.net
sherriegallerie.com

Representing:
Tom Bartel
Curtis Benzle
Karen Gilbert
Chris Gustin
Sharon Meyer

Chris Gustin, **Vessel #0511,** *2005*
reduction-fired stoneware, 44 x 26 x 27
photo: Dean Powell Photography

Judy Onofrio, I Put a Spell on You, *2006*
carved wood, glass, ceramic, metal, 52.5 x 40 x 24
photo: Rik Sferra

Sherry Leedy Contemporary Art

Emerging and established national and international artists working in all media
Staff: Sherry Leedy; Jennifer Bowerman; Tuan; Glenn Bruner

2004 Baltimore Avenue
Kansas City, MO 64108
voice 816.221.2626
fax 816.221.8689
sherryleedy@sherryleedy.com
sherryleedy.com

Jun Kaneko, 05-10-08, *2005*
glazed ceramic, 30.25 x 20 x 12.5
photo: Dirk Bakker

Representing:
Michael Eastman
Jun Kaneko
Judy Onofrio
Doug Owen
Charles Timm-Ballard
Zia

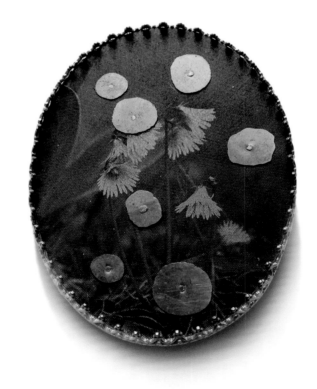

Bettina Speckner, **Brooch,** *2006*
photo on zinc, 18k gold, 2.75 x 2.25 x .125
photo: Kevin Sprague

Sienna Gallery

International contemporary jewelry
Staff: Raissa Bump; Sienna Patti

80 Main Street
Lenox, MA 01240
voice 413.637.8386
sienna@siennagallery.com
siennagallery.com

Representing:
Shihoko Amano
Johan van Aswegen
Giampaolo Babetto
Jamie Bennett
Melanie Bilenker
Lola Brooks
Raissa Bump
Noam Elyashiv
Vered Kaminski
Esther Knobel
Jacqueline Lillie
Tina Rath
Marzia Rossi
Barbara Seidenath
Bettina Speckner

Tina Rath, **Tubastaea Coccinea***, 2006*
pink ivorywood, mink, peridot, 18k gold, 2.5 x 2 x 1.25
photo: Robert Diamonte

Barbara Lee Smith, **The Narrows,** *2006*
synthetic materials; printed, painted, fused and stitched, 44 x 63 x 1
photo: Tom Holt

Snyderman-Works Galleries

Contemporary textile/fiber, glass, jewelry, ceramics, furniture, wood, painting and sculpture
Staff: Rick and Ruth Snyderman, owners; Bruce Hoffman, director; Frank Hopson, director Works Gallery;
Michiyo Oishi, assistant director; Christopher Lawrence, installer; Lynn Schubertz, associate; Leonard Moody, installer

303 Cherry Street
Philadelphia, PA 19106
voice 215.238.9576
fax 215.238.9351
bruce@snyderman-works.com
snyderman-works.com

Eva Steinberg, **Pearl Bracelet**
2 x 2.75
photo: Matthias Demand

Representing:

Dan Anderson	Kim Kamens
Kate Anderson	Nancy Koenigsberg
Pamela Becker	David Lacata
Lanny Bergner	Ed Bing Lee
Bo Breda	Gabrielle Malek
Katia Bulbenko	Ruth McCorrison
Jacek Byczewski	Milissa Montini
Dorothy Caldwell	Debora Muhl
David K. Chatt	Leslie Pontz
Sonya Clark	Jo Ricci
Barbara Cohen	Henry Royer
Joyce Crane	JoAnne Russo
Katherine Crone	Michelle Sales
Nancy Crow	Amanda Salms
Daniel Cutrone	Judith Schaechter
Michael Davis	Johnathon Schmuck
Marcia Docter	Biba Schutz
Steven Ford	Warren Seelig
David Forlano	Karen Shapiro
Karen Gilbert	Barbara Lee Smith
Katherine Glover	Eva Steinberg
Danielle Gori-Montanelli	Charlotte Thorp
	Carmen Valdes
Matthew Harris	Kiwon Wang
Jan Hopkins	Kathy Wegman
Kyoko Ibe	Tom Wegman
Marie-Laure Ilie	David Williamson
Hildegund Ilkerl	Roberta Williamson
Reiko Ishiyama	Yoko Yagi
Ferne Jacobs	Soonran Youn

Elisabett Gudmann, **Arising** (detail), *2005*
etched copper panel, chemical patinas, 72 x 48 x 2

ten472 Contemporary Art

Contemporary art

Staff: Hanne Sorensen, owner; Elis Gudmann

10472 Alta Street
Grass Valley, CA 95945
voice 707.484.2685
info@ten472.com
ten472.com

Representing:
Elisabett Gudmann
Kirk H. Slaughter

Kirk H. Slaughter, **Mask, X,** *2005*
bronze, stainless steel, silver, copper, 24 x 8 x 6

Philip Baldwin and Monica Guggisberg, **The Gateway,** *2006*
blown glass with color overlay and cut in Italian battuto cutting techniques; stainless steel frame, 94.5 x 43 x 23.5
photo: Christophe Lehmannn

Thomas R. Riley Galleries

Timeless evocative, conceptual forms presented with service, education and integrity
Staff: Thomas R. Riley; Cindy L. Riley; Cheri Discenzo

28699 Chagrin Boulevard
Cleveland, OH 44122
voice 216.765.1711
fax 216.765.1311
trr@rileygalleries.com
rileygalleries.com

Representing:
Abbott-Leva	Peter Layton
Rik Allen	Jeremy Lepisto
Shelley Muzylowski	Lucy Lyon
Allen	William Morris
Ron Artman	Ralph Mossman
Philip Baldwin	Nick Mount
Bennett Bean	Jeremy Neuman
Peggy Bjerkan	Jeremy Popelka
Latchezar Boyadjiev	Seth Randal
John Brekke	David Reekie
Peter Bremers	Sally Rogers
Sergey Bunkov	Joseph Rossano
Ken Carder	Richard Royal
Allison Ciancibelli	Kari Russell-Pool
Matthew Curtis	Jennifer Skirball
Donald Derry	Jerry Soble
Matt Eskuche	Jake Stout
Kyohei Fujita	Jonathan Swanz
Monica Guggisberg	Milon Townsend
Mark Harris	Stephanie Trenchard
Luke Jacomb	Karen Willenbrink-
Nancy Klimley	Johnsen
	John Woodward

Peter Bremers, **Icebergs & Paraphernalia**, *2005*
kiln-casted, cut and polished crystal, 23.5 x 33 x 11
photo: Paul Niessen

Emrys Berkower, **Pitcher of a Lamb***, 2005*
glass, mixed media, 14 x 15 x 6

UrbanGlass

An international center for new art made from glass
Staff: Dawn Bennett, executive director; Brooke Benaroya, director of development

647 Fulton Street
Brooklyn, NY 11217
voice 718.625.3685
fax 718.625.3889
info@urbanglass.org
urbanglass.org

Leo Tecosky, Grillin, *2004*
neon, 27 x 16

Representing:
Deborah Faye Adler
Emrys Berkower
Becki Melchione
Helene Safire
Leo Tecosky
Melanie Ungvarsky

William Morris, **Buffalo Artifact Pouch,** *1997*
blown glass, 12 x 12 x 14
photo: John Carlano

Wexler Gallery

Specialists in secondary market and contemporary glass, studio furniture, and the decorative arts
Staff: Lewis Wexler, proprietor; Sherri Apter Wexler, co-proprietor; Sienna Freeman, associate director

201 North 3rd Street
Philadelphia, PA 19106
voice 215.923.7030
fax 215.923.7031
info@wexlergallery.com
wexlergallery.com

Representing:
Philip Baldwin
Giles Bettison
Wendell Castle
José Chardiet
Dale Chihuly
Tessa Clegg
Dan Dailey
Robin Grebe
Monica Guggisberg
William Harper
Dominick Labino
Marvin Lipofsky
Harvey K. Littleton
Richard Marquis
Massimo Micheluzzi
William Morris
Joel Philip Myers
Yoichi Ohira
Albert Paley
Tom Patti
Paul Stankard
Lino Tagliapietra
Bertil Vallien
Frantisek Vizner
Toots Zynsky

Tom Patti, **Solar Riser,** *1979*
glass, 5 x 3.5 x 2.5
photo: John Carlano

Bradley Bowers, **Eat Your Vegetables Poetry Vessel,** *2005*
plaster, marble dust, sculpture paste, copper, acrylic paint, India ink, 28h

The William and Joseph Gallery

Contemporary glass, outdoor sculpture and two dimensional work
Staff: Mary Bonney, owner

70 West Marcy Street
Santa Fe, NM 87501
voice 505.982.9404
fax 505.982.2321
mary@thewilliamandjoseph
 gallery.com
thewilliamandjosephgallery.com

Representing:
Leon Applebaum
Bradley Bowers
Barrett DeBusk
Kate Dunn
Jan Frydrych
Tomas Hlavicka
Rene Roubicek
Eric Rubinstein
stohanzel
Ales Vasicek

Barrett DeBusk, **Daddy Fat on Stairs,** *2006*
steel, 80 x 60 x 30
photo: Barrett DeBusk

271

Davide Salvadore, **Vutuche,** *2006*
glass, 43 x 15.25 x 8.25
photo: Francesco Ferruzzi

William Traver Gallery

Contemporary movements in glass, sculpture, and painting

Staff: William Traver, owner; Grace Meils, associate director, Seattle; Sarah Traver, associate director, Tacoma

110 Union Street
Suite 200
Seattle, WA 98101
voice 206.587.6501
fax 206.587.6502
info@travergallery.com
www.travergallery.com

1821 East Dock Street, #100
Tacoma, WA 98402
voice 253.383.3685
fax 253.383.3687

Jay Macdonell, **Articulated,** *2006*
glass, 26.5 x 17 x 8
photo: Jay Macdonell

Representing:
Sean Albert
Jay Macdonell
Davide Salvadore
David Walters
Nick Wirdnam

Emma Rodgers, **Raging Bull,** *2006*
bronze, 32 x 32 x 25
photo: Hap Sakwa

William Zimmer Gallery

Excellence

Staff: William and Lynette Zimmer, owners; Owen Edwards and Barbara Hobbs, associates

10481 Lansing Street
Box 263
Mendocino, CA 95460
voice 707.937.5121
fax 707.937.2405
wzg@mcn.org
williamzimmergallery.com

Representing:
Carolyn Morris Bach
Keith Brandman
Graham Carr
Tanija Carr
David Crawford
John Dodd
Barbara Heinrich
Tai Lake
Sydney Lynch
Hiroki Morinoue
Paula Murray
Emma Rodgers
Cheryl Rydmark
Noi Volkov
Rusty Wolfe

Carolyn Morris Bach, **River Rock***, 2006*
dendridic quartz, frosted citrine, 18k and 22k gold, 6 x 1.25
photo: Hap Sakwa

*Russell Trusso, **Untitled**, 2006*
18k gold, South Seas pearls, diamonds, 6 x 5.5 x .75
photo: R.H. Hensleigh

Yaw Gallery

Contemporary national and international goldsmiths
Staff: Nancy Yaw; Jim Yaw; Edith Robertson

550 North Old Woodward
Birmingham, MI 48009
voice 248.647.5470
fax 248.647.3715
yawgallery@msn.com
yawgallery.com

Representing:
Maria Bealieux
Myron Bikakis
Falk Burger
Susan Hoge
Ion Ionescu
Laila Ionescu
John Iversen
Kim Sun Jung
Shay Lahover
Mary Preston
Jayne Redman
Lauren Schlossberg
Russell Trusso
Alto Vandian

Shay Lahover, **Untitled Ring,** *2006*
raw ruby, Russian drusy, 22 and 14k gold, diamonds, 1.5 x 1 x 1
photo: R.H. Hensleigh

Roger Atkins, **Seduction & Confidence,** *2006*
American cherry, rock maple, 59 x 23
photo: James Hart

Zane Bennett Galleries

Contemporary fine art in all media

Staff: Sandy Zane, owner; Mary Anne Redding, director; Brad Hart and Christian Cheneau, associates

826 Canyon Road
Santa Fe, NM 87501
voice 505.982.8111
fax 505.982.8160
zanebennett@aol.com
zanebennettgallery.com

Representing:
Roger Atkins
Julia Barello
Mark Bressler
Mari Broenen
Richard Hoey
Maria Hwang-Levy
Cornelia Kubler
 Kavanagh
Connie Mississippi
Harry Pollitt
Rachel Stevens

Maria Hwang-Levy, **Pod of Secrets***, 2005*
encaustic, pigment, charcoal, sheep and human hair, 22 x 16
photo: Eric Swanson

Layne Rowe, Scarify, *2005*
blown glass, 11 x 11 x 4

ZeST Contemporary Glass Gallery

Contemporary British glass
Staff: Naomi Hall, gallery manager

Roxby Place
London SW6 1RS
England
voice 44.20.7610.1900
fax 44.20.7610.3355
info@zestgallery.com
zestgallery.com

Representing:
Adam Aaronson
Vic Bamforth
Katharine Coleman
Alison Kinnaird, MBE
Layne Rowe

Alison Kinnaird, MBE, **Passing Through,** *2005*
engraved crystal, 16 x 51
photo: Robin Morton

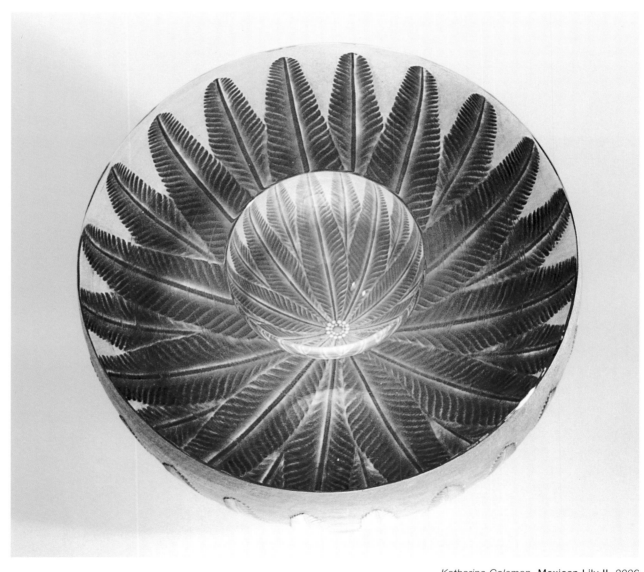

Katharine Coleman, **Mexican Lily II,** *2006*
engraved glass, 4.5 x 7 x 7

Adam Aaronson, **Nocturne,** *2006*
blown glass, 13 x 7 x 7

ources

Particular Particles:
International Pâte de Verre

BY JOHN PERREAULT

What is *pâte de verre*? Aficionados of glass know it when they see it: glass that's satiny, buttery (or crusty too); cloudy or "lucent," to invent a term—lucent rather than translucent (i.e., somewhere between the translucent and the opaque). You can't see into it or through it, but pâte de verre figurines and thick little vases, even tiles, have an inner light. And the colors are subdued, more pastel or chalky than the usual bright colors of stained or blown glass. It is also the predecessor of all other mold-melted glass that uses frit or chunks of glass rather than paste.

Pâte de verre came about in the late 19th century because the French artist Henry Cros (1840-1907) wanted to use glass to further polychromatic sculpture. He found a way to melt a glass paste in both open and closed molds, the latter made by the lost-wax process employed in bronze casting. Cros claimed he was merely reintroducing a long-lost ancient Egyptian technique.

"Particle Theories: International Pâte de Verre and Other Cast Glass Granulations," at the Museum of American Glass at Wheaton Village, Millville, New Jersey (April 1 to December 31), starts off, as does its catalog,* by presenting a few works by Cros and other artists working in pâte de verre in France during the Art Nouveau period. Cros's Mask, 1900, is the key piece in the introductory section of the exhibition.

In what surely will be considered a definitive essay, Susanne K. Frantz, the guest curator, suggests that the intention of the pioneers was to imitate marble. But the sampling of works by Georges Despret, François-Emile-Décorchemont, Jules-Paul Brateau, Victor Amalric Walter and Joseph-Gabriel Argy-Rousseau shows that the method was better at imitating wax—which, however, is not an unattractive result. Intentions often have little to do with results. Didn't glass come about because the ancient Egyptians wanted to imitate gems? Didn't plastic come about because someone tried to imitate bone to make collar stays?

The short catalog essay "The Mythologies, Origins, and Developments of Pâte de Verre," by Jean-Luc Olivié, an art historian and curator of the Centre du Verre, Musée des Arts Décoratifs in Paris, reveals that Décorchemont's pâte de

SYLVIE VANDENHOUCKE (Belgium)—*Raw Target*, 2004, detail, multiple parts, pâte de verre (frit and oxides), variable 69–79 inches diameter. BELOW: ADRIANNE EVANS (United States)—Two rocks from *Four Rocks*, 2002-4, pâte de verre (fused glass sediment collected from the studios of various artists), 2 by 5 by 3 inches. OPPOSITE PAGE: ERIKA TADA (Japan)—*Letter*, 2004, detail, 30 parts, blown glass envelopes with pâte de verre inserts, overall 40 by 59 by 4 inches.

AMERICAN CRAFT **45** OCTOBER/NOVEMBER 2005

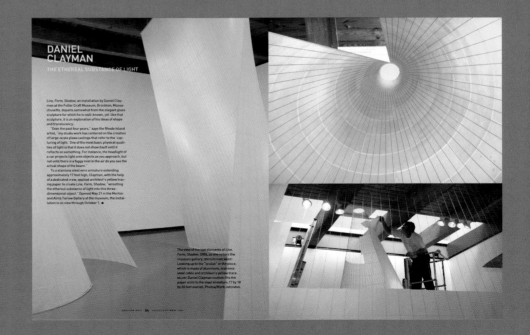

DANIEL CLAYMAN
THE ETHEREAL SUBSTANCE OF LIGHT

Line, Form, Shadow, an installation by Daniel Clayman at the Fuller Craft Museum, Brockton, Massachusetts, departs somewhat from the elegant glass sculpture for which he is well-known, yet like that sculpture, it is an exploration of his ideas of shape and translucency.

"Over the past four years," says the Rhode Island artist, "my studio work has been centered on the creation of large-scale glass castings that refer to the 'capturing of light.' One of the most basic physical qualities of light is that it does not show itself until it reflects on something. For instance, the headlight of a car projects light onto objects as you approach, but not until there is a foggy mist in the air do you see the actual shape of the beam."

To a stainless steel wire armature extending approximately 17 feet high, Clayman, with the help of a dedicated crew, applied architect's yellow tracing paper to create *Line, Form, Shadow*, "wrestling the ethereal substance of light into this three-dimensional object." Opened May 21 in the Merton and Alma Tarlow Gallery at the museum, the installation is on view through October 1. ■

The view of the two elements of *Line, Form, Shadow*, 2004, as one enters the museum gallery. OPPOSITE PAGE ABOVE: Looking up to the "oculus" of the piece, which is made of aluminum, stainless steel cable and architect's yellow tracing paper. BELOW: Daniel Clayman custom-fits the paper units to the steel armature, 17 by 18 by 20 feet overall. Photos/Mark Johnston.

AMERICAN CRAFT **54** OCTOBER/NOVEMBER 2005

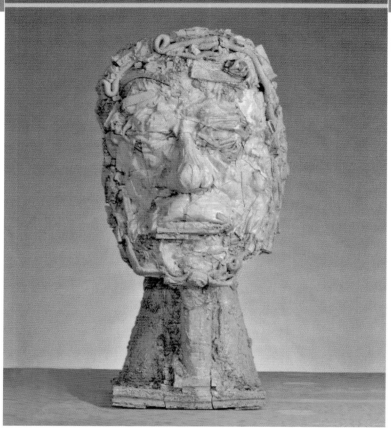

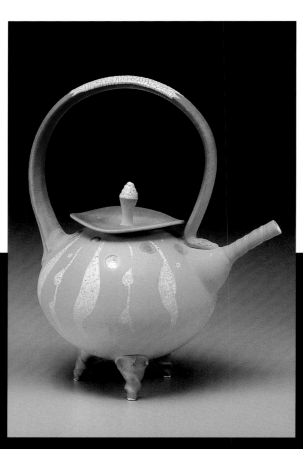

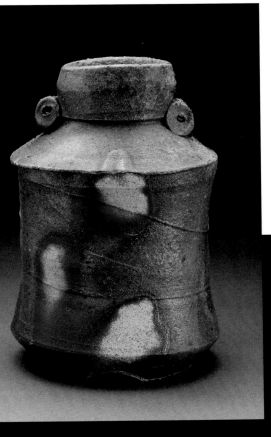
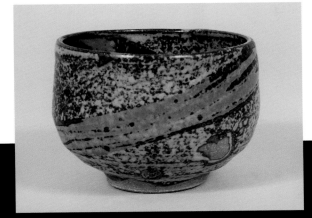

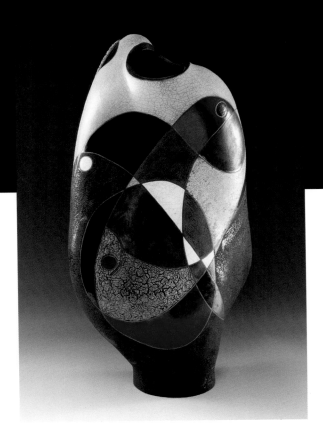

 chicago artists' coalition

home | about | register | log in

 services galleries calendar art open

about the cac
faq
news
contact
publications
suggestions ?
illinois art fairs
upcoming events
online job bank

get involved
register
become a member
create online gallery
join email list
volunteer
donate

username
password
☐ remember me
log in

Website by:
Niche Action Software

CAC's many services to artists are discounted or free for members.

Chicago Artists' News
Online Gallery
Event Calendar
Books & Publications
CAC Discussion Board
Upcoming Events
Job Listings
Resources

Become a member
Create a Gallery!
About CAC

Read Artists' News!
BREAKING WEB NEWS

CAC Services
CAC is an arts service organization open to all More...

Online Galleries More...
Free access to 3000 art works by CAC artists

Chicago Art Calendar More...
All that's happening in the Chicago Art Scene
◆ Prudential Plaza Artists..
◆ Ethnic Arts Spree/Bazaar..
◆ Ford Free Evenings, Thursdays & F..
◆ 32nd Annual Oak Park Ave-Lake Art..
◆ Ford Free Evenings, Thursdays & F..
◆ Women of Courage Exhibition..
◆ Deadline for Juried Print Show..
◆ Art in Galena..
◆ "CAC Garage Sale"..
◆ The Chicago Artists' Coalition's..

Chicago Art Open More...
Chicagoland's premier non-juried art show
The 2006 Art Open runs Oct. 17 - Nov. 3

Illinois Art Fairs More...
Illinois Art Fair Directory lists over 200 art fairs
[] Find Art Fair

CAC Job Bank More...
Where employers and artists meet
[] Find Artist
Browse Jobs *(Members Only)* | Post a Job

And now, *Chicago Artists' News* entire content is available

to members online – with bigger, full color photographs,

special Web-extra content and breaking news as it happens.

Chicago Artists' Coalition

Celebrates over 30 Years
of Supporting Visual Artists
and the *Chicago Artists' News,* the
Most-Read Artists' Newspaper in the Midwest

Published monthly, *Chicago Artists' News* includes features on current events in the regional, national and international art worlds; profiles of artists and galleries; informative reviews of art exhibitions; advice on how to market art; book reviews; and more.

The newspaper's extensive classified section lists exhibition opportunities, jobs, studio space, gallery openings, art events, classes and workshops, member announcements, and more, useful to artists all over the country.

Chicago Artists' News is a great resource to keep artists in touch with the art scene and provide career-development information.

The **Chicago Artists' Coalition** (CAC) offers many other services, including our web site, www.caconline.org, showcasing the works of member artists, some of which are available for sale. In addition, our Online Discussion Board for Visual Artists, **www.cacdiscussion.org**, provides a variety of forums where artists worldwide can ponder and debate visual art topics.

Join the **Chicago Artists' Coalition** today, start receiving your subscription to *Chicago Artists' News* and become more active in the visual art community. As a member, you can also take advantage of CAC's job referral service, our programs and monthly artists' salons, discounts at art supply and framing stores, plus gain access to health insurance and a credit union.

Call, write or print up the membership form from our web site: www.caconline.org

 Chicago Artists' Coalition 70 E. Lake Street, Suite 230, Chicago, IL 60601
Phone: 312-781-0040; Fax: 312-781-0042
Web: www.caconline.org
E-mail: editor@caconline.org

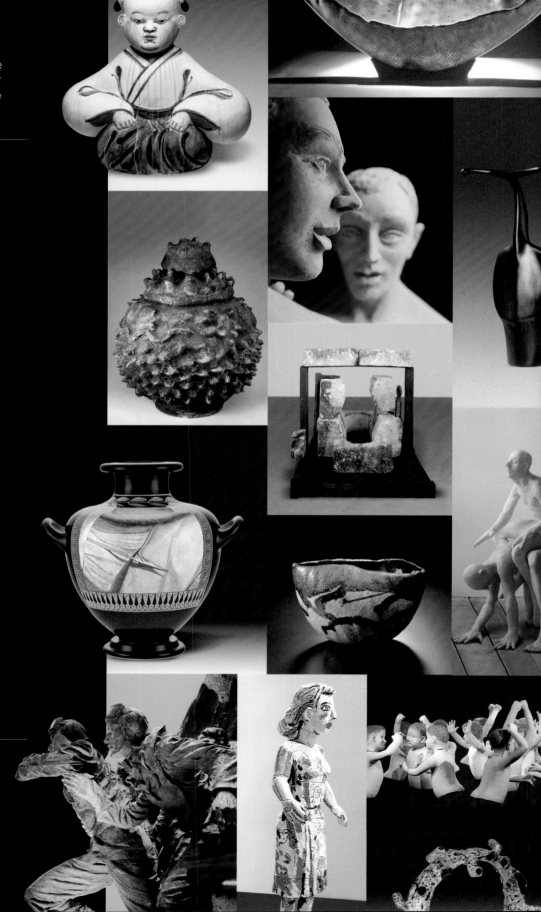

CLAY IN ART

INTERNATIONAL
Y E A R B O O K

ClayArt
INTERNATIONAL
cai@clayart-international.com
www.clayart-international.com
P.O Box 79006, NEA SMYRNI 171 10
ATHENS-GREECE
Tel./Fax: +30 210 6752766

Since 1987 we began publishing in Greece
kerameiki techni *International Ceramic Art Review.*

In its 18 years of existence, our magazine established itself as one of the most important ceramic journals internationally, promoting and raising the profile of contemporary ceramic art around the world - subscribers in 98 countries.

On the threshold of its 50th edition, kerameiki techni underwent a radical transformation. We extended the boundaries of our magazine by transforming it into a multifaceted format for art, information, communication and interaction

The new media is composed of two parts:

The Annual publication (printed part)

CLAY IN ART INTERNATIONAL –Yearbook

Published at the end of each year, with insightful features, reviews and articles, indispensable reports on major events and exhibitions, exclusive interviews and criticism, it constitutes an exclusive annual record of the current international trends and developments in the field of contemporary clay art.

The first edition, a 260 page, hard cover (cloth bound), high quality volume, was published at the end of 2005 and is now available.

Inserted in the yearbook our readers will find the:

ANNUAL CLAYART INTERNATIONAL PANORAMA CD-Rom

A selection of images and information from the most important exhibitions, competitions and other events held worldwide through the year.

The 2005 CD-Rom includes 460 high quality images from over 200 exhibitions, competitions and other events.

The Web-page (digital part)

CLAYART INTERNATIONAL – soon online

An innovative source of online news and updates, featuring images, information and reports on exhibitions, competitions and other significant current events held worldwide. It will also supplement the contents of the yearbook with extended theoretical and visual coverage. It constitutes an alternative way for the international clay art community to communicate and interact.

DECORATIVE AND APPLIED ARTS • No.197 NOVEMBER/DECEMBER 2005

UK: £5.50 • US: $11.95

DECORATIVE AND APPLIED ARTS • No.198 JANUARY/FEBRUARY 2006

crafts

UK: £5.95 • US: $12.50

FULL CIRCLE
Naoko Yoshizawa's
folded paper
jewellery

MAKING HISTORY
America's Black
Mountain College

PRIZE METAL
The work of
Simone ten Hompel

crafts

World-class crafts on every page

Crafts magazine is the UK's leading authority on decorative and applied arts. Published every two months, we report on quality work from within the UK and beyond. Supplying in-depth coverage and debate across the full spectrum of crafts disciplines, *Crafts* is dedicated to showcasing the best work in ceramics, textiles, jewellery, metal, wood, furniture, glass, fashion and architecture. If you're looking for inspiration and vital information, *Crafts* is the only resource you need.

Subscribe to *Crafts* magazine today and receive your first issue absolutely FREE - that's 7 issues for the price of 6. A one year subscription costs just $72.

To take advantage of this special offer, contact us today, quoting 'SOFA06' when you order to claim your free issue.

Subscribe today:

Visit www.craftscouncil.org.uk and subscribe online

Call our hotline on: +44 (0) 20 7806 2542

Email your details to: subscriptions@craftscouncil.org.uk

from top to bottom:
Jet Mous, *Three Vases In One*, 2003, 25 × 8 cm
Yoko Izawa, *Necklace Petals*, 2004, lycra and nylon yarn, silver, polypropylene
Hans Stofer, *Bucket*, 1999 – 2000, 30 × 42 cm, coated steel, saucer

A touchstone for collectors

CRAFT ARTS INTERNATIONAL is one of the most respected magazines in its field. For over 22 years it has attracted worldwide acclaim for its "international scope" and the variety of contemporary visual and applied arts it documents in a lucid editorial style and elegant graphic format. A continuously updated index on-line includes every article and artist that has appeared in the magazine since it was launched in 1984. And access to this remarkable resource, one of the most comprehensive available on the Internet, is totally free.

Each issue of *Craft Arts International* contains 128 pages in full colour, with over 400 color images of innovative concepts and new work by leading artists and designer/makers, supported by authoritative and insightful essays, that are essential reading for those interested in the contemporary visual and applied arts.

Subscriptions: subs@craftarts.com.au
Advertising: info@craftarts.com.au

craft arts
INTERNATIONAL

AUSTRALIA $18.50 (incl. GST)
US$15, UK £8
NZ $22.50 (incl. GST)
JAPAN ¥1680
(本体¥1600)

GLASS BY JUDI ELLIOTT, BRUNO ROMANELLI
SCULPTURE BY DENESE OATES, CHRISTIAN BURCHARD
& WARREN LANGLEY, CERAMICS BY AVITAL SHEFFER,
PLIQUE-A-JOUR BY VALERI TIMOFEEV

64

ISSN 1038-846X

Kiln-formed glass by Judi Elliott (Australia)

craft arts
INTERNATIONAL

AUSTRALIA $16.50 (incl. GST)
US$15, UK £8
NZ $22.50 (incl. GST)
JAPAN ¥1680
(本体¥1600)

RICHARD RAFFAN, ROB KNOTTENBELT
DAVID GROTH, ARLINE FISCH, SARAH PERKINS
ABIE LOY KEMARRE, JANET LAURENCE
MARK ZIRPEL, NINA HOLE, EFFIE HALKIDIS

65

ISSN 1038-846X

Woodturning by Richard Raffan (Australia)

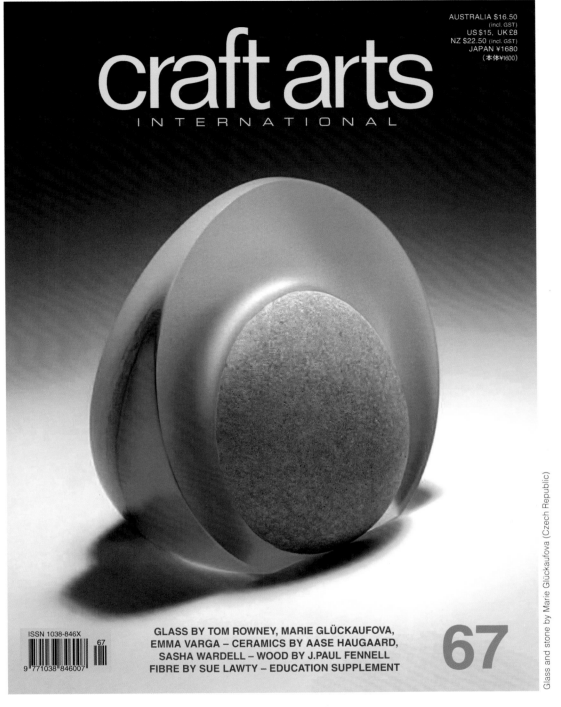

craft arts
INTERNATIONAL

AUSTRALIA $16.50 (incl. GST)
US $15, UK £8
NZ $22.50 (incl. GST)
JAPAN ¥1680
(本体¥1600)

GLASS BY TOM ROWNEY, MARIE GLÜCKAUFOVA,
EMMA VARGA – CERAMICS BY AASE HAUGAARD,
SASHA WARDELL – WOOD BY J.PAUL FENNELL
FIBRE BY SUE LAWTY – EDUCATION SUPPLEMENT

67

ISSN 1038-846X

Glass and stone by Marie Glückaufova (Czech Republic)

Craft Arts International
PO Box 363, Neutral Bay, NSW 2089, Australia
Tel: +61-2 9908 4797, Fax: +61-2 9953 1576
Limited stocks of back issues may be ordered from our secure website.

www.craftarts.com.au

INSPIRATION

INNOVATION

INFORMATION

LET US INSPIRE YOU!

SEP/OCT 2006

*Fiber*ARTS

CONTEMPORARY
TEXTILE ART
AND CRAFT

Art of the Doll

Figurative
Sculpture
Knitted, Beaded, Knotted

Louise
Bourgeois

Sublime
Stitching

*Fiber*ARTS

CONTEMPORARY
TEXTILE ART
AND CRAFT

LEFT TO RIGHT, TOP TO BOTTOM: *Deborah Cross*, rayon blouses with dyed silk appliqué; *J. R. Campbell and Jean Parsons*, Transformation: Icarus; *China Marks*, The Proxy; *Peter Clark*, rome is where the heart is; *Bernie Rowell*, Four Seasons; *Anne Bossert*, Atomic Egg Side Table; *Judith Poxson Fawkes*, House That Jack Built. All images are details.

UrbanGlass is a not-for-profit international center that promotes the use and appreciation of glass as a creative medium and makes glass accessible to an increasingly diverse audience through its programs, educational initiatives, and publications. Programs include the open-access Studio; classes and workshops; *GLASS: The UrbanGlass Art Quarterly*, the Robert Lehman Gallery, on- and off-site exhibitions; The Bead Project and Bead Expo; Visiting Artists, The Atelier, and The Store at UrbanGlass.

UrbanGlass

647 Fulton Street · Brooklyn, NY 11217 · 718.625.3685 · info@urbanglass.org · www.urbanglass.org

GLASS: The UrbanGlass Art Quarterly puts the work of emerging and established artists into critical context. Our contributors—top art critics, curators, and art historians—are your expert guides to this dynamic field. Beautifully printed with the highest production values, *GLASS* is an international showcase of the best work in glass.

Don't miss a single issue.

Subscribe

800.607.4410

subscribe@glassquarterly.com

Advertise

212.431.4403

publisher@glassquarterly.com

Learn More

www.glassquarterly.com

The Center for Intuitive

Intuit

756 N. Milwaukee Avenue
Chicago, IL 60622
T 312.243.9088
www.art.org

Gallery Hours
Tuesdays-Saturdays 11am - 5pm
Thursdays 11am - 7:30pm
Admission is free

and Outsider Art
celebrates its 15 Year Anniversary with

TAKE ME TO THE RIVER
September 15, 2006 - January 5, 2007
Curated by Ken Burkhart

Celebrate the birth of Intuit with featured
works by William Dawson, Lee Godie, Justin
McCarthy, Aldo Piacenza, Drossos Skyllas,
and Joseph Yoakum, among others.

Opening Friday, September 15
5:00 pm - 9:00 pm at Intuit
756 North Milwaukee Avenue
Chicago, Illinois

Your window to Europe!

Between art and craft.

With the aim of shedding light on clay as a design medium, KeramikMagazin bridges the gap between art and craft. Going beyond German-speaking countries, KeramikMagazin is a technical journal with a European focus. In addition to exhibition reviews, portraits of artists, and reports from studios and workshops, the magazine provides information on major international competitions and symposia. It profiles galleries, museums and markets, discusses topical issues relevant to the ceramics scene, and examines historical matters. Every issue contains a comprehensive round-up of forthcoming exhibitions, competitions, and museum and market events, and looks at recently published books. KeramikMagazin is published 6 times annually.

NOW ALSO AVAILABLE ENTIRELY IN ENGLISH!

METALSMITH

JEWELRY ▪ DESIGN ▪ METAL ARTS FALL 2006

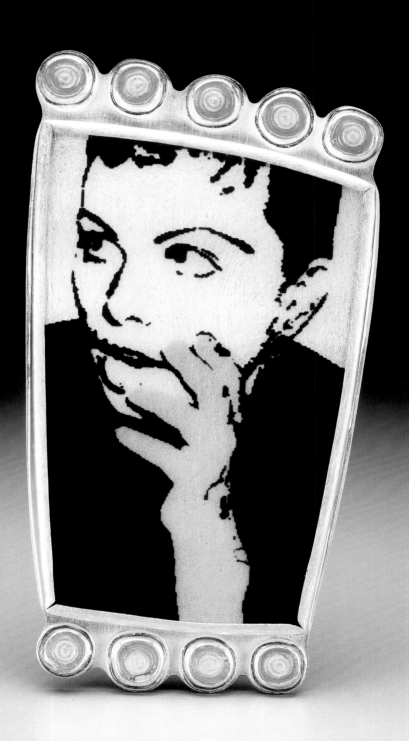

volume 26 number 3
www.snagmetalsmith.org

Eye Music

Reflexive Specimens

Sculpting in Miniature

NEUES GLAS
NEW GLASS

The Best of International

NEW CERAMICS

THE EUROPEAN CERAMICS MAGAZINE

Gives a clear overview of the international developments in ceramics, focusing particularly on the situation in Europe.

The **NEWS** reports on the latest from the ceramics scene in Germany, Austria and Switzerland, but it also includes what is going on in other countries in Europe as well as internationally. **This is where you can find the most important dates for competitions, events and new developments.**

PORTRAITS OF ARTISTS form the main part of the magazine. Craftspeople, designers and artists working with ceramics are presented with their work, their methods and techniques, and their artistic careers. Reports about current **EXHIBITIONS, WORKSHOPS AND SYMPOSIA** are the second focal point.

In **FORUM**, philosophical and historical topics are taken up, explained and discussed.
In **HISTORY**, interesting historical developments in ceramics are covered. Other permanent sections in **NEW CERAMICS** include:
KNOWLEDGE & SKILL - with techniques, new developments and the necessary background knowledge.
CERAMICS & TRAVEL shows the way to ceramically interesting destinations.
GALLERY GUIDE lists dates and details from European and international galleries.
BOOK REVIEWS cover the latest publications and offers: standard works for ceramics.

And we give listings of **COURSES, MARKETS** and **ADVERTISEMENTS.**

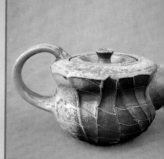

NEW CERAMICS - 6 issues a year

ANNUAL SUBSCRIPTION:

Worldwide by surface mail	US$ 56 (46 €)
Worldwide by airmail	US$ 70 (59 €)
Ask for a trial copy	US$ 9.50

NEW CERAMICS

Publishing House
NEW CERAMICS
Steinreuschweg 2
D-56203 Hoehr-Grenzhausen
Germany
Phone: +49 (0)2624-948068
Fax: +49 (0)2624-948071
info@neue-keramik.de
www.neue-keramik.de
www.ceramics.de

object magazine

For a fresh perspective
on craft and design.

Australia's leading
craft and design
magazine brings
you inspiration,
innovation and
information
from Australia,
New Zealand and
across the globe.

Become entranced by PATTERN,
while DROOG puts the human back into
design, FRANCIS UPRITCHARD gets
weird, we lift the lid on WEMBLEY WARE
and SOUTHERN ICE porcelain proves
ceramics are cooler than ever.

Find the potential in RAW MATERIALS,
as DRUSILLA MODJESKA explores
the looking-glass world of
JANET LAURENCE, we eavesdrop on
CRAFT IN DIALOGUE and discover
there's more to F!NK than you think.

Weave your way around new TEXTILES,
discover WARWICK FREEMAN's
mysterious secrets, and learn how to
FREESTYLE, while we see what makes
DAMIAN BARTON so intriguing and
what gets BOB ELLIS inspired!

object 48

object 49

object 50

A$15.00 (INC GST)
NZ$17.50 (INC GST)

SUBSCRIBE

→ one issue free

→ free delivery to your door

→ your copy before it hits the stores

→ great gift idea

Australia $45.00 (incl. GST)
New Zealand/Asia A$72.00
USA/Europe A$85.00

Simply copy this form and fax to: + 61 2 9361 4533
Telephone: + 61 2 9361 4555
Email object@object.com.au
Visit www.object.com.au
for a downloadable subscription form

Object **Magazine is essential reading for anyone passionate about contemporary craft and design.**

☐ Yes, I would like a four-issue subscription
delivered to my door, starting with issue no: _____
Australia $45.00 (inc. GST) / New Zealand & Asia A$72.00 / USA & Europe A$85.00

☐ Yes, this is a gift subscription for:

Name _____

Address _____

Please complete the form below, then either:
Fax to: +61 2 9361 4533
Mail to: Object: Australian Centre for Craft and Design
 PO Box 63 Strawberry Hills NSW 2012
or email to: object@object.com.au
Telephone: +61 2 9361 4555

Your Details:

Name _____

Address _____

Telephone _____

Email _____

Payment Details:

TOTAL $ _____

☐ Cheque (in A$) payable to: Object: Australian Centre for Craft and Design

☐ Please charge my card: ☐ Bankcard ☐ MasterCard ☐ Visa ☐ Amex ☐ Diners

Card no: | | | | | | | | | | | | | | | | | Card expiry: | | | |

Name on card: _____

Cardholder signature: _____

Conditions: Subscription and Supporter rates are valid until 31 March 2007.
Object is committed to handling your personal information in accordance with the Australian Privacy Act.

selvedge •••

ISSUE 13
UK £7.50 EUROPE €15
USA $20 CANADA $25
REST OF WORLD £15

THE FABRIC OF YOUR LIFE: TEXTILES IN FINE ART, FASHION, INTERIORS, TRAVEL AND SHOPPING

surface design *association*

definition:

Surface Design encompasses the coloring, patterning, and structuring of fiber and fabric.

This involves the creative exploration of processes such as dyeing, painting, printing, stitching, embellishing, quilting, weaving, knitting, felting, and papermaking.

mission:

The mission of Surface Design Association is to increase awareness, understanding, and appreciation of textiles in the art and design communities as well as the general public.

We inspire creativity and encourage innovation and further the rich tradition of textile arts through publications, exhibitions, conferences, and educational opportunities.

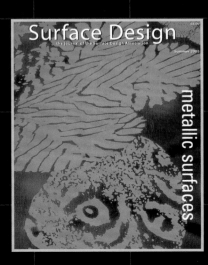

member benefits:

- Four issues of the Surface Design Journal
- Four issues of the SDA Newsletter
- National and regional conferences
- Networking opportunities
- Inclusion in SDA Slide Library
- SDA Instructors Registry
- Avenues for promotion of your work
- Opportunities for professional development
- Free 30-word non-commercial classified ad in the newsletter
- Exhibition opportunities

member services:

- Access to fabric sample library and slide library
- Access to instructor directory
- Resource recommendations

For membership information, visit our web site
www.surfacedesign.org

Surface Design Association
PO Box 360
Sebastopol CA 95473
707.829.3110
surfacedesign@mail.com

www.surfacedesign.org

Membership benefits

- Subscription to *American Woodturner*

- Member discounts on books, dvds, and more

- Annual symposium

- Educational Opportunity Grants

- Resource directory

- Networking opportunities

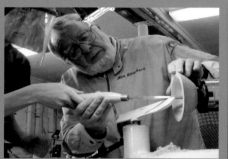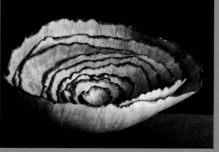

American Association of Woodturners

222 Landmark Center, Saint Paul, Minnesota 55102 | 651.484.9094 | www.woodturner.org

Art Alliance for Contemporary Glass

The Art Alliance for Contemporary Glass
is a not–for–profit organization whose mission is to further the
development and appreciation of art made from glass. The Alliance
informs collectors, critics and curators by encouraging and
supporting museum exhibitions, university glass departments and
specialized teaching programs, regional collector groups, visits
to private collections, and public seminars.

Support Glass

Membership $65
Your membership entitles you to a
subscription to the AACG newsletter and
opportunities to attend private events at
studios, galleries, collectors homes, Glass
Weekend and SOFA. For more information
visit our web site at www.ContempGlass.org,
email at admin@contempglass.org or
call at 847-869-2018.

We invite you to
join the Art Jewelry Forum

and participate with other collectors who share
your enthusiasm for contemporary art jewelry.

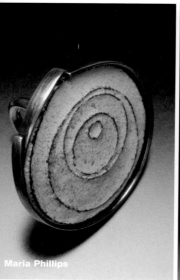

Maria Phillips

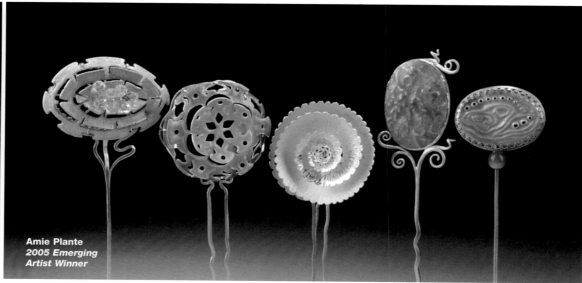

Amie Plante
2005 Emerging
Artist Winner

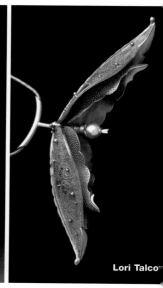

Lori Talco

OUR MISSION To promote education, appreciation,
and support for contemporary art jewelry.

OUR GOALS To sponsor educational programs,
panel discussions, and lectures about national and
international art jewelry.

To encourage and support exhibitions, publications,
and programs which feature art jewelry.

To organize trips with visits to private collections,
educational institutions, exhibitions, and artists' studios.

Join the Art Jewelry Forum today!

E-mail: **info@artjewelryforum.org**

Call: **415.522.2924**

Website: **www.artjewelryforum.org**

Write us at: **Art Jewelry Forum,
P.O. Box 590216, San Francisco, CA
94159-0216**

artnet®

Is it on artnet?

61 Broadway, 23rd Floor _ New York, NY 10006 _ info@artnet.com _ www.artnet.com
Mauerstraße 83 / 84 _ D-10117 Berlin _ info@artnet.de _ www.artnet.de

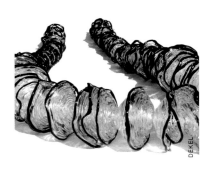

DEKEL

GELBARD & LEITERSDORF

AIDA
association of israel's decorative arts

REDDISH

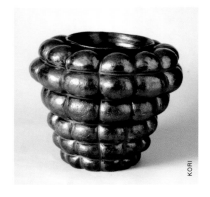

KORI

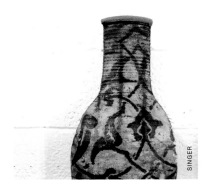

SINGER

GAMZOU

110 East 59TH Street
26TH Floor
New York, NY 1022
212.931.0089
www.AIDAarts.org

Progressions

GOREN-AMIR

AIDA FOUNDERS
Dale Anderson
Doug Anderson
Andy Bronfman
Charles Bronfman

ADVISORS
Jane Adlin
Mark Lyman
Anne Meszko
Jo Mett
Lois Moran
Stephen Novick
Yael Reinharz
Jeffrey Solomon
Davira Taragin

DIRECTORS
Sandy Baklor
Sharon Karmazin
Arlene Kaufman
Jane Korman
Leonard Korman
Doron Livnat
Marianne Livnat
Rivka Saker
Elisabeth Sandler
Norman Sandler
Lynn Schusterman
Jason Soloway
Anita Wornick
Ron Wornick

STAFF
Erika Vogel
DIRECTOR
NEW YORK

Aviva Ben Sira
PROJECT DIRECTOR
TEL AVIV

ENGELSTEIN

BERMAN

The Passion of Art
The Glory of Antiques

THE ESSENTIAL GUIDE TO FALL'S MAJOR FAIRS

art&antiques

SEPTEMBER 2006

ART INSPIRES!
New York Collectors' Passion for the Masters

Lalique: Then and Now
Biedermeier Gets its Due
Plus: California Modernism

The authoritative source for elegant,
sophisticated coverage of the art and antiques market.

Collectors of Wood Art

Honors
William Hunter
2006 Recipient
Lifetime Achievement Award

William Hunter entered the field of contemporary wood sculpture in its formative stages in early 1970s. His early forms in wood exploited the material's rich expressive potential and advanced a new direction for the entire field of contemporary wood sculpture. Through the years since, he has led the field as the medium evolved from its foundations in traditional woodturning practices to its emergence as a vehicle for artistic invention. Today, Bill is considered among the foremost artistic leaders and visionaries in this important field that is the focus of the Collectors of Wood Art.

Collectors of Wood Art is committed to the development and appreciation of studio wood art, including turned objects, sculpture, and furniture. Find out more about CWA — and join! Register at our website: www.CollectorsOfWoodArt.org
phone: 888.393.8332 email: CWA@NYCAP.RR.com
or mail inquiries to: Collectors of Wood Art, P.O. Box 402
Saratoga Springs, NY 12866

William Hunter with his sculpture entitled "Creation" 2006
Jarah burl, 29"h x 27"w x 20"d
Photo: Alan Shaffer

Collectors of Wood Art
is proud to sponsor a talk by
William Hunter
with
Hal Nelson
Director of the Long Beach Museum of Art
and
Kevin Wallace
Curator of *Transforming Vision:*
The Wood Sculpture of William Hunter, 1970-2005

SOFA Chicago, Friday, November 10, 2006

The Corning Museum of Glass most gratefully thanks Chicago collectors Ben and Natalie Heineman for their extraordinary gift in 2006

The Ben W. Heineman Sr. Family Collection of Contemporary Studio Glass

250 objects from 89 artists spanning 40 years
Artists represented in the collection include:

Peter Aldridge • Howard Ben Tré • Dale Chihuly • Dan Dailey

Michael Glancy • Eric Hilton • Pavel Hlava • David Huchthausen

Marian Karel • Dominick Labino • Stanislav Libenský and

Jaroslava Brychtová • Marvin Lipofsky • Harvey Littleton

Dante Marioni • Richard Marquis • Klaus Moje • William Morris

Joel Philip Myers • Thomas Patti • Mark Peiser • Clifford Rainey

Mary Shaffer • Lino Tagliapietra • Bertil Vallien • František

Vízner • Steven Weinberg • Dana Zámečníková • Toots Zynsky

Corning Museum of Glass
One Museum Way
Corning, New York 14830
www.cmog.org

CHAIRITY

CRAFT EMERGENCY RELIEF FUND

THIS CHAIRITY SUPPORTS CRAFT ARTISTS

 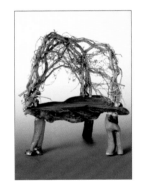

Top row (L to R): Donna D'Aquino, Charissa Brock, Lisa Harris , Mark Del Guidice, Aaron Kramer, Dale Broholm
Middle row: Heather Allen Swarttouw, Merrill Morrison, Julie Girardini, Susan Kavicky, Daniel Mack, Jerilyn Virden
Bottom row: Dean Pulver, Harriete Estel Berman, Jen Violette, Hope Rovelto, Renee Harris, Andrea Christie, Jo Stone
Also included but not shown: L. John Andrew, Emily Brock, Nick Davis, Flo Perkins. All works are no larger than 4" x 4" x 4".

Come view CERF's CHAIRITY collection at the SOFA CHICAGO Resource Center

Raffle tickets: $50 each or books of five for $200. Drawing November 12, 2006

You do not need to be present to win.

www.craftemergency.org or 802.229.2306

The mission of CERF is to strengthen and sustain the careers of craft artists across the United States

Tapestry woven by Jon Eric Riis titled *Icarus No. 1*

Sculpture stuffed and quilted by Margaret Cusack titled *Hands*

Drawing embroidered by B.J. Adams titled *Hands Drawing Hands*

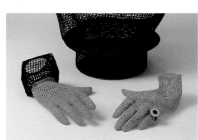

Sculpture crocheted by Norma Minkowtiz titled *Sandy G*

WALL WORKS AND SOFT SCULPTURE will complement the glass, clay, metal and wooden objects now adorning your home. Discover the impressive range of works being produced today by a talented bevy of artists who employ countless techniques to construct enviable art works of natural and man-made flexible materials.

SEE PRIVATE COLLECTIONS OF FIBER ART on tours organized by Friends of Fiber Art. Generous collector members show you how handsome fiber art looks in their elegant homes. Many were listed among the "100 Top Collectors in America" published by *Art & Antiques* magazine.

NETWORK WITH THE MOVERS AND SHAKERS who share ideas with the buyers and makers at all programs sponsored by Friends of Fiber Art, the only organization that fosters communication among collectors, curators, critics, dealers and artists.

LEARN WHERE FIBER ART IS ON VIEW by reading the outspoken newsletter for members of Friends of Fiber Art. It notes developments in the museum world and features the achievements of its members.

OUR MISSION is to inform and inspire the art-appreciative public about the "collectability" of contemporary art made of flexible materials.

CONTACT US by phone, fax or mail. Learn about scheduled programs at www.**f**riends**off**iber**a**rt.org our developing Web site.

*friends of fiber***Art** *International*™

Post Office Box 468
Western Springs, IL 60558
Phone/Fax 708-246-9466

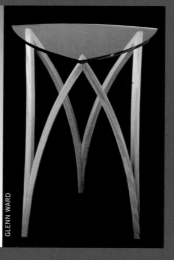

GLASS ART SOCIETY

JOIN US!

Membership is open to anyone interested in glass art:

- Artists • Students • Collectors • Educators
- Galleries • Museums • Administrators
- Manufacturers and Suppliers • Writers

You receive:

- *GAS NEWS* : 6 newsletters each year
- Journal documenting our Annual Conference
- Member and Education Roster • Web Link
- Resource Guide • Newsletter Ad Discounts

Take advantage of:

- Annual Conference • Mailing Lists
- Networking Opportunities
- Website Message Board and Members Only Section

OVER 3000 MEMBERS IN 54 COUNTRIES

Images (from top):
Bruno Romanelli, "Two Heads"
John de Wit, "Peer"
Rex Trimm, "Championship"

Glass Art Society's 37th Annual
Conference: Transformational Matter
Pittsburgh, Pennsylvania
June 7-9, 2007

Photo courtesy of the Pittsburgh
Convention and Visitor's Bureau

JOIN US IN PITTSBURGH FOR:

Demonstrations	Technical Resource Center
Lectures	Education Resource Center
Gallery Forum	Auctions
Tours	Exhibitions
Parties ...*and More!*	

For more information or to register,
go to www.glassart.org, or contact GAS.

Visit us at SOFA Chicago, Nov. 10-12, 2006

GLASS ART
SOCIETY

3131 Western Avenue, Suite 414, Seattle, Washington 98121 USA
Tel: 206.382.1305 Fax: 206.382.2630 E-mail: info@glassart.org Web: www.glassart.org

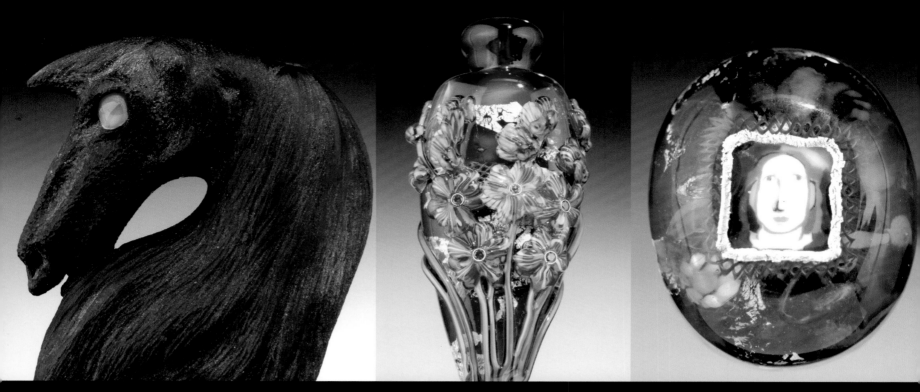

THE INTERNATIONAL SOCIETY OF GLASS BEADMAKERS
PROGRESSIONS IN CONTEMPORARY GLASS BEADMAKING

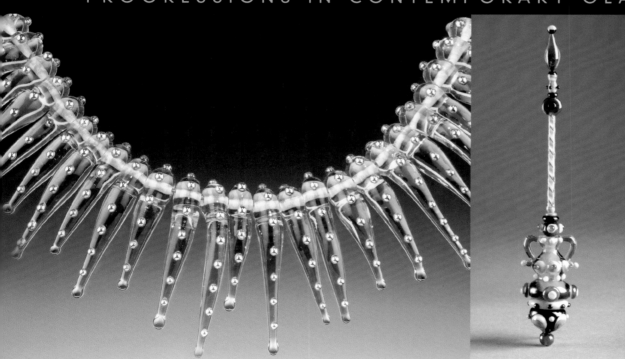

From it's early roots to collaborating with The Bead Museum in the creation of the *Trajectories* exhibit, the ISGB focuses on progressions made in contemporary glass beadmaking.

Our reach encompasses our yearly *Gathering*, museum exhibits and SOFA Chicago, to involvement with contemporary art glass conferences,

Our success is formed by continually fueling the awareness of this art form, and through support of our member's endeavors by our diverse programming and benefits.

For information on ISGB programs and membership, please visit www.isgb.org.

The *Trajectories* exhibit is currently showing at the Bead Museum in Glendale, Arizona. Running through March 2007, the show will travel nationally thereafter.

International Society of Glass Beadmakers

ISGB

International Society of Glass Beadmakers · 1120 Chester Ave. #470 · Cleveland, OH 44114 USA · 888 742-0242

Artist's work from Trajectories - top left to right and below left, Lucio Bubacco, Unicorn, Leah Fairbanks, *Golden Gladiolus*, Wakana Takahashi, *Person Against Blue Background*, Jennifer Wood, *Burst*. Below right, ISGB member: Pam Wolfesberger

CELEBRATE AMERICAN CRAFT ART AND ARTISTS JOIN THE JAMES RENWICK ALLIANCE.

LEARN
about contemporary crafts at our seminars,

SHARE
in the creative vision of craft artists at workshops,

REACH OUT
by supporting our programs for school children,

INCREASE
your skills as a connoisseur,

ENJOY
the comaraderie of fellow craft enthusiasts,

PARTICIPATE
in Craft Weekend including symposium and auction, and

TRAVEL
with fellow members on our craft study tours.

"Cinerary Urn", 2002, by William Morris, was sold at our 2005 Craft Weekend Auction. Photo by Rob Vinnedge.

As a member you will help build our nation's premiere collection of contemporary American craft art at the Renwick Gallery.

The James Renwick Alliance, founded in 1982, is the exclusive support group of the Renwick Gallery of the Smithsonian American Art Museum.

For more information: Call 301-907-3888. Or visit our website: www.jra.org

JOHN MICHAEL **KOHLER ARTS CENTER**

expect the unexpected

With 30 powerful exhibitions (8–10 simultaneously) each year, plus astonishing collections, the world-renowned Arts/Industry artists-in-residence program, thrilling performances, fascinating opportunities to interact with artists and scholars, sculpture gardens, and a charming café and shops, the **John Michael Kohler Arts Center** is "…a classy, sassy tour de force." —Milwaukee Journal-Sentinel

Don't miss…
ADAPTATION through January 2007
A series of exhibitions exploring the work of artists who invent new cultural identities, imbue existing objects with new meaning, or transform their personal appearances.

ECHOES OF THE PAST February–May 2007
A series involving artists who draw on Western cultural and art historical forms to make provocative works that echo the past, yet are grounded in concerns of the present.

THE ROAD LESS TRAVELED June–December 2007
An exhibition series, international conference (September 27–30), and major book—presenting the Arts Center's own collection of works by Vernacular Environment Builders, the only collection of its kind in the world. These artists transformed their homes, yards, or other spaces into multifaceted works of art embodying heritage, place, and the fabric of life.

Top, **ADAPTATION**: *Converging Territories #11* by Lalla Essaydi (C-print; courtesy Lisa Sette Gallery)
Relic 10 by Hung Liu (oil on canvas, lacquered wood; courtesy Nancy Hoffman Gallery)
Middle, **ECHOES OF THE PAST**: *Air Loom*, detail, by Linda Ridgway (bronze; courtesy Dunn and Brown Contemporary)
Plaid and Lace Neckpiece #4, detail, by Mary Preston (gold and enamel)
Bottom, **THE ROAD LESS TRAVELED**: *Seated Saddhu* by Nek Chand (concrete, glass and ceramic shards, metal)
Untitled Chandelier, detail, from *The Healing Machine* by Emery Blagdon (wire, paper, mixed media)

JOHN MICHAEL KOHLER ARTS CENTER
608 New York Avenue, Sheboygan, WI 53081
920 458 6144 / www.jmkac.org

Gallery hours: MWF 10–5; TTh 10–8; SSun 10–4

CERAMICS MUSEUM WESTERWALD

1500 m^2 (next year 3000) Exhibition Area

ARTS & CRAFTS

EXHIBITIONS & SYMPOSIA

DIDACTICS & HISTORY

TOOLS & LIFESTYLE

Lindenstraße 13, D-56203 Hoehr-Grenzhausen
Tel. +49-2624-9460-10 Fax: -9460-120
info@keramikmuseum.de
www.keramikmuseum.de

Ceramics Textiles Printmaking Metalsmithing Painting & Drawing

Adult Classes & Kids Classes

EST. 1975

CHICAGO

773.769.4226

www.lillstreet.com

Working Proof

Print works by:
Julian Cox
Elke Claus
Alan Lerner
Thomas Lucas
Oli Watt

Exhibition Opening and Artist Reception:

November 11th, 4-6pm 2006
Reception will be followed by a
printmaking demonstration and
introduction to Lillstreet's new
printmaking facilities.

Image by Thomas Lucas

Image by Alan Lerner

Lillstreet Art Center has an
internationally recognized
gallery, featuring works by:

Elizabeth Robinson
Michael Wisner
Meredith Brickell
David Crane
Josh DeWeese
Julia Galloway
Matthew Metz
Linda Sikora
Kari Radasch
Sam Chung

and more!

Gallery Studios Clas

Founders' Circle

THE NATIONAL SUPPORT AFFILIATE FOR THE *Mint Museum of Craft + Design*

Michael Sherrill, American
Temple of the Cool Beauty
mixed media

Ian Woo, Singaporean
Forest Noise
woven textile

Daniel Kruger, South African
Untitled Necklace
mixed media

The Mint Museums
Founders' Circle
Mint Museum of Craft + Design

www.founderscircle.org

**ARTS &
SCIENCE
COUNCIL**
Advancing Arts, Science & History

The Founders' Circle partners with the Mint Museum of Craft +
Design to promote appreciation of contemporary craft and design.

EXHIBITIONS:

Woven Worlds: Basketry from the Clark Field Collection
September 9, 2006 – December 31, 2006

Twisted!
December 9, 2006 – May 27, 2007

Observations: Works by Ann Wolff
January 27, 2007 – July 29, 2007

FiberArt International
September 15, 2007 – February 24, 2008

Daniel Clayman
January-May, 2008

simply droog

Our elegant new home is taking shape at

2 Columbus Circle, and will open in 2008.

Meanwhile, when you're in New York, please

be sure to visit us at 40 West 53rd Street.

10 + 3 years of creating innovation and discussion

Exclusive North American presentation
September 21, 2006 — January 14, 2007

Surveying the projects and designs
of the groundbreaking Dutch collective

Upcoming exhibitions

Radical Lace & Subversive Knitting
January 25 – May 6, 2007

Magical Miniatures: Contemporary Netsuke
January 25 – May 6, 2007

GlassWear
May 17 – September 2, 2007

Museum of Arts & Design
40 West 53rd Street, New York, NY 10019
212.956.3535
www.madmuseum.org

Droog Design, *Chest of Drawers* by Tejo Remy, 1991, 60 x 110 x 120 cm.
Used drawers, maple, jute strap. Collection Droog Design.
Photo: Bob Goedewagen.

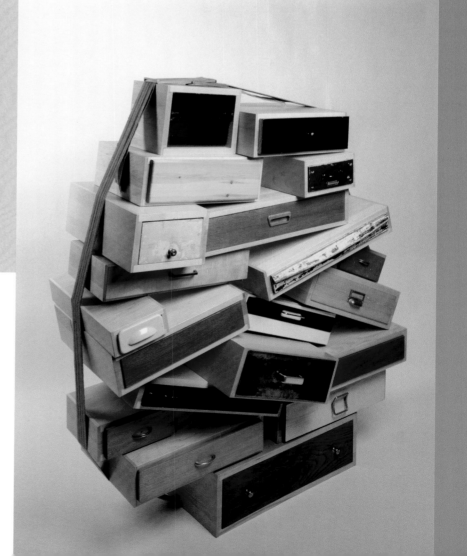

Museum of Arts & Design

National Basketry Organization, Inc.

Promoting the art, skill, heritage and education of traditional and contemporary basketry

Porcupine, JoAnne Russo.
Photo, Jeff Baird.

Circling Fern, Fran Reed.
Photo by Chris Arend.

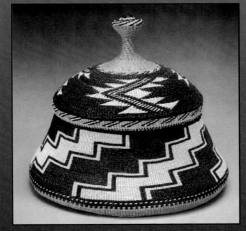

Karok Covered Basket,
Elizabeth Hickox, pre-1926,
Gift of Catherine Marshall Gardiner,
Collection of Lauren Rogers Museum of Art.

Swing Handled Egg Basket,
Aaron Yakim. Photo, Paul Jeremias.

Onyx, Polly Adams Sutton.
Photo by Bill Wickett.

Membership • Newsletters • Exhibitions • Conferences
National Basketry Organization
PO Box 3425 • Suwanee, GA 30024 • 678-546-1246
www.nationalbasketry.org

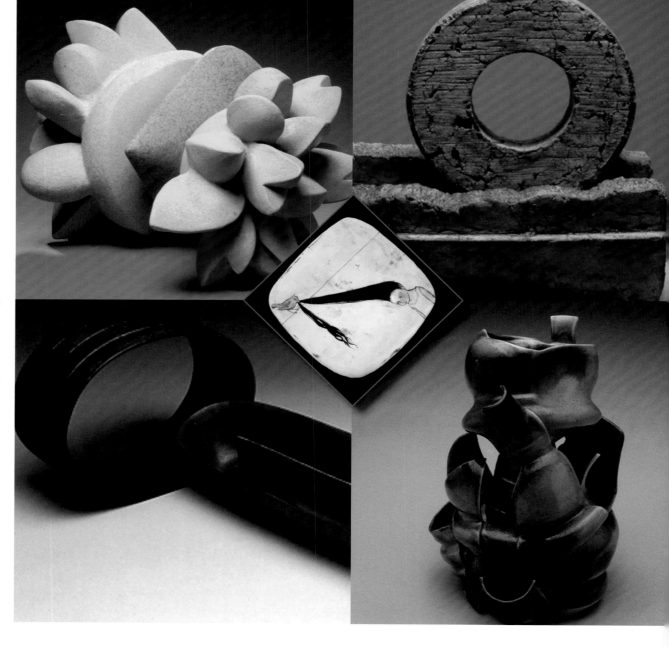

SOFA*NCECA
March 14-17, 2007

Louisville, Kentucky
41st Annual Conference

IMAGES CLOCKWISE FROM TOP LEFT:

BIG GIRL WRIST CORSAGE by Jordan Siri Wood, Brigham
Young University, HORIZONTAL JOURNEY by Gary Hall,
Brigham Young University, , UNTITLED by Cindy Van Amerongen,
Alberta College of Art and Design, ELLIPTICAL MEMORY by
Hak Kyun Kim, The University of Montana, STUCK by
Amanda Lynch, San Jose State University.

SELECTED WORKS FROM THE NCECA,
2006 REGIONAL STUDENT JURIED EXHIBITION (RSJE),
PORTLAND, OREGON.

A GLIMPSE AT THE NEXT
GENERATION OF CERAMIC ARTISTS

N·C·E·C·A

National Council on Education for the Ceramic Arts

W W W . N C E C A . N E T

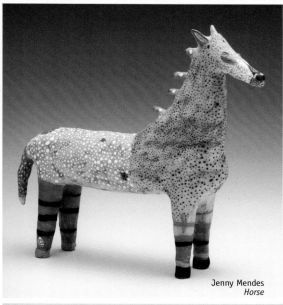

Jenny Mendes
Horse

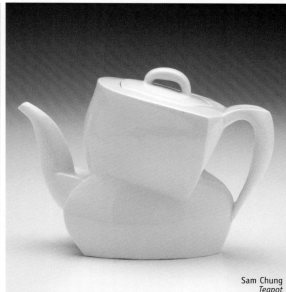

Sam Chung
Teapot

Penland
School
of **Crafts**

A National Center for Craft Education

Workshops • Gallery • Artist Residencies
Annual Benefit Auction: August 10–11, 2007

P.O. Box 37, Penland, NC 28765
828.765.2359
www.penland.org

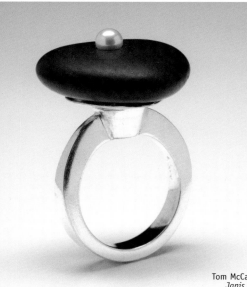

Tom McCarthy
Janis Ring

Bonnie O'Connell
Spiked Furrow

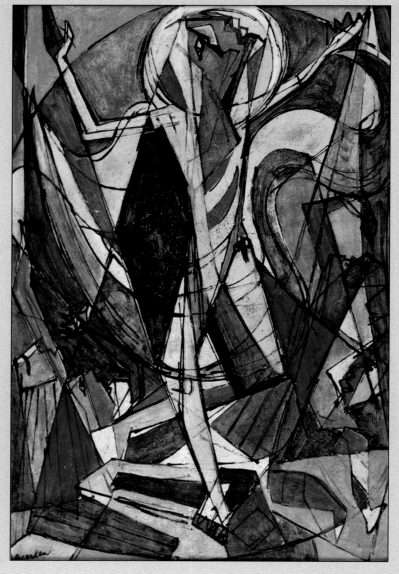

Romare Bearden, *He is Risen (The Passion of Christ Series)*
1945, Oil on gessoed board, 36 x 24 inches
Signed lower left: "Bearden"
Hollis Taggart Gallery, New York

Where The World's
Connoisseurs And Collectors
Meet In The Sun

PALM BEACH!
America's International Fine Art & Antique Fair

A Vetted Collection From The Finest Dealers In The World

February 2–11, 2007

Vernissage February 1 benefiting *The Mosaic Fund* of the
Community Foundation for Palm Beach and Martin Counties.

Palm Beach County Convention Center | +1.561.209.1338 | www.palmbeachfair.com

Community Foundation
FOR PALM BEACH AND MARTIN COUNTIES

THE ART LOSS ■ REGISTER™
www.artloss.com
LONDON · NEW YORK · COLOGNE

Palm Beach County Florida
THE BEST OF EVERYTHING.®
PALM BEACH COUNTY CONVENTION AND VISITORS BUREAU

palmbeach³
CONTEMPORARY
**International galleries
exhibiting contemporary art.**

palmbeach³
PHOTOGRAPHY
**Leading dealers presenting classical
and contemporary photography.**

palmbeach³
ART+DESIGN
**Decorative arts and
contemporary design.**

palmbeach³
CONTEMPORARYPHOTOGRAPHYART+DESIGN

January 12-15, 2007

January 11, 2007–Private Preview By Invitation Only
To Benefit the School of the Arts Foundation
Serving the Alexander Dreyfoos, Jr. School of the Arts

For information about the Private Preview please call 561.805.6298

Palm Beach County Convention Center
Ⓟ 561.209.1308 Ⓦ www.palmbeach3.com

Partner Travel Agency: **TURON TRAVEL**
www.turontravel.com

Pilchuck Glass School … then

… and now!

Experience Pilchuck for yourself during our 2007 Summer Program or during our fall, winter, or spring residency programs.

PILCHUCK
GLASS
SCHOOL

1201 – 316th Street NW
Stanwood, WA 98292-9600
Tel: 360.445.3111
Fax: 360.445.5515
e-mail: registrar@pilchuck.com
www.pilchuck.com

KICKIN' IT WITH JOYCE J. SCOTT

○ ○

A 30-YEAR RETROSPECTIVE OF THE ARTIST'S MIXED-MEDIA OBJECTS
November 10, 2006 through January 7, 2007

(A Program of **Exhibits**usa, a national division of Mid-America Arts Alliance and the National Endowment for the Arts)

CCA: A LEGACY IN STUDIO GLASS
Celebrating California College of the Art's 100 year anniversary
January 26, 2007 through April 8, 2007

TOOLS AS ART: THE HECHINGER COLLECTION
Honoring familiar forms in new and imaginative ways
April 27, 2007 through June 10, 2007

SCULPTURE TRANSFORMED: THE WORK OF MARJORIE SCHICK
Breaking traditional boundaries of form, texture and color
June 29, 2007 through September 9, 2007

**SAN FRANCISCO
MUSEUM OF
CRAFT+DESIGN**

Lips, 1992,
beads and thread, 6 1/4" x 10"

550 SUTTER STREET ○ SAN FRANCISCO, CA 94102
WWW.SFMCD.ORG ○ 415.773.0303

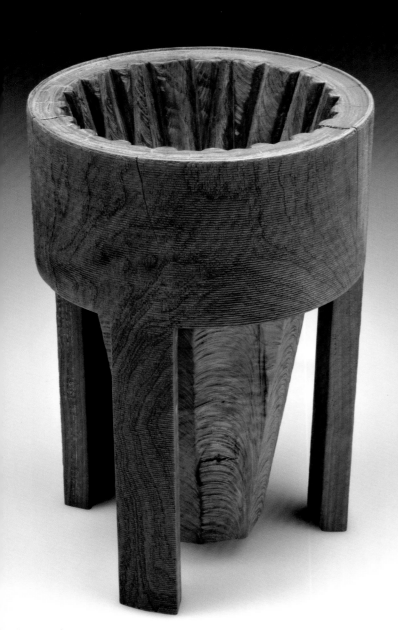

Competition
International Competition - Ceramics for Use, Ceramics as Expression
National Competition - Beautiful Korean Ceramics

Main Exhibition
World Contemporary Ceramics - Ceramic, Skin of Asias
Crossroads of Ceramics - Turkey, where the East and West meet
Ceramic House III

Special Exhibition
Special Korean Ceramics
deLIGHted Ceramic

International Ceramic Symposium
Renaissance in Asian Ceramics

Education
Do Ceramic

Workshop
International Ceramic Workshop
Asian Students Festival for Ceramic Arts

The 4th **World Ceramic Biennale 2007** Korea (CEBIKO)

Reshaping Asia

Organized by
World Ceramic Exposition Foundation

Venue
Icheon World Ceramic Center
Gwangju Joseon Royal Kiln Museum
Yeoju World Ceramic Livingware Gallery

Period
April 28 ~ June 24, 2007 (58days)

재단법인세계도자기엑스포
WORLD CERAMIC EXPOSITION FOUNDATION

Global Inspiration
GyeongGi-Do

SOFA 2006

Advertisements

TOD & EARL PARDON

December 1 · January 1, 2007

PATINA

GALLERY™

131 West Palace Avenue, Santa Fe, New Mexico 87504

505-986-3432 patina-gallery.com

CONTEMPORARY FINE CRAFT

CELEBRATING 7 SOUL-STIRRING YEARS

PATINA 2007 EXHIBITIONS

- Clay Foster
- Ivan Barnett
- John Iversen
- Lucia Antonelli
- Jewelry Invitational
- George Peterson
- Zobel

DOUGLAS DAWSON GALLERY

FRANK CONNET Textiles November 4 - December 22, 2006

Reception for the artist

November 10, 6 - 9:30PM

also on exhibit

UKHAMBA:

Masterworks of Zulu Potters

Douglas Dawson 400 North Morgan Street Chicago, Illinois 60622 douglasdawson.com info@douglasdawson.c

Let
Julie
Make
Your
Wedding
Into a
Work
of Art

Julie Howard, the premier Wedding Coordinator in Chicago, customizes sophisticated, elegant weddings to remember, exclusively at The Wedding Centre

Make an appointment and Julie will turn your wedding or special event into a masterpiece

- *Elegant Five Course Dinner*
- *Four Hour Premium Bar*
- *Champagne Toast & Wine Service*
- *Choice of Chair Covers in a Variety of Styles and Colors*
- *Accomodations for the Bride and Groom*
- *Superb Staff Who Attend to Your Every Need*

Receptions up to 500 guests offering a variety of American & International Cuisine

THE WEDDING CENTRE

300 East Ohio Street • Chicago, IL • 312.224.3808 • www.weddingcentre.chicc.com • jhoward@chicc.com

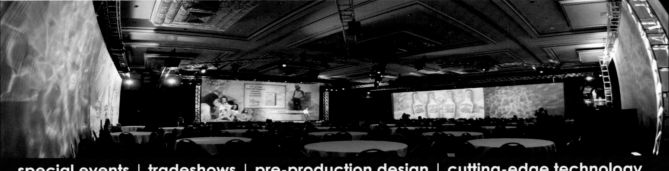

Northwestern Memorial Foundation

Chris Nissen, *Chicago Night*, oil on canvas,103 x 65"
Northwestern Memorial Hospital art collection, Galter Pavilion, third floor

Healing Through Art

Northwestern Memorial Hospital is in the building stages for a new women's hospital that will become the premier facility for women's health care in the nation. Art will be an important component in the development of a healing and welcoming environment for the facility. The Arts Program is made possible through the generosity of our friends and supporters. We welcome the opportunity to discuss ways that you can make a difference at the hospital through philanthropy. For more information, contact the Office of the Vice President of Northwestern Memorial Foundation at 312-926-7066.

The international art fair for contemporary objects
Presented by the Crafts Council

8 – 12 February 2007
At the V&A, London
www.craftscouncil.org.uk/collect

co[]ect®

Venue
Victoria and Albert Museum
South Kensington
London SW7 2RL, UK

Organisers
Crafts Council
44a Pentonville Road
London N1 9BY, UK

For visitor information
+44 (0)20 7806 2512
collect@craftscouncil.org.uk
www.craftscouncil.org.uk/collect

Registered Charity Number 280956
The Crafts Council is committed to equal opportunities

Alternatives Gallery, Italy
Australian Contemporary, Australia
Bishopsland Educational Trust, Reading
blås & knåda, Sweden
Clare Beck at Adrian Sassoon, London
*Four Decades of Glass Graduates from the
 Royal College of Art*; Dan Klein Associates
 at Adrian Sassoon, London
Collectief Amsterdam, The Netherlands
Contemporary Applied Art, London
Contemporary Art Gallery, The Netherlands
Contemporary Ceramics, London
Cultural Connections CC, Buckinghamshire
Design Nation, London
Drud & Køppe Gallery, Denmark
Flow, London
Galerie Carla Koch, The Netherlands
Galerie für Angewandte Kunst, Germany
Galerie Hélène Porée, France
Galerie Louise Smit, The Netherlands
Galerie Marianne Heller, Germany
Galerie Marzee, The Netherlands
Galerie Ra, The Netherlands

Galerie S O, Switzerland
Galleria Norsu, Finland
Galerie Rosemarie Jaeger, Germany
Galleri Format, Norway
Galleri Nørby, Denmark
Galleria Blanchaert, Italy
Gallery Terra Delft, The Netherlands
Glass Artists' Gallery, Australia
Hannah Peschar Sculpture Garden, Surrey
Joanna Bird Pottery, London
Katie Jones, London
Lesley Craze Gallery, London
Plateaux Gallery, London
Sarah Myerscough Fine Art, London
Six Danish Silversmiths, Denmark
The 62 Group of Textile Artists
The Bullseye Gallery, USA
The Devon Guild of Craftsmen, Devon
The Gallery, Ruthin Craft Centre, Wales
The Grace Barrand Design Centre, Surrey
The Scottish Gallery, Edinburgh
Scottish Tapestry in the 21st Century; The Scottish
 Gallery and Dovecot Studios, Edinburgh

hibitors

Aaron Faber Gallery
666 Fifth Avenue
New York, NY 10103
212.586.8411
fax 212.582.0205
info@aaronfaber.com
aaronfaber.com

Adamar Fine Arts
358 San Lorenzo Avenue
Suite 3210
Miami, FL 33146
305.576.1355
fax 305.448.5538
adamargal@aol.com
adamargallery.com

AKTUARYUS - Galerie Daniel Guidat
23 Rue de la Nuee Bleue
Strasbourg 67000
France
33.3.8822.4444
fax 33.6.0821.9308
albertfeix3@earthlink.net
galeriedanielguidat.com

Aldo Castillo Gallery
675 North Franklin Street
Chicago, IL 60610
312.337.2536
fax 312.337.3627
info@artaldo.com
artaldo.com

Ann Nathan Gallery
212 West Superior Street
Chicago, IL 60610
312.664.6622
fax 312.664.9392
nathangall@aol.com
annnathangallery.com

Australian Contemporary
19 Morphett Street
Adelaide, South Australia 5000
Australia
61.8.8410.0727
fax 61.8.8231.0434
stephen.bowers@jamfactory.com.au
jamfactory.com.au

Beaver Galleries
81 Denison Street, Deakin
Canberra, ACT 2600
Australia
61.2.6282.5294
fax 61.2.6281.1315
mail@beavergalleries.com.au
beavergalleries.com.au

Berengo Fine Arts
Fondamenta Vetrai 109/A
Murano, Venice 30141
Italy
39.041.739453
39.041.5276364
fax 39.041.527.6588
adberen@berengo.com
berengo.com

Berengo Collection
Calle Larga San Marco 412/413
Venice 30124
Italy
39.041.241.0763
fax 39.041.241.9456

Kortestraat 7
Arnhem 6811 EN
The Netherlands
31.26.370.2114
31.61.707.4402
fax 31.26.370.3362
berengo@hetnet.nl

Bluecoat Display Centre
Bluecoat Chambers
College Lane
Liverpool L1 3BZ
England
44.151.709.4014
fax 44.151.707.8106
crafts@bluecoatdisplaycentre.com
bluecoatdisplaycentre.com

browngrotta arts
Wilton, CT
203.834.0623
fax 203.762.5981
art@browngrotta.com
browngrotta.com

Brushings, LTD.
By Appointment Only
16165 Thompson Road
Thompson, OH 44086
440.488.0687
fax 440.298.3782
brushings@gmail.com
brushings.com

The Bullseye Gallery
300 NW Thirteenth Avenue
Portland, OR 97209
503.227.0222
fax 503.227.0008
gallery@bullseyeglass.com
bullseyeconnectiongallery.com

Caterina Tognon Arte Contemporanea
San Marco 2671
Campo San Maurizio
Venice 30124
Italy
39.041.520.7859
fax 39.041.520.7859
info@caterinatognon.com
caterinatognon.com

Chappell Gallery
526 West 26th Street
Suite 317
New York, NY 10001
212.414.2673
fax 212.414.2678
amchappell@aol.com
chappellgallery.com

Charon Kransen Arts
By Appointment Only
456 West 25th Street
New York, NY 10001
212.627.5073
fax 212.633.9026
charon@charonkransenarts.com
charonkransenarts.com

Collection-Ateliers d'Art de France
4 Rue de Thorigny
Paris 75003
France
33.1.4401.0830
fax 33.1.4401.0835
galerie@ateliersdart.com
ateliersdart.com

CREA, Galerie des Métiers d'Art du Québec
350 St. Paul Street East
Suite 400
Montreal, Quebec H2Y 1H2
Canada
514.861.2787, ext. 2
fax 514.861.9191
cmaq@metiers-d-art.qc.ca
metiers-d-art.qc.ca

Dai Ichi Arts, Ltd.
249 East 48th Street
New York, NY 10017
212.230.1680
fax 212.230.1618
daiichiarts@yahoo.com
daiichiarts.com

The David Collection
44 Black Spring Road
Pound Ridge, NY 10576
914.764.4674
fax 914.764.5274
jkdavid@optonline.net
thedavidcollection.com

del Mano Gallery
11981 San Vicente Boulevard
Los Angeles, CA 90049
310.476.8508
fax 310.471.0897
gallery@delmano.com
delmano.com

DF ARTS INTERNATIONAL
1-7-3 Hozumi
Toyonaka-shi
Osaka 561-0856
Japan
81.6.6866.1400
fax 81.6.6866.2104
art@watouki.com
watouki.com

Donna Schneier Fine Arts
By Appointment Only
910 Fifth Avenue
New York, NY 10021
212.472.9175
fax 212.472.6939
dnnaschneier@mhcable.com

Drud & Køppe Gallery
Bredgade 66
Copenhagen 1260
Denmark
45.3333.0087
info@drud-koppe.com
drud-koppe.com

Duane Reed Gallery
7513 Forsyth Boulevard
St. Louis, MO 63105
314.862.2333
fax 314.862.8557
info@duanereedgallery.com
duanereedgallery.com

Dubhe Carreño Gallery
1841 South Halsted Street
Chicago, IL 60608
312.666.3150
fax 312.577.0988
info@dubhecarrenogallery.com
dubhecarrenogallery.com

Eden Gallery
10 King David Street
Jerusalem 94101
Israel
972.2.624.4831
fax 972.2.624.4832
info@eden-gallery.com
eden-gallery.com

Elliott Brown Gallery
By Appointment Only
Mailing address: PO Box 1489
North Bend, WA 98045
206.660.0923
fax 425.831.3709
kate@elliottbrowngallery.com
elliottbrowngallery.com

Ferrin Gallery
69 Church Street
Lenox, MA 01240
413.637.4414
fax 413.637.4232
info@ferringallery.com
ferringallery.com

Frederic Got Fine Art
64 Rue Saint Louis en l'Ile
Paris 75004
France
33.14.326.1033
got3@wanadoo.fr
artchic.com

**Function + Art/PRISM
Contemporary Glass**
1046-1048 West Fulton Market
Chicago, IL 60607
312.243.2780
312.243.4885
info@functionart.com
info@prismcontemporary.com
functionart.com
prismcontemporary.com

Galerie Besson
15 Royal Arcade
28 Old Bond Street
London W1S 4SP
England
44.20.7491.1706
fax 44.20.7495.3203
enquiries@galeriebesson.co.uk
galeriebesson.co.uk

Galerie Elena Lee
1460 Sherbrooke West
Suite A
Montreal, Quebec H3G 1K4
Canada
514.844.6009
info@galerieelenalee.com
galerieelenalee.com

Galerie Meridian
Siroka 8
Prague 1, 110 00
Czech Republic
420.2.2481.9154
fax 420.2.24815759
galeriemeridian@volny.cz
galeriemeridian.cz

Galerie Pokorná
Janský Vrsek 15
Prague 1, 11800
Czech Republic
420.222.518635
fax 420.222.518635
office@galeriepokorna.cz
galeriepokorna.cz

Galerie Vee
Shop 225, 2/F
Prince's Building
Central, Hong Kong
852.2522.3166
fax 852.2522.1677
vanessa@galerievee.com
interiors@galerievee.com
galerievee.com

Galerie Vivendi
28 Place des Vosges
Paris 75003
France
33.1.4276.9076
fax 33.1.4276.9547
vivendi@vivendi-gallery.com
vivendi-gallery.com

Galleri Grønlund
Birketoften 16a
Copenhagen 3500
Denmark
45.44.442798
fax 45.44.442798
groenlund@get2net.dk
glassart.dk

Galleri Nørby
Vestergade 8
Copenhagen 1456
Denmark
45.33.151920
fax 45.33.151963
info@galleri-noerby.dk
galleri-noerby.dk

Galleri Udengaard
Vester Alle 9
Aarhus C, 8000
Denmark
45.8625.9594
udengaard@c.dk
galleriudengaard.com

Gallery 500 Consulting
3502 Scotts Lane
Philadelphia, PA 19129
215.849.9116
610.240.9626
fax 610.277.1733
gallery500@hotmail.com
gallery500.com

gallery gen
158 Franklin Street
New York, NY 10013
212.226.7717
fax 212.226.3722
info@gallerygen.com
gallerygen.com

The Gallery, Ruthin Craft Centre
Park Road
Ruthin, Denbighshire LL15 1BB
Wales
44.1824.704774
fax 44.1824.702060
thegallery@rccentre.org.uk

Glass Artists' Gallery
70 Glebe Point Road
Glebe, Sydney, NSW 2037
Australia
61.2.9552.1552
fax 61.2.9552.1552
mail@glassartistsgallery.com.au
glassartistsgallery.com.au

Guil-Guem Metal Arts Research Center
112-2 Samsung-dong
Gangnam-gu
Seoul 135-090
Korea
82.2.556.5376
fax 82.2.556.5395
ipsa78@hanmail.net
guilguemcraft.org

Habatat Galleries
608 Banyan Trail
Boca Raton, FL 33431
561.241.4544
fax 561.241.5793
info@habatatgalleries.com
habatatgalleries.com

Habatat Galleries
4400 Fernlee Avenue
Royal Oak, MI 48073
248.554.0590
fax 248.554.0594
info@habatat.com
habatatglass.com
habatat.com

222 West Superior Street
Chicago, IL 60610
312.440.0288
fax 312.440.0207
karen@habatatchicago.com
habatatchicago.com

Hawk Galleries
153 East Main Street
Columbus, OH 43215
614.225.9595
fax 614.225.9550
tom@hawkgalleries.com
hawkgalleries.com

Heller Gallery
420 West 14th Street
New York, NY 10014
212.414.4014
fax 212.414.2636
info@hellergallery.com
hellergallery.com

Hibberd McGrath Gallery
101 North Main Street
PO Box 7638
Breckenridge, CO 80424-7638
970.453.6391
fax 970.453.6391
terry@hibberdmcgrath.com
hibberdmcgrath.com

Holsten Galleries
3 Elm Street
Stockbridge, MA 01262
413.298.3044
fax 413.298.3275
artglass@holstengalleries.com
holstengalleries.com

Jane Sauer
Thirteen Moons Gallery
652 Canyon Road
Santa Fe, NM 87501
505.995.8513
fax 505.995.8507
jsauer@thirteenmoonsgallery.com
thirteenmoonsgallery.com

Jean Albano Gallery
215 West Superior Street
Chicago, IL 60610
312.440.0770
fax 312.440.3103
jeanalbano@aol.com
jeanalbanogallery.com

Joanna Bird Pottery
By Appointment
19 Grove Park Terrace
London W4 3QE
England
44.208.995.9960
fax 44.208.742.7752
joanna.bird@btinternet.com
joannabirdpottery.com

John Natsoulas Gallery
521 First Street
Davis, CA 95616
530.756.3938
fax 530.756.3961
art@natsoulas.com
natsoulas.com

Katie Gingrass Gallery
241 North Broadway
Milwaukee, WI 53202
414.289.0855
fax 414.289.2855
gingrassgallery@tds.net
gingrassgallery.com

KEIKO Gallery
121 Charles Street
Boston, MA 02114
617.725.2888
fax 617.725.2888
keiko.fukai@verizon.net
keikogallery.com

Kirra Galleries
Shop M11 (Mid Level)
Southgate Arts & Leisure Precinct
Southbank, Victoria 3006
Australia
61.3.9682.7923
fax 61.3.9682.7923
kirra@kirra.com
kirra.com

Federation Square
Cnr Swanston and Flinders Streets
Melbourne, Victoria 3000
Australia
61.3.9639.6388
fax 61.3.9639.8522

Lacoste Gallery
25 Main Street
Concord, MA 01742
978.369.0278
fax 978.369.3375
info@lacostegallery.com
lacostegallery.com

Leo Kaplan Modern
41 East 57th Street
7th floor
New York, NY 10022
212.872.1616
fax 212.872.1617
lkm@lkmodern.com
lkmodern.com

Living Arts Centre
4141 Living Arts Drive
Mississauga, Ontario L5B 4B8
Canada
519.596.2900
boncoeur68@amtelecom.net
livingartscentre.ca

Longstreth-Goldberg ART
5640 Taylor Road
Naples, FL 34109
239.514.2773
fax 239.514.3890
jlongstreth@plgart.com
plgart.com

María Elena Kravetz
San Jeronimo 448
Cordoba X5000AGJ
Argentina
54.351.422.1290
fax 54.351.422.4430
mek@mariaelenakravetzgallery.com
mariaelenakravetzgallery.com

Marx-Saunders Gallery, Ltd.
230 West Superior Street
Chicago, IL 60610
312.573.1400
fax 312.573.0575
marxsaunders@earthlink.net
marxsaunders.com

Mattson's Fine Art
2579 Cove Circle
Atlanta, GA 30319
404.636.0342
fax 404.636.0342
sundew@mindspring.com
mattsonsfineart.com

Maurine Littleton Gallery
1667 Wisconsin Avenue NW
Washington, DC 20007
202.333.9307
fax 202.342.2004
info@littletongallery.com
littletongallery.com

Mobilia Gallery
358 Huron Avenue
Cambridge, MA 02138
617.876.2109
fax 617.876.2110
mobiliaart@verizon.net
mobilia-gallery.com

Modus Art Gallery
23 Place des Vosges
Paris 75003
France
33.1.4278.1010
fax 33.1.4278.1400
modus@galerie-modus.com
galerie-modus.com

Mostly Glass Gallery
34 Hidden Ledge Road
Englewood, NJ 07631
201.816.1222
fax 201.503.9522
info@mostlyglass.com
mostlyglass.com

Mowen Solinsky Gallery
225 Broad Street
Nevada City, CA 95959
530.265.4682
fax 530.265.8469
info@mowensolinskygallery.com
mowensolinskygallery.com

**The National Craft
Gallery Ireland**
Castle Yard
Kilkenny
Ireland
353.5677.61804
fax 353.5677.63754
ncg@ccoi.ie
ccoi.ie

**Next Step Studio
& Gallery**
530 Hilton Road
Ferndale, MI 48220
248.414.7050
248.342.5074
fax 248.414.7038
nextstepstudio@aol.com
nextstepstudio.com

**Niemi Sculpture
Gallery & Garden**
13300 116th Street
Kenosha, WI 53142
262.857.3456
fax 262.857.4567
gallery@bruceniemi.com
bruceniemi.com

Option Art
4216 de Maisonneuve Blvd. West
Suite 302
Montreal, Quebec H3Z 1K4
Canada
514.932.3987
info@option-art.ca
option-art.ca

Orley & Shabahang
520 West 23rd Street
New York, NY 10011
646.383.7511
fax 646.383.7954
orleyshabahang@gmail.com
shabahangcarpets.com

240 South County Road
Palm Beach, FL 33480
561.655.3371
shabahangorley@adelphia.net

Shabahang Persian Carpets
223 East Silver Spring Drive
Whitefish Bay, WI 53217
414.332.2486
shabahangcarpets@gmail.com

By Appointment Only
5841 Wing Lake Road
Bloomfield Hills, MI 48301
586.996.5800
geoffreyorley@aol.com
shabahangcarpets.com

Ornamentum
506.5 Warren Street
Hudson, NY 12534
518.671.6770
fax 518.822.9819
info@ornamentumgallery.com
ornamentumgallery.com

**Palette Contemporary
Art & Craft**
7400 Montgomery Blvd. NE
Albuquerque, NM 87109
505.855.7777
fax 505.855.7778
palette@qwest.net
palettecontemporary.com

Perimeter Gallery
210 West Superior Street
Chicago, IL 60610
312.266.9473
fax 312.266.7984
perimeterchicago@
perimetergallery.com
perimetergallery.com

Persterer Art Gallery
Bahnhofstrasse 37
Zurich 8001
Switzerland
41.44.212.5292
fax 41.44.212.5294
art@persterer.com
perstererart.com

Pistachios
55 East Grand Avenue
Chicago, IL 60611
312.595.9437
fax 312.595.9439
pistachi@ameritech.net
pistachiosonline.com

Plateaux Gallery
1 Brewery Square
Tower Bridge Piazza
London SE1 2LF
England
44.20.7357.6880
fax 44.20.7357.8265
gallery@plateaux.co.uk
plateaux.co.uk

Portals Ltd.
742 North Wells Street
Chicago, IL 60610
312.642.1066
fax 312.642.2991
artisnow@aol.com
portalsgallery.com

Raglan Gallery
5-7 Raglan Street
Manly, Sydney, NSW 2095
Australia
61.2.9977.0906
fax 61.2.9977.0906
jan@raglangallery.com.au
raglangallery.com.au

Rena Bransten Gallery
77 Geary Street
San Francisco, CA 94108
415.982.3292
fax 415.982.1807
info@renabranstengallery.com
renabranstengallery.com

Sabbia
66 East Walton Street
2nd floor
Chicago, IL 60611
312.440.0044
fax 312.440.0007
sabbiafinejewelry@hotmail.com
sabbiafinejewelry.com

Santa Fe Clay
1615 Paseo de Peralta
Santa Fe, NM 87501
505.984.1122
fax 505.984.1706
sfc@santafeclay.com
santafeclay.com

Sherrie Gallerie
694 North High Street
Columbus, OH 43215
614.221.8580
fax 614.221.8550
sherriegallerie@sbcglobal.net
sherriegallerie.com

**Sherry Leedy
Contemporary Art**
2004 Baltimore Avenue
Kansas City, MO 64108
816.221.2626
fax 816.221.8689
sherryleedy@sherryleedy.com
sherryleedy.com

Sienna Gallery
80 Main Street
Lenox, MA 01240
413.637.8386
sienna@siennagallery.com
siennagallery.com

Snyderman-Works Galleries
303 Cherry Street
Philadelphia, PA 19106
215.238.9576
fax 215.238.9351
bruce@snyderman-works.com
snyderman-works.com

ten472 Contemporary Art
10472 Alta Street
Grass Valley, CA 95945
707.484.2685
info@ten472.com
ten472.com

Thomas R. Riley Galleries
28699 Chagrin Boulevard
Cleveland, OH 44122
216.765.1711
fax 216.765.1311
trr@rileygalleries.com
rileygalleries.com

UrbanGlass
647 Fulton Street
Brooklyn, NY 11217
718.625.3685
fax 718.625.3889
info@urbanglass.org
urbanglass.org

Wexler Gallery
201 North 3rd Street
Philadelphia, PA 19106
215.923.7030
fax 215.923.7031
info@wexlergallery.com
wexlergallery.com

**The William and
Joseph Gallery**
70 West Marcy Street
Santa Fe, NM 87501
505.982.9404
fax 505.982.2321
mary@thewilliamandjoseph
 gallery.com
thewilliamandjosephgallery.com

William Traver Gallery
110 Union Street
Suite 200
Seattle, WA 98101
206.587.6501
fax 206.587.6502
info@travergallery.com
www.travergallery.com

1821 East Dock Street, #100
Tacoma, WA 98402
253.383.3685
fax 253.383.3687

William Zimmer Gallery
10481 Lansing Street
Box 263
Mendocino, CA 95460
707.937.5121
fax 707.937.2405
wzg@mcn.org
williamzimmergallery.com

Yaw Gallery
550 North Old Woodward
Birmingham, MI 48009
248.647.5470
fax 248.647.3715
yawgallery@msn.com
yawgallery.com

Zane Bennett Galleries
826 Canyon Road
Santa Fe, NM 87501
505.982.8111
fax 505.982.8160
zanebennett@aol.com
zanebennettgallery.com

**ZeST Contemporary
Glass Gallery**
Roxby Place
London SW6 1RS
England
44.20.7610.1900
fax 44.20.7610.3355
info@zestgallery.com
zestgallery.com

SOFA 2006

Artists

Aaronson, Adam
ZeST Contemporary
 Glass Gallery

Abait, Luciana
Jean Albano Gallery

Åberg, Barbro
Galleri Nørby

Abbott-Leva
Thomas R. Riley Galleries

Adams, Hank Murta
Elliott Brown Gallery
Marx-Saunders Gallery, Ltd.

Adams, Renie Breskin
Mobilia Gallery

Adensamová, Blanka
Galerie Meridian

Adler, Deborah Faye
UrbanGlass

Agam, Jacob
Donna Schneier Fine Arts

Agee, Ann
Rena Bransten Gallery

Aguilar, Jorge
Option Art

Ahlgren, Jeanette
Mobilia Gallery

Ahlmann, Per
Galleri Nørby

Akers, Adela
browngrotta arts
Jane Sauer Thirteen
 Moons Gallery

Alan, Jeffrey
Palette Contemporary
 Art & Craft

Albert, Sean
William Traver Gallery

Aldrete-Morris, Catherine
Palette Contemporary
 Art & Craft

Alepedis, Efharis
Charon Kransen Arts

Allen, Rik
Thomas R. Riley Galleries

Allen, Ruth
Chappell Gallery

Allen, Shelley Muzylowski
Thomas R. Riley Galleries

Aloni, Mical
Hibberd McGrath Gallery

Amano, Shihoko
Sienna Gallery

Amendolara, Sue
Mobilia Gallery

Amrhein, Scott
Mowen Solinsky Gallery

Amromin, Pavel
Ann Nathan Gallery

Anagnostou, Alex
Living Arts Centre

Anderegg, Wesley
John Natsoulas Gallery

Anderson, Dan
Snyderman-Works Galleries

Anderson, Dona
browngrotta arts

Anderson, Jeanine
browngrotta arts

Anderson, Kate
Snyderman-Works Galleries

Anderson, Ken
Katie Gingrass Gallery

Anderson, Marianne
Aaron Faber Gallery

Andersson, Jonathan
Niemi Sculpture
 Gallery & Garden

Angelino, Gianfranco
del Mano Gallery

Applebaum, Leon
The William and Joseph Gallery

Arai, Junichi
gallery gen

Arata, Tomomi
Mobilia Gallery

Arawjo, Darryl
Katie Gingrass Gallery

Arawjo, Karen
Katie Gingrass Gallery

Ardiff, Alan
The National Craft
 Gallery Ireland

Arentzen, Glenda
Aaron Faber Gallery

Arleo, Adrian
Jane Sauer Thirteen
 Moons Gallery

Arman
Galerie Vivendi

Arneson, Robert
John Natsoulas Gallery

Arp, Marijke
browngrotta arts

Artman, Ron
Thomas R. Riley Galleries

Asawa, Ruth
Rena Bransten Gallery

Aslanis, George
Kirra Galleries

Assakr, Khalid
Mostly Glass Gallery

Atkins, Roger
Zane Bennett Galleries

Autio, Rudy
Duane Reed Gallery

Ayliffe, Nicole
Glass Artists' Gallery

Babcock, Herb
Habatat Galleries

Babetto, Giampaolo
Sienna Gallery

Babula, Mary Ann
Chappell Gallery

Bach, Carolyn Morris
William Zimmer Gallery

Bachorík, Vladimír
Galerie Pokorná

Baharal, Talya
Pistachios

Bailey, Clayton
John Natsoulas Gallery

Bak, Kirsten
Charon Kransen Arts

Bakker, Ralph
Charon Kransen Arts

Baldwin, Gordon
Galerie Besson

Baldwin, Philip
Thomas R. Riley Galleries
Wexler Gallery

Balgavy, Milos
Plateaux Gallery

Balles, Cali
Living Arts Centre

Balsgaard, Jane
browngrotta arts

Bamforth, Vic
ZeST Contemporary
 Glass Gallery

Barello, Julia
Zane Bennett Galleries

Barker, Jo
browngrotta arts

Barnaby, Margaret
Aaron Faber Gallery

Barnes, Dorothy Gill
browngrotta arts

Barrett, Seth
Katie Gingrass Gallery

Barry, Donna
Mobilia Gallery

Bartel, Tom
Sherrie Gallerie

Bartels, Rike
Charon Kransen Arts

Bartlett, Caroline
browngrotta arts

Bartley, Roseanne
Charon Kransen Arts

Basch, Sara
The David Collection

Bassler, James
Jane Sauer Thirteen
 Moons Gallery

Bastin, Nicholas
Charon Kransen Arts

Bauer, Carola
Charon Kransen Arts

Bauer, Cecilia
Aaron Faber Gallery

Bauer, Ela
Charon Kransen Arts

Baxter, Laura
Bluecoat Display Centre

Bealieux, Maria
Yaw Gallery

Bean, Bennett
Thomas R. Riley Galleries

Beasecker, Peter
Santa Fe Clay

Beck, Rick
Marx-Saunders Gallery, Ltd.

Becker, Michael
Charon Kransen Arts

Becker, Pamela
Snyderman-Works Galleries

Beckman, Jackie
Palette Contemporary
 Art & Craft

Bégou, Alain
AKTUARYUS - Galerie
 Daniel Guidat

Bégou, Marisa
AKTUARYUS - Galerie
 Daniel Guidat

Behar, Linda
Mobilia Gallery

Behennah, Dail
browngrotta arts

Behrens, Hanne
Mobilia Gallery

Belfrage, Clare
Beaver Galleries

Bell-Hughes, Beverley
The Gallery, Ruthin
 Craft Centre
Next Step Studio & Gallery
Sherry Leedy Contemporary Art

Benchek, Brian
Function + Art/PRISM
 Contemporary Glass

Benharrouche, Yoel
Eden Gallery

Bennett, David
Habatat Galleries

Bennett, Garry Knox
Leo Kaplan Modern

Bennett, Jamie
Sienna Gallery

Bennett, Roger
The National Craft
 Gallery Ireland

Benwell, Stephen
Australian Contemporary

Benzle, Curtis
Sherrie Gallerie

Benzoni, Luigi
Berengo Fine Arts

Bergner, Lanny
Snyderman-Works Galleries

Bergsvik, Silje
The David Collection

Berkower, Emrys
UrbanGlass

Berman, Harriete Estel
Mobilia Gallery

Bernardi, Luis
María Elena Kravetz

Bernstein, Alex Gabriel
Chappell Gallery

Bero, Mary
Ann Nathan Gallery
Hibberd McGrath Gallery
Mobilia Gallery

Bérubé, Louise Lemieux
CREA, Galerie des Métiers
 d'Art du Québec

Bess, Nancy Moore
browngrotta arts

Bettison, Giles
Jane Sauer Thirteen
 Moons Gallery
Wexler Gallery

Beugel, Jacob van der
Joanna Bird Pottery

Bigger, Michael
Niemi Sculpture
 Gallery & Garden

Bikakis, Myron
Yaw Gallery

Bilenker, Melanie
Sienna Gallery

Biles, Russell
Ferrin Gallery

Bird, Stephen
Australian Contemporary

Bishoff, Bonnie
Function + Art/PRISM
 Contemporary Glass

Bjerkan, Peggy
Thomas R. Riley Galleries

Bjorg, Toril
Charon Kransen Arts

Black, Lisa
Aaron Faber Gallery

Black, Sandra
Raglan Gallery

Blackmore, Cassandria
Duane Reed Gallery

Bladholm, Eric
Katie Gingrass Gallery

Blair, Annette
Kirra Galleries

Blank, Alexander
The David Collection

Blank, Martin
Habatat Galleries

Blavarp, Liv
Charon Kransen Arts

Blechner, Dganit
Eden Gallery

Bleem, Jerry
del Mano Gallery

Bloch, Ingrid Goldbloom
Mobilia Gallery

Bloch, Ruth
Frederic Got Fine Art

Bloomfield, Greg
Leo Kaplan Modern

Bobrowski, Gina
Santa Fe Clay

Bødker, Lene
Galleri Grønlund

Body Politics
Ornamentum

Boger, Chris
Longstreth-Goldberg ART

Bokesch-Parsons, Mark
Maurine Littleton Gallery

Bolt, Gary
Option Art

Bonaventura, Mauro
Mostly Glass Gallery

Book, Flora
Mobilia Gallery

Borgenicht, Ruth
Lacoste Gallery

Borghesi, Marco
Aaron Faber Gallery

Borgman, Mary
Ann Nathan Gallery

Borowski, Stanislaw
Habatat Galleries

Boscacci, Louise
Raglan Gallery

Boucard, Yves
Leo Kaplan Modern

Boucher, Babette
The David Collection

Bourquin, Rémi
Frederic Got Fine Art

Bova, Jodi
Jean Albano Gallery

Bowers, Bradley
The William and Joseph Gallery

Boyadjiev, Latchezar
Thomas R. Riley Galleries

Boyd, Michael
Mobilia Gallery

Boydell, Cormac
The National Craft
 Gallery Ireland

Brady, Robert
John Natsoulas Gallery

Braga, Celio
Charon Kransen Arts

Brandes, Juliane
Ornamentum

Brandman, Keith
William Zimmer Gallery

Bravo, Gonzalez
Frederic Got Fine Art

Bravura, Dusciana
Berengo Fine Arts

Breda, Bo
Snyderman-Works Galleries

Brekke, John
Thomas R. Riley Galleries

Bremers, Peter
Thomas R. Riley Galleries

Brennan, Sara
browngrotta arts

Bressler, Mark
del Mano Gallery
Zane Bennett Galleries

Brickell, Meredith
Dubhe Carreño Gallery

Brink, Joan
Katie Gingrass Gallery

Brock, Emily
Habatat Galleries

Broenen, Mari
Zane Bennett Galleries

Brolly, Michael
del Mano Gallery
Katie Gingrass Gallery

Brooks, Lola
Sienna Gallery

Brouillard, Bill
Lacoste Gallery

Brown, Denis
The National Craft
 Gallery Ireland

Brown, Melanie
The Gallery, Ruthin
 Craft Centre

Bruce, Jane
The Bullseye Gallery

Brychtová, Jaroslava
Mostly Glass Gallery

Brzon, Tomas
Chappell Gallery

Buckman, Jan
browngrotta arts

Budish, Jim
Niemi Sculpture
 Gallery & Garden

Buescher, Sebastian
Charon Kransen Arts

Bulbenko, Katia
Snyderman-Works Galleries

Bump, Raissa
Sienna Gallery

Bunkov, Sergey
Thomas R. Riley Galleries

Burchard, Christian
del Mano Gallery

Burgel, Klaus
Mobilia Gallery

Burger, Falk
Yaw Gallery

Bussières, Maude
CREA, Galerie des Métiers
 d'Art du Québec

Buus, Marianne
Galleri Grønlund

Byczewski, Jacek
Snyderman-Works Galleries

Caballero, Ernest
Mowen Solinsky Gallery

Cacicedo, Jean
Hibberd McGrath Gallery

Cahill, Lisa
Kirra Galleries

Caldwell, Dorothy
Option Art
Snyderman-Works Galleries

Calvo, Salvador
Aldo Castillo Gallery

Campbell, Louise
Drud & Køppe Gallery

Campbell, Pat
browngrotta arts

Cantin, Annie
Galerie Elena Lee

Carder, Ken
Thomas R. Riley Galleries

Cardew, Michael
Joanna Bird Pottery

Carlin, David
del Mano Gallery

Carlson, Robert
Habatat Galleries

Carlson, William
Leo Kaplan Modern
Marx-Saunders Gallery, Ltd.

Carlton-Smith, Stephanie
Plateaux Gallery

Carney, Shannon
Charon Kransen Arts

Carr, Graham
William Zimmer Gallery

Carr, Tanija
William Zimmer Gallery

Carvalho, Adriana
Aldo Castillo Gallery

Casanovas, Claudi
Galerie Besson

Casasempere, Fernando
Joanna Bird Pottery

Cash, Sydney
Chappell Gallery

Cassell, Halima
Bluecoat Display Centre

Castle, Wendell
Wexler Gallery

Cathie, Christie
Chappell Gallery

Celotto, Afro
Function + Art/PRISM
 Contemporary Glass

Cepka, Anton
Charon Kransen Arts

Čermák, Richard
Galerie Pokorná

Čermáková, Lenka
Galerie Pokorná

Chabrier, Gilles
AKTUARYUS - Galerie
 Daniel Guidat

Chagué, Thiébaut
Joanna Bird Pottery

Chandler, Gordon
Ann Nathan Gallery

Chardiet, José
Leo Kaplan Modern
Marx-Saunders Gallery, Ltd.
Wexler Gallery

Chase, M. Dale
del Mano Gallery

Chaseling, Scott
Leo Kaplan Modern

Chatt, David K.
Mobilia Gallery
Snyderman-Works Galleries

Chatterley, Mark
Gallery 500 Consulting
Longstreth-Goldberg ART
Niemi Sculpture
 Gallery & Garden

Chavent, Claude
Aaron Faber Gallery

Chavent, Françoise
Aaron Faber Gallery

Chen, Yu Chun
Charon Kransen Arts

Chesney, Nicole
Heller Gallery

Chihuly, Dale
Donna Schneier Fine Arts
Elliott Brown Gallery
Wexler Gallery

Christensen, Stopher
Living Arts Centre

Ciancibelli, Allison
Thomas R. Riley Galleries

Cígler, Václav
Caterina Tognon
 Arte Contemporanea
Galerie Pokorná

Cinnamon, Olga D.
Hibberd McGrath Gallery

Ciscato, Carina
Joanna Bird Pottery

Clague, Lisa
John Natsoulas Gallery

Clark, Sonya
Snyderman-Works Galleries

Class, Petra
Aaron Faber Gallery

Clausager, Kirsten
Mobilia Gallery

Clayman, Daniel
Habatat Galleries

Clayton, Deanna
Habatat Galleries

Clayton, Keith
Habatat Galleries

Clegg, Tessa
The Bullseye Gallery
Wexler Gallery

Cobb, Charles
Mowen Solinsky Gallery

Cohen, Barbara
Snyderman-Works Galleries

Cohen, Carol
Maurine Littleton Gallery

Coignard, James
Berengo Fine Arts

Coleman, Katharine
ZeST Contemporary
 Glass Gallery

Consentino, Cynthia
Dubhe Carreño Gallery

Cook, Lia
Mobilia Gallery
Perimeter Gallery

Cooper, Diane
Jean Albano Gallery

Cope, Mitsuru
CREA, Galerie des Métiers
 d'Art du Québec

Coper, Hans
Galerie Besson
Joanna Bird Pottery

Copping, Brad
Galerie Elena Lee

Cordova, Cristina
Ann Nathan Gallery

Corney, Michael
Santa Fe Clay

Corvaja, Giovanni
Charon Kransen Arts

Cottrell, Simon
Charon Kransen Arts

Couradin, Jean-Christophe
del Mano Gallery

Couarraze, Pierre Jean
Frederic Got Fine Art

Crane, Joyce
Snyderman-Works Galleries

Craste, Laurent
CREA, Galerie des Métiers
 d'Art du Québec

Crawford, David
William Zimmer Gallery

Crawford, Hilary
Chappell Gallery

Cribbs, KéKé
Leo Kaplan Modern
Marx-Saunders Gallery, Ltd.

Crone, Katherine
Snyderman-Works Galleries

Crow, Nancy
Snyderman-Works Galleries

Cruz-Diez, Carlos
Galerie Vivendi

Cucchi, Claudia
Charon Kransen Arts

Curneen, Claire
The Gallery, Ruthin
 Craft Centre

Curtis, Matthew
Thomas R. Riley Galleries

Cutler, Robert
del Mano Gallery

Cutrone, Daniel
Snyderman-Works Galleries

Da Silva, Jack
Mobilia Gallery

Da Silva, Marilyn
Mobilia Gallery

Dahm, Johanna
Ornamentum

Dailey, Dan
Leo Kaplan Modern
Wexler Gallery

Dalí, Salvador
Aldo Castillo Gallery

Dalton, Tali
Glass Artists' Gallery

Dam, Steffen
Galleri Grønlund

Danberg, Leah
del Mano Gallery

d'Aroma, Fabio
Mostly Glass Gallery

Davies, Lowri
The Gallery, Ruthin
 Craft Centre

Davis, Michael
Snyderman-Works Galleries

de Corte, Annemie
Charon Kransen Arts

de Goey, Marijke
Charon Kransen Arts

De Keyzer, Dirk
Galerie Vivendi

Deacon, Norah
Option Art

Dean, Tami
Mowen Solinsky Gallery

DeBusk, Barrett
The William and Joseph Gallery

DeMonte, Claudia
Jean Albano Gallery

Derry, Donald
Thomas R. Riley Galleries

Detering, Saskia
Charon Kransen Arts

Deval, Elisa
The David Collection

Devitt, Nell
Palette Contemporary
 Art & Craft

DeVore, Richard
Donna Schneier Fine Arts

Di Cono, Margot
Aaron Faber Gallery

Di Fiore, Miriam
Mostly Glass Gallery

Dill, Dieter
Pistachios

Dillingham, Rick
Donna Schneier Fine Arts

Dillon, Marcus
Kirra Galleries

Dixon, Stephen
Bluecoat Display Centre

Docter, Marcia
Snyderman-Works Galleries

Dodd, John
William Zimmer Gallery

Dolack, Linda
Mobilia Gallery

Dolderer, Corinna
Charon Kransen Arts

Dombrowski, Joachim
The David Collection

Donefer, Laura
Duane Reed Gallery

Donzelli, Maurizio
Caterina Tognon
 Arte Contemporanea

Doolan, Devta
Aaron Faber Gallery

Douglas, Mel
Beaver Galleries

Dresang, Paul
Ferrin Gallery

Drivsholm, Trine
Galleri Grønlund

Drury, Chris
browngrotta arts

Dubois, Valentine
The David Collection

Dulla, Joan
Mobilia Gallery

Dunn, J. Kelly
del Mano Gallery

Dunn, Kate
The William and Joseph Gallery

Duong, Sam Tho
Ornamentum

E

Earl, Jack
Perimeter Gallery

Eastman, Michael
Duane Reed Gallery
Sherry Leedy
 Contemporary Art

Eberle, Edward
Perimeter Gallery

Eckert, Carol
Jane Sauer Thirteen
 Moons Gallery

Edols, Ben
Raglan Gallery

Edwards, Tim
Beaver Galleries

Ehmck, Nina
The David Collection

Eichenberg, Iris
Ornamentum

Eickhoff, Jürgen
The David Collection

Eitzenhoefer, Ute
Ornamentum

Ekegren, Björn
Galleri Udengaard

Eliáš, Bohumil
Galerie Meridian

Elliot, Kathleen
Function + Art/PRISM
 Contemporary Glass

Elliott, Kathy
Raglan Gallery

Ellsworth, David
del Mano Gallery

Elyashiv, Noam
Sienna Gallery

Emery, Leslie
Katie Gingrass Gallery

Erickson, Robert
Mowen Solinsky Gallery

Erion, Travis Conrad
Persterer Art Gallery

Eskuche, Matt
Thomas R. Riley Galleries

Espersen, Morten Løbner
Galleri Nørby

Evans, Ann Catrin
The Gallery, Ruthin
 Craft Centre

F

Faba
María Elena Kravetz

Fanourakis, Lina
Sabbia

Farey, Lizzie
browngrotta arts

Farge, Catherine
Collection-Ateliers
 d'Art de France

Fehr, Sherrie
Gallery 500 Consulting

Feibleman, Dorothy
Mobilia Gallery

Fein, Harvey
del Mano Gallery

Fekete, Alex
Function + Art/PRISM
 Contemporary Glass

Feller, Lucy
Ferrin Gallery

Fennell, J. Paul
del Mano Gallery

Fenton, Nadine
CREA, Galerie des Métiers
 d'Art du Québec

**Fernández-Merino,
Magdalena**
Aldo Castillo Gallery

Ferrari, Gerard
Ann Nathan Gallery

Fifield, Jack
Katie Gingrass Gallery

Fifield, Linda
Katie Gingrass Gallery

Finneran, Bean
Perimeter Gallery

Fisch, Arline
Mobilia Gallery

Fischer, Katje
The David Collection

Fisher, Daniel
Joanna Bird Pottery

Flanary, Peter
Niemi Sculpture
 Gallery & Garden

Fleischhut, Jantje
The David Collection

Fleming, Ron
del Mano Gallery

Flockinger, CBE, Gerda
Mobilia Gallery

Flynn, Liam
The National Craft
 Gallery Ireland

Fok, Nora
Mobilia Gallery

Foks, Hilde
Charon Kransen Arts

Ford/Forlano
Charon Kransen Arts
Snyderman-Works Galleries

Frank, Peter
Charon Kransen Arts

Franzin, Maria Rosa
Ornamentum

Frejd, Martina
Charon Kransen Arts

Fretz, Jordan
Aaron Faber Gallery

Frève, Carole
CREA, Galerie des Métiers
 d'Art du Québec

Frey, Viola
Donna Schneier Fine Arts
Rena Bransten Gallery

Fritsch Elizabeth
Joanna Bird Pottery
Mobilia Gallery

Fritts, Debra
Gallery 500 Consulting

Frolic, Irene
Habatat Galleries

Frydrych, Jan
Galerie Pokorná
The William and Joseph Gallery

Fujita, Kyohei
Thomas R. Riley Galleries

Fukuchi, Kyoko
The David Collection

Fukumoto, Shigeki
KEIKO Gallery

Fullerton & Bahr
Pistachios

Furimsky, Erin
Dubhe Carreño Gallery

Galazka, Rafal
Mattson's Fine Art

Galbraith, Tom
Katie Gingrass Gallery

Gall, Theodore
Niemi Sculpture
 Gallery & Garden

Gallagher, Dennis
Rena Bransten Gallery

Gargano, John
Next Step Studio & Gallery

Garland, David
Galerie Besson

Garrett, John
Katie Gingrass Gallery
Mobilia Gallery

Gates, Lindsay Ketter
Jane Sauer Thirteen
 Moons Gallery

Gateson, Recko
Mostly Glass Gallery

Gavotti, Elizabeth
María Elena Kravetz

Gazier, Alain
Frederic Got Fine Art

Geertsen, Michael
Drud & Køppe Gallery

Gelbard, Anat
Aaron Faber Gallery

Geldersma, John
Jean Albano Gallery

Gentille, Thomas
Ornamentum

George, Mel
The Bullseye Gallery

Georgieva, Ceca
browngrotta arts

Gérard, Bruno
CREA, Galerie des Métiers
 d'Art du Québec

Gerbig-Fast, Lydia
Mobilia Gallery

Gerstein, David
Eden Gallery

Giacchina, Polly Jacobs
Katie Gingrass Gallery

Gilbert, Chantal
CREA, Galerie des Métiers
 d'Art du Québec

Gilbert, Karen
Sherrie Gallerie
Snyderman-Works Galleries

Giles, Mary
browngrotta arts
Duane Reed Gallery

Gill, John
Santa Fe Clay

Gill, Seamus
The National Craft
 Gallery Ireland

Glasgow, Susan Taylor
Heller Gallery

Glendinning, John
Option Art

Glover, Katherine
Snyderman-Works Galleries

Gnaedinger, Ursula
Charon Kransen Arts
The David Collection

Godbout, Rosie
Option Art

Goetschius, Stephan
Katie Gingrass Gallery

Goldsmith, Cornelia
Gallery 500 Consulting

Gonzalez, Arthur
John Natsoulas Gallery

González, Eladio
Aldo Castillo Gallery

González, Esperanza
Aldo Castillo Gallery

Good, Michael
The David Collection

Gori-Montanelli, Danielle
Snyderman-Works Galleries

Gottlieb, Dale
Gallery 500 Consulting

Gouldson, Rebecca
Bluecoat Display Centre

Grace, Holly
Glass Artists' Gallery

Graham, Virginia
The Gallery, Ruthin
 Craft Centre

Gralnick, Lisa
Ornamentum

Grebe, Robin
Wexler Gallery

Grecco, Krista
Ann Nathan Gallery

Green, Linda
browngrotta arts

Greenaway, Victor
Raglan Gallery

Grégoire, Anioclès
Option Art

Gross, Michael
Ann Nathan Gallery

Grossen, Françoise
browngrotta arts

Gudmann, Elisabett
ten472 Contemporary Art

Guetersloh, Herman
Katie Gingrass Gallery

Guggisberg, Monica
Thomas R. Riley Galleries
Wexler Gallery

Gurhan
Aaron Faber Gallery

Gustin, Chris
Sherrie Gallerie

Hagen, Rikke
Galleri Grønlund

Halabi, Sol
María Elena Kravetz

Hall, Laurie
Hibberd McGrath Gallery

Halt, Karen
Portals Ltd.

Hamada, Shoji
Dai Ichi Arts, Ltd.
Galerie Besson
Joanna Bird Pottery

Hamlyn, Jane
Galerie Besson

Hamm, Ulrike
The David Collection

Hamma, Michael
The David Collection

Hammerstrøm, Ditte
Drud & Køppe Gallery

Hanagarth, Sophie
Charon Kransen Arts

Hanning, Tony
Kirra Galleries

Hannon, Rebecca
Ornamentum

Hansen, Bente
Galleri Nørby

Hansen, Castello
Drud & Køppe Gallery

Hansen, Steve
Function + Art/PRISM
 Contemporary Glass

Harari, Yossi
Sabbia

Harding, Tim
Jane Sauer Thirteen
 Moons Gallery

Harper, William
Wexler Gallery

Harris, Mark
Thomas R. Riley Galleries

Harris, Matthew
Snyderman-Works Galleries

Hart, Noel
Kirra Galleries

Hatekayama, Norie
browngrotta arts

Haugh, Kimberly
Function + Art/PRISM
 Contemporary Glass

Hauss, Sabine
Ornamentum

Havea, Tevita
Glass Artists' Gallery

Hawley, Kandy
Mobilia Gallery

Hayashi, Yasuo
Dai Ichi Arts, Ltd.

Heathcote, Rex
Brushings, LTD.

Hedman, Hanna
Ornamentum

Heerkens, Ineke
Ornamentum

Hefetz, Sarit
Eden Gallery

Heine, Elisabeth
Ornamentum

Heinrich, Barbara
Aaron Faber Gallery
William Zimmer Gallery

Helbig, Mike
Niemi Sculpture
 Gallery & Garden

Helig, Marion
The David Collection

Henricksen, Ane
browngrotta arts

Henton, Maggie
browngrotta arts

Hernmarck, Helena
browngrotta arts

Hettmansperger, Mary
Katie Gingrass Gallery

Hickok, Cindy
Jane Sauer Thirteen
 Moons Gallery

Hicks, Giselle
Ferrin Gallery

Hicks, Sheila
browngrotta arts

Higashida, Shigemasa
Dai Ichi Arts, Ltd.

Hildebrandt, Marion
browngrotta arts
del Mano Gallery

Hill, Chris
Ann Nathan Gallery

Hill, Thomas
Bluecoat Display Centre

Hiller, Mirjam
Charon Kransen Arts

Hilton, Eric
Habatat Galleries

Hindsgavl, Louise
Drud & Køppe Gallery

Hinoda, Takashi
Dai Ichi Arts, Ltd.

Hiramatsu, Yasuki
Charon Kransen Arts

Hiroi, Nobuko
KEIKO Gallery

His, Agnés
Collection-Ateliers
 d'Art de France

Hlavicka, Tomas
The William and Joseph Gallery

Hloska, Pavol
Plateaux Gallery

Hobin, Agneta
browngrotta arts

Hoey, Richard
Zane Bennett Galleries

Hogan, Joe
The National Craft
 Gallery Ireland

Hoge, Susan
Yaw Gallery

Hogg, Bev
Australian Contemporary

Holder, Tina Fung
Mobilia Gallery

Holmes, Kathleen
Chappell Gallery

Hong, In-Suk
Guil-Guem Metal Arts
 Research Center

Hong, Jung-Sil
Guil-Guem Metal Arts
 Research Center

Hong, Kyung-A
Guil-Guem Metal Arts
 Research Center

Honma, Kazue
browngrotta arts

Hopkins, Jan
Jane Sauer Thirteen
 Moons Gallery
Mobilia Gallery
Snyderman-Works Galleries

Hora, Petr
Habatat Galleries

Horn, Robyn
del Mano Gallery

Hoshi, Mitsue
KEIKO Gallery

Hou, Rong
Niemi Sculpture
 Gallery & Garden

Houserova, Ivana
Mostly Glass Gallery

Howe, Brad
Adamar Fine Arts

Howell, Catrin
The Gallery, Ruthin
 Craft Centre

Hu, Mary Lee
Mobilia Gallery

Huchthausen, David
Habatat Galleries
Leo Kaplan Modern

Hughes, Linda
Charon Kransen Arts

Hughes, Pauline
Bluecoat Display Centre

Hunt, Kate
browngrotta arts

Hunter, Lissa
Jane Sauer Thirteen
 Moons Gallery

Hunter, William
del Mano Gallery

Hurlbert, Jacquline
Mowen Solinsky Gallery

Hutter, Sidney
Marx-Saunders Gallery, Ltd.

Hwang Bo, Ji-Young
Guil-Guem Metal Arts
 Research Center

Hwang-Levy, Maria
Zane Bennett Galleries

I

Ibe, Kyoko
Snyderman-Works Galleries

Iezumi, Toshio
Chappell Gallery

Iida, Michihisa
KEIKO Gallery

Ilie, Marie-Laure
Snyderman-Works Galleries

Ilkerl, Hildegund
Snyderman-Works Galleries

Imura, Toshimi
Dai Ichi Arts, Ltd.

Inbar, Tolla
Adamar Fine Arts

Ionescu, Ion
Yaw Gallery

Ionescu, Laila
Yaw Gallery

Ipsen, Steen
Drud & Køppe Gallery

Isaacs, Ron
Katie Gingrass Gallery

Ishida, Meiri
Charon Kransen Arts

Ishikawa, Mari
The David Collection

Ishiyama, Reiko
Charon Kransen Arts
Snyderman-Works Galleries

Isphording, Anja
Heller Gallery

Isupov, Sergei
Ferrin Gallery

Isverding, Melanie
The David Collection

Ito, Hirotoshi
KEIKO Gallery

Iversen, John
Yaw Gallery

Iwata, Hiroki
Charon Kransen Arts

Iwata, Kiyomi
Perimeter Gallery

Izawa, Yoko
The David Collection

J

Jacobi, Ritzi
browngrotta arts

Jacobs, Ferne
Snyderman-Works Galleries

Jacomb, Luke
Thomas R. Riley Galleries

Jalilova, Annette
Frederic Got Fine Art

Janacek, Vlastislav
Mostly Glass Gallery

Janich, Hilde
Charon Kransen Arts

Jenkins, Caitlin
The Gallery, Ruthin
 Craft Centre

Jensen, Mette
Charon Kransen Arts

Jivetin, Sergey
Ornamentum

Jocz, Daniel
Mobilia Gallery

Johanson, Rosita
Mobilia Gallery

Johansson, Karin
Charon Kransen Arts

Jolley, Richard
Leo Kaplan Modern

Jones, Christine
The Gallery, Ruthin
 Craft Centre

Jonsdottír, Kristín
browngrotta arts

Jordan, John
del Mano Gallery

Joy, Christine
browngrotta arts
Jane Sauer Thirteen
 Moons Gallery

Juenger, Ike
Charon Kransen Arts

Jung, Kim Sun
Yaw Gallery

Jungersen, Gitte
Galleri Nørby

Juparulla, Sam
Glass Artists' Gallery

K

Kadishman, Menashe
Eden Gallery

Kahana-Gueler, Dina
Mobilia Gallery

Kaiser, Virginia
Raglan Gallery

Kaldahl, Martin Bodilsen
Galleri Nørby

Kamata, Jiro
Ornamentum

Kamens, Kim
Snyderman-Works Galleries

Kaminski, Vered
Sienna Gallery

Kaneko, Jun
Sherry Leedy
 Contemporary Art

Kaneshige, Kosuke
Dai Ichi Arts, Ltd.

Kaolin, Missy
Mostly Glass Gallery

Kaolin, Sandy
Mostly Glass Gallery

Karlslund, Micha
Galleri Grønlund

Karpowicz, Terry
Niemi Sculpture
 Gallery & Garden

Kato, Karin
Charon Kransen Arts

Kato, Tsubusa
Dai Ichi Arts, Ltd.

Kaufman, Glen
browngrotta arts

Kaufmann, Martin
Charon Kransen Arts

Kaufmann, Ruth
browngrotta arts

Kaufmann, Ulla
Charon Kransen Arts

Kavanagh, Cornelia Kubler
Zane Bennett Galleries

kavicky, Susan
Katie Gingrass Gallery

Kawata, Tamiko
browngrotta arts

Keefe, Hannah
Mobilia Gallery

Keelan, Margaret
Lacoste Gallery

Keeler, Walter
The Gallery, Ruthin
 Craft Centre

Kelman, Janet
Function + Art/PRISM
 Contemporary Glass

Kennard, Steven
del Mano Gallery

Kent, Ron
del Mano Gallery

Kerman, Janis
Aaron Faber Gallery
Option Art

Kettle, Alice
Bluecoat Display Centre

Khan, Kay
Jane Sauer Thirteen
 Moons Gallery

Kim, Hong-Yong
Guil-Guem Metal Arts
Research Center

Kim, Jeong Yoon
Charon Kransen Arts

Kim, Moon-Jung
Guil-Guem Metal Arts
Research Center

Kim, Sun-Jung
Guil-Guem Metal Arts
Research Center

Kim, You Ra
Ornamentum

Kinart, Odile
Frederic Got Fine Art

King, Kathy
Santa Fe Clay

Kinghorn, Judith
Charon Kransen Arts

Kinnaird, MBE, Alison
ZeST Contemporary
Glass Gallery

Kirk, Richard
The National Craft
Gallery Ireland

Klancic, Anda
browngrotta arts

Klein, Steve
The Bullseye Gallery

Klemp, Stefanie
Charon Kransen Arts

Klimley, Nancy
Thomas R. Riley Galleries

Klingebiel, Jutta
Ornamentum

Kliss, Bob
Mowen Solinsky Gallery

Kliss, Laurie
Mowen Solinsky Gallery

Klumpar, Vladimira
Heller Gallery

Knauss, Lewis
browngrotta arts

Knecht, Housi
Persterer Art Gallery

Knobel, Esther
Sienna Gallery

Knowles, Sabrina
Duane Reed Gallery

Kobayashi, Masakazu
browngrotta arts

Kobayashi, Naomi
browngrotta arts

Koenigsberg, Nancy
browngrotta arts
Snyderman-Works Galleries

Kohl-Spiro, Barbara
Portals Ltd.

Kohr, Erika
Palette Contemporary
Art & Craft

Kohyama, Yasuhisa
browngrotta arts

Kojima, Yukako
Palette Contemporary
Art & Craft

Kolesnikova, Irina
browngrotta arts

Korobow-Main, Karen
Palette Contemporary
Art & Craft

Korowitz-Coutu, Laurie
Chappell Gallery

Kosonen, Markku
browngrotta arts

Krakowski, Yael
Charon Kransen Arts

Kratz, Mayme
Elliott Brown Gallery

Kraus, Chuck
Niemi Sculpture
Gallery & Garden

Krupenia, Deborah
Charon Kransen Arts

Kuhn, Jon
Marx-Saunders Gallery, Ltd.

Kulka, Lilla
browngrotta arts

Kumai, Kyoko
browngrotta arts

Kuraoka, David
Mowen Solinsky Gallery

Kurokawa, Okinari
Mobilia Gallery

Kusumoto, Mariko
Mobilia Gallery

Kwang-Jin, Park
Galerie Vivendi

Kyriacou, Constantinos
The David Collection

L

La Scola, Judith
Maurine Littleton Gallery

Labelle, Ronald
Option Art

Labianca, Lawrence
browngrotta arts

Labino, Dominick
Wexler Gallery

Lacata, David
Snyderman-Works Galleries

LaCroix, Pasqual
Mowen Solinsky Gallery

Lahaie, Thérèse
Heller Gallery

Lahover, Shay
Yaw Gallery

Lake, Pipaluk
Chappell Gallery

Lake, Tai
William Zimmer Gallery

Laky, Gyöngy
browngrotta arts

Lam Laam, Jaffa
Galerie Vee

Lamar, Stoney
del Mano Gallery

Lamarche, Antoine
CREA, Galerie des Métiers
d'Art du Québec

Landweer, Sonja
The National Craft
Gallery Ireland

Langley, Warren
Raglan Gallery

Lapka, Eva
CREA, Galerie des Métiers
d'Art du Québec

Larner, Marian
Brushings, LTD.

Larssen, Ingrid
The David Collection

Latven, Bud
del Mano Gallery

Lawrence, Wendy
The Gallery, Ruthin
Craft Centre

Lawton, Jim
Lacoste Gallery

Lawty, Sue
browngrotta arts

Layport, Ron
del Mano Gallery

Layton, Peter
Thomas R. Riley Galleries

Lazareff, Alexandra
Galerie Vivendi

Leach, Bernard
Joanna Bird Pottery

Leach, David
Joanna Bird Pottery

Lebescond, Jacques
Frederic Got Fine Art

Lee, Dongchun
Charon Kransen Arts

Lee, Ed Bing
Snyderman-Works Galleries

Lee, Jennifer
Galerie Besson

Leestemaker, Luc
Persterer Art Gallery

Lehtinen, Helena
Ornamentum

Leiss, Hilde
Charon Kransen Arts

Lepisto, Jeremy
Thomas R. Riley Galleries

LeQuier, Bill
Habatat Galleries

Lerssi, Mia
Drud & Koppe Gallery

Lesso, Oliver
Plateaux Gallery

Levenson, Silvia
The Bullseye Gallery
Caterina Tognon Arte
 Contemporanea

Levinstein, Dorit
Eden Gallery

Leviton, Linda
Katie Gingrass Gallery

Lewis, John
Leo Kaplan Modern

Lieglein, Wolli
Ornamentum

Liestman, Art
del Mano Gallery

Lillie, Jacqueline
Sienna Gallery

Lindqvist, Inge
browngrotta arts

Linssen, Jennifer Falck
del Mano Gallery
Mobilia Gallery

Linssen, Nel
Charon Kransen Arts

Lipofsky, Marvin
Duane Reed Gallery
Wexler Gallery

Littleton, Harvey K.
Donna Schneier Fine Arts
Maurine Littleton Gallery
Wexler Gallery

Littleton, John
Maurine Littleton Gallery

Liu, Hong
Rena Bransten Gallery

Ljones, Åse
browngrotta arts

Lo, Beth
Santa Fe Clay

Loeser, Thomas
Leo Kaplan Modern

Loew, Susanna
Charon Kransen Arts

Look, Dona
Perimeter Gallery

López Cruz, Luis
Aldo Castillo Gallery

Lorenson, Rob
Niemi Sculpture
 Gallery & Garden

Lotz, Tyler
Dubhe Carreño Gallery

Loughlin, Jessica
The Bullseye Gallery

Løvaas, Astrid
browngrotta arts

Lucas, Glenn
The National Craft
 Gallery Ireland

Lucero, Michael
Donna Schneier Fine Arts

Luna, Emma
Mostly Glass Gallery

Lundberg, Tom
Hibberd McGrath Gallery

Lupien, Sylvie
Option Art

Lynch, Sydney
William Zimmer Gallery

Lyon, Lucy
Thomas R. Riley Galleries

Lyons, Tanya
Galerie Elena Lee

Maberley, Simon
Kirra Galleries

Macdonell, Jay
William Traver Gallery

Macnab, John
del Mano Gallery

MacNeil, Linda
Leo Kaplan Modern

MacNutt, Dawn
browngrotta arts

Madsen, Lone Skov
Galleri Nørby

Maeda, Asagi
Mobilia Gallery

Maestre, Jennifer
Mobilia Gallery

Mailland, Alain
del Mano Gallery

Major, Dana
Ferrin Gallery

Majoral, Enric
Aaron Faber Gallery

Majumdar, Sangram
Ann Nathan Gallery

Malek, Gabrielle
Snyderman-Works Galleries

Malinowski, Ruth
browngrotta arts

Malone, Cheryl
Portals Ltd.

Maloof, Sam
Donna Schneier Fine Arts

Maltby, John
Joanna Bird Pottery

Maltz, Friederike
Charon Kransen Arts

Malysz, Piotr
Charon Kransen Arts

Maman, Niso
Adamar Fine Arts

Manz, Bodil
Galleri Nørby

Manz, Cecilie
Drud & Køppe Gallery

Marchetti, Stefano
Charon Kransen Arts

Marder, Donna Rhae
Mobilia Gallery

Marek, Josef
Galerie Meridian

Marioni, Dante
The Bullseye Gallery
Marx-Saunders Gallery, Ltd.

Marks-Swanson, Brooke
Aaron Faber Gallery

Maro, Antonio
Persterer Art Gallery

Marques, Ruth
The David Collection

Marquis, Richard
The Bullseye Gallery
Elliott Brown Gallery
Wexler Gallery

Marsh, Lorna
Aldo Castillo Gallery

Martenon, Thierry
del Mano Gallery

Martin, Catherine
Mobilia Gallery

Martin, Christopher J.
Function + Art/PRISM
 Contemporary Glass

Martin, Jim
Mowen Solinsky Gallery

Maruyama, Tomomi
Mobilia Gallery

Mason, John
Perimeter Gallery

Massaro, Karen Thuesen
Perimeter Gallery

Massei, Lucia
Charon Kransen Arts

Mata, Carlos
Frederic Got Fine Art

Mathes, Jesse
Mobilia Gallery

Matouš, Jaroslav
Galerie Meridian

Matsuda, Yuriko
Dai Ichi Arts, Ltd.

Mattar, Tasso
The David Collection

Mattes, Jesse
The David Collection

Matthias, Christine
Charon Kransen Arts

Mayadas, Ayesha
Gallery 500 Consulting

Mayeri, Beverly
Perimeter Gallery

Mays, Laura
The National Craft
 Gallery Ireland

Mazzoni, Ana
María Elena Kravetz

McCarthy, Michael
Ferrin Gallery

McCorrison, Ruth
Snyderman-Works Galleries

McDevitt, Elizabeth
Charon Kransen Arts

McDonald, Pat
Niemi Sculpture
 Gallery & Garden

McFarlane, Kristin
Kirra Galleries

McQueen, John
Mobilia Gallery
Perimeter Gallery

Medwedeff, John
Function + Art/PRISM
 Contemporary Glass

Melchione, Becki
UrbanGlass

Mendive, Manuel
Aldo Castillo Gallery

Merkel-Hess, Mary
browngrotta arts

Messmer, Marcus
Persterer Art Gallery

Meszaros, Mari
Duane Reed Gallery

Metcalf, Bruce
Charon Kransen Arts

Metcalf, Sally
Katie Gingrass Gallery

Metzler, Kurt Laurenz
Persterer Art Gallery

Meyer, Gudrun
Pistachios

Meyer, Sharon
Sherrie Gallerie

Michel, Nancy
Mobilia Gallery

Micheluzzi, Massimo
Wexler Gallery

Miles, Cathy
Bluecoat Display Centre

Mincham, Jeff
Raglan Gallery

Minnhaar, Gretchen
Adamar Fine Arts

Misoda, Melissa
Chappell Gallery

Mississippi, Connie
Zane Bennett Galleries

Mitchell, Dennis Lee
Dubhe Carreño Gallery

Mitsushima, Kazuko
gallery gen

Mizuno, Keisuke
Ferrin Gallery

Møhl, Tobias
Galleri Grønlund

Moje, Klaus
The Bullseye Gallery

Møller, Anne Fabricius
Drud & Køppe Gallery

Mondro, Anne
Mobilia Gallery

Mongrain, Jeffrey
Perimeter Gallery

Montini, Milissa
Snyderman-Works Galleries

Monzo, Marc
Ornamentum

Moon, Ellen
Mobilia Gallery

Moore, Amy Clarke
Hibberd McGrath Gallery

Moore, Debora
Habatat Galleries

Mori, Junko
Bluecoat Display Centre

Morin, Hilde
María Elena Kravetz

Morinoue, Hiroki
William Zimmer Gallery

Morris, William
Donna Schneier Fine Arts
Thomas R. Riley Galleries
Wexler Gallery

Morrison, Merrill
Mobilia Gallery

Moseholm, Keld
Galleri Udengaard

Mossman, Ralph
Thomas R. Riley Galleries

Moult, Kate
Bluecoat Display Centre

Moulthrop, Matt
del Mano Gallery

Moulthrop, Philip
del Mano Gallery

Mount, Nick
Thomas R. Riley Galleries

Mowen, John
Mowen Solinsky Gallery

Muerrle, Norbert
Pistachios

Muhl, Debora
del Mano Gallery
Snyderman-Works Galleries

Mulford, Judy
browngrotta arts
del Mano Gallery
Mobilia Gallery

Munakata, Machiko
Dubhe Carreño Gallery

Munsteiner, Bernd
Aaron Faber Gallery

Munsteiner, Tom
Aaron Faber Gallery

Murray, Paula
CREA, Galerie des Métiers
 d'Art du Québec
William Zimmer Gallery

Musler, Jay
Marx-Saunders Gallery, Ltd.

Mustonen, Eija
Ornamentum

Myers, Joel Philip
Wexler Gallery

Myers, Rebecca
Next Step Studio & Gallery

N

Nagano, Kazumi
Mobilia Gallery

Nagle, Ron
Rena Bransten Gallery

Nahabetian, Dennis
del Mano Gallery

Nakamura, Naoka
Charon Kransen Arts

Nakanishi, Dawn
Aaron Faber Gallery

Nakashima, Harumi
Dai Ichi Arts, Ltd.

Nancey, Christophe
Collection-Ateliers
d'Art de France

Nasisse, Andy
Santa Fe Clay

Naylor, Karen
Niemi Sculpture
Gallery & Garden

Neal, Gareth
Plateaux Gallery

Neubauer, Ben
Pistachios

Neuman, Jeremy
Thomas R. Riley Galleries

Newell, Catharine
The Bullseye Gallery

Newsome, Farraday
Katie Gingrass Gallery

Nicholson, Laura Foster
Katie Gingrass Gallery

Nicholson, Rick
Mowen Solinsky Gallery

Niemi, Bruce A.
Niemi Sculpture
Gallery & Garden

Niessing
Pistachios

Nijland, Evert
Charon Kransen Arts

Nio, Keiji
browngrotta arts

Nishimura, Yuko
KEIKO Gallery

Nishizaki, Satoshi
DF ARTS INTERNATIONAL

Nittmann, David
del Mano Gallery

Nobles, Beth
Hibberd McGrath Gallery

Nolan, Lesley
Palette Contemporary
Art & Craft

Noten, Ted
Ornamentum

Notkin, Richard T.
Ferrin Gallery
John Natsoulas Gallery

Nowak, Craig Paul
Next Step Studio & Gallery

Nuis, Carla
Charon Kransen Arts

Nuñez, Cristina
María Elena Kravetz

O'Connell, Sean
Charon Kransen Arts

O'Connor, Harold
Aaron Faber Gallery
Mobilia Gallery

O'Dwyer, Kevin
The National Craft
Gallery Ireland

Ohira, Yoichi
Wexler Gallery

O'Kelly, Angela
The National Craft
Gallery Ireland

Okim, Komelia Hongja
Guil-Guem Metal Arts
Research Center

Okubo, Kyoko
Mobilia Gallery

Oldland, Mark
Mowen Solinsky Gallery

Olsen, Fritz
Niemi Sculpture
Gallery & Garden

Onofrio, Judy
Sherry Leedy
Contemporary Art

Orchard, Jenny
Australian Contemporary

Ossipov, Nikolai
del Mano Gallery

Osterrieder, Daniela
Charon Kransen Arts

Ouellette, Caroline
Galerie Elena Lee

Owen, Doug
Sherry Leedy
Contemporary Art

Ozawa, Emi
Palette Contemporary
Art & Craft

Paganin, Barbara
Charon Kransen Arts

Pala, Štěpán
Galerie Pokorná

Paley, Albert
Hawk Galleries
Wexler Gallery

Palová, Zora
Galerie Pokorná

Pardon, Earl
Aaron Faber Gallery

Pardon, Tod
Aaron Faber Gallery

Park, Soo-Ryeon
Guil-Guem Metal Arts
Research Center

Patti, Tom
Wexler Gallery

Pawlak, Jolanta
María Elena Kravetz

Payette, Gilles
Mowen Solinsky Gallery

Peich, Francesc
CREA, Galerie des Métiers
d'Art du Québec

Peper, Wiebke
Aaron Faber Gallery

Perez, Jesus Curia
Ann Nathan Gallery

Perez Guaita, Gabriela
María Elena Kravetz

Perez-Flores, Dario
Galerie Vivendi

Perkins, Danny
Duane Reed Gallery

Perkins, Kevin
Brushings, LTD.

Perkins, Sarah
Mobilia Gallery

Perrotte, Simone
Collection-Ateliers
d'Art de France

Perry, Sam
Rena Bransten Gallery

Persson, Stig
Drud & Køppe Gallery

Pesce, Antastacia
Mobilia Gallery

Peters, Ruudt
Ornamentum

Peterson, George
del Mano Gallery

Peterson, Michael
del Mano Gallery

Petter, Gugger
Mobilia Gallery

Pezzi, Daniel
María Elena Kravetz

Phardel, Tom
Next Step Studio & Gallery

Pharis, Mark
Lacoste Gallery

Pheulpin, Simone
browngrotta arts

Phillips, Maria
The David Collection

Pho, Binh
del Mano Gallery

Pielcke, Gitta
The David Collection

Pilon, Carole
Galerie Elena Lee

Pimental, Alexandra
The David Collection

Pinchuk, Anya
Charon Kransen Arts

Pinchuk, Natalya
Charon Kransen Arts

Pino, Claudio
Option Art

Pohlman, Jenny
Duane Reed Gallery

Poissant, Gilbert
Option Art

Pollitt, Harry
del Mano Gallery
Zane Bennett Galleries

Pompili, Lucian
John Natsoulas Gallery

Pontz, Leslie
Snyderman-Works Galleries

Ponzio, Rick
Niemi Sculpture
 Gallery & Garden

Popelka, Jeremy
Thomas R. Riley Galleries

Portnoy, Sallie
Raglan Gallery

Powell, Stephen
Marx-Saunders Gallery, Ltd.

Powers, Jill
del Mano Gallery

Pragnell, Valerie
browngrotta arts

Preston, Mary
Ornamentum
Yaw Gallery

Price, Beverley
Charon Kransen Arts

Priddle, Graeme
del Mano Gallery

Priest, Linda Kindler
Aaron Faber Gallery

Primeau, Patrick
CREA, Galerie des Métiers
 d'Art du Québec

Prip, Janet
Mobilia Gallery

Prowse-Fainmel, Carolyn
Living Arts Centre

Que, Sharon
Next Step Studio & Gallery

Quigley, Robin
Mobilia Gallery

Raible, Kent
Mowen Solinsky Gallery

Rambadt, Don
Niemi Sculpture
 Gallery & Garden

Ramirez, Rafael
Persterer Art Gallery

Ramshaw, CBE RDI, Wendy
Mobilia Gallery

Randal, Seth
Leo Kaplan Modern
Thomas R. Riley Galleries

Rankin, Susan
Option Art

Rannik, Kaire
Charon Kransen Arts

Ranucci
Frederic Got Fine Art

Rath, Tina
Sienna Gallery

Rauschke, Tom
Katie Gingrass Gallery

Rawdin, Kim
Aaron Faber Gallery

Rea, Kirstie
The Bullseye Gallery

Redman, Jayne
Yaw Gallery

Reed Fran
Mobilia Gallery

Reed, Inga
The National Craft
 Gallery Ireland

Reekie, David
Thomas R. Riley Galleries

Reid, Colin
Maurine Littleton Gallery

Reiner, Alyssa
Aaron Faber Gallery

Reitz, Don
Maurine Littleton Gallery

Rench, Scott
Dubhe Carreño Gallery

Reymann, Julia
The David Collection

Rezac, Suzan
Mobilia Gallery

Rhoads, Kait
Chappell Gallery

Ricci, Jo
Snyderman-Works Galleries

Richardson, Henry
Adamar Fine Arts

Richardson, Sarah
Mobilia Gallery

Richmond, Ross
Duane Reed Gallery

Richmond, Vaughn
del Mano Gallery

Ricks, Madelyn
Mostly Glass Gallery

Ricourt, Marc
Collection-Ateliers
 d'Art de France

Rie, Lucie
Galerie Besson
Joanna Bird Pottery

Ries, Christopher
Hawk Galleries

Riis, Jon
Jane Sauer Thirteen
 Moons Gallery

Rinneberg, Claudia
The David Collection

Ripollés, Juan
Berengo Fine Arts

Ritter, Richard
Marx-Saunders Gallery, Ltd.

Roberson, Sang
Hibberd McGrath Gallery

Roberts, Constance
Portals Ltd.

Robinson, Ann
Elliott Brown Gallery

Robinson, John Paul
CREA, Galerie des Métiers
 d'Art du Québec

Robinson, Marion
Gallery 500 Consulting

Rodgers, Emma
William Zimmer Gallery

Roehm, Mary
Santa Fe Clay

Roeper, Florian
Mowen Solinsky Gallery

Rogers, Sally
Thomas R. Riley Galleries

Rohde, Michael
Katie Gingrass Gallery

Romberg, Jim
Hibberd McGrath Gallery

Rose, Jim
Ann Nathan Gallery

Rose, Marlene
Adamar Fine Arts

Rosen, Annabeth
Lacoste Gallery
Santa Fe Clay

Rosenthal, Donna
Jean Albano Gallery

Rosin, Maria Grazia
Caterina Tognon
Arte Contemporanea

Rosol, Martin
Function + Art/PRISM
Contemporary Glass

Rossano, Joseph
Thomas R. Riley Galleries

Rossbach, Ed
browngrotta arts

Rossi, Marzia
Sienna Gallery

Rothmann, Gerd
Ornamentum

Rothstein, Scott
browngrotta arts
Mobilia Gallery

Roubicek, Rene
The William and Joseph Gallery

Rousseau-Vermette, Mariette
browngrotta arts

Roussel, Lucy
Living Arts Centre

Roux, Isabelle
Collection-Ateliers
d'Art de France

Rowan, Tim
Lacoste Gallery

Rowe, Layne
ZeST Contemporary
Glass Gallery

Royal, Richard
Thomas R. Riley Gallery

Royer, Henry
Snyderman-Works Galleries

Rubinstein, Eric
Mostly Glass Gallery
The William and Joseph Gallery

Ruby, Katrina
Next Step Studio & Gallery

Rudavsky, Zuzana
Mobilia Gallery

Ruffner, Ginny
Maurine Littleton Gallery

Ruhwald, Anders
Drud & Køppe Gallery

Rushmore, Gail
Mowen Solinsky Gallery

Russell-Pool, Kari
Thomas R. Riley Galleries

Russo, Howard
Niemi Sculpture
Gallery & Garden

Russo, JoAnne
Snyderman-Works Galleries

Ryan, Jackie
Charon Kransen Arts

Rybák, Jaromir
Galerie Meridian

Rydmark, Cheryl
William Zimmer Gallery

Saabye, Mette
Drud & Køppe Gallery

Sachs, Debra
browngrotta arts

Safire, Helene
UrbanGlass

Sahagian, Beth
Niemi Sculpture
Gallery & Garden

Saito, Kayo
The David Collection

Saito, Yuka
Mobilia Gallery

Sakamoto, Madoka
KEIKO Gallery

Sakamoto, Rie
KEIKO Gallery

Sales, Michelle
Snyderman-Works Galleries

Salms, Amanda
Snyderman-Works Galleries

Salvadore, Davide
William Traver Gallery

Samplonius, David
Option Art

San Jose, Teo
María Elena Kravetz Gallery

Sano, Youko
Chappell Gallery

Santillana, Laura de
Elliott Brown Gallery

Sarneel, Lucy
Charon Kransen Arts

Saupe, Ted
Santa Fe Clay

Sawyer, Ted
The Bullseye Gallery

Saylan, Merryll
del Mano Gallery

Schaechter, Judith
Snyderman-Works Galleries

Schick, Marjorie
Mobilia Gallery

Schimmel, Heidrun
browngrotta arts

Schlatter, Sylvia
Charon Kransen Arts

Schliwinski, Marianne
The David Collection

Schlossberg, Lauren
Yaw Gallery

Schmid, Annegret
Mobilia Gallery

Schmidlin, Stephan
Persterer Art Gallery

Schmidt, Jack
Habatat Galleries

Schmidt, Thomas
Dubhe Carreño Gallery

Schmitz, Claude
Charon Kransen Arts

Schmuck, Johnathon
Snyderman-Works Galleries

Schreiber, Siegfried
del Mano Gallery

Schroeder, Scott
Function + Art/PRISM
Contemporary Glass

Schuerenkaemper, Frederike
Charon Kransen Arts

Schultz, Bryan
Niemi Sculpture
Gallery & Garden

Schulze, Elizabeth Whyte
del Mano Gallery
Mobilia Gallery

Schutz, Biba
Charon Kransen Arts
Snyderman-Works Galleries

Schwarcz, June
Mobilia Gallery

Schwarz, David
Marx-Saunders Gallery, Ltd.

Scobie, Neil
del Mano Gallery

Scoon, Thomas
Marx-Saunders Gallery, Ltd.

Scott, Gale
Chappell Gallery

Scott, Joyce
Mobilia Gallery

Seelig, Warren
Snyderman-Works Galleries

Seeman, Bonnie
Santa Fe Clay

Segura Sanz, Rosa
Aldo Castillo Gallery

Seid, Eva
Aaron Faber Gallery

Seide, Paul
Leo Kaplan Modern

Seidenath, Barbara
Sienna Gallery

Sekiji, Toshio
browngrotta arts

Sekijima, Hisako
browngrotta arts

Sekimachi, Kay
browngrotta arts
del Mano Gallery

Selva, Margarita
María Elena Kravetz

Sepkus, Alex
Sabbia

Sepulveda, Polimnia
María Elena Kravetz

Sermol, Lilo
Mobilia Gallery

Seufert, Karin
Charon Kransen Arts

Sewell, Ben
Chappell Gallery

Shabahang, Bahram
Orley & Shabahang

Shapiro, Karen
Snyderman-Works Galleries

Shapiro, Mark
Ferrin Gallery

Shaw, Richard
John Natsoulas Gallery
Mobilia Gallery

Sheffer, Avital
Beaver Galleries

Shelsher, Amanda
Raglan Gallery

Sherrill, Micah
Ferrin Gallery

Sherrill, Michael
Ferrin Gallery

Shimaoka, Tatsuzo
Joanna Bird Pottery

Shimazu, Esther
John Natsoulas Gallery

Shimizu, Yoko
Mobilia Gallery

Shindo, Hiroyuki
browngrotta arts

Shinn, Carol
Hibberd McGrath Gallery

Shioya, Naomi
Chappell Gallery

Shore, Phillip
Niemi Sculpture
 Gallery & Garden

Shuldiner, Joseph
Jane Sauer Thirteen
 Moons Gallery

Shuler, Michael
del Mano Gallery

Shull, Randy
Ferrin Gallery

Sieber Fuchs, Verena
Charon Kransen Arts

Sieminski, Rob
Lacoste Gallery

Simpson, Tommy
Leo Kaplan Modern

Sinding, Charlotte
Charon Kransen Arts

Sinner, Steve
del Mano Gallery

Sipkes, Evelien
Charon Kransen Arts

Sisson, Karyl
browngrotta arts
Mobilia Gallery

Skau, John
Katie Gingrass Gallery

Skirball, Jennifer
Thomas R. Riley Galleries

Skjøttgaard, Bente
Galleri Nørby

Slaughter, Kirk H.
ten472 Contemporary Art

Slavik, John
Niemi Sculpture
 Gallery & Garden

Sloan, Susan Kasson
Aaron Faber Gallery

Smelvaer, Britt
browngrotta arts

Smith, Barbara Lee
Snyderman-Works Galleries

Smith, Christina
Mobilia Gallery

Smith, Fraser
del Mano Gallery
Katie Gingrass Gallery

Smith, William
del Mano Gallery

Smuts, Butch
del Mano Gallery

Snipes, Kevin
Santa Fe Clay

So, Jin-Sook
browngrotta arts

Soble, Jerry
Thomas R. Riley Galleries

Solinsky, Steve
Mowen Solinsky Gallery

Son, Seock
Galerie Vivendi

Sonobe, Etsuko
Mobilia Gallery

Soosloff, Philip
Gallery 500 Consulting

Sørenson, Grethe
browngrotta arts

Spano, Elena
Charon Kransen Arts

Speckner, Bettina
Sienna Gallery

Spencer, Sharon
Mowen Solinsky Gallery

Spies, Klaus
Aaron Faber Gallery

Spitzer, Silke
Ornamentum

Šrámková, Ivana
Heller Gallery

Stair, Julian
Joanna Bird Pottery

Staley, Chris
Santa Fe Clay

Standhardt, Kenneth
Mowen Solinsky Gallery

Stanger, Jay
Leo Kaplan Modern

Stankard, Paul
Marx-Saunders Gallery, Ltd.
Wexler Gallery

Stankiewicz, Miroslaw
Mattson's Fine Art

Starr, Ron
Niemi Sculpture
 Gallery & Garden

Statom, Therman
Maurine Littleton Gallery

Stebler, Claudia
Charon Kransen Arts

Stein, Linda
Longstreth-Goldberg ART

Steinberg, Eva
Snyderman-Works Galleries

Stern, Ethan
Chappell Gallery

Stevens, Missy
Hibberd McGrath Gallery

Stevens, Rachel
Zane Bennett Galleries

Stiansen, Kari
browngrotta arts

Stirt, Alan
del Mano Gallery

St. Michael, Natasha
CREA, Galerie des Métiers
 d'Art du Québec

Stockwell, John
Persterer, Art Gallery

stohanzel
The William and Joseph Gallery

Stout, Jake
Thomas R. Riley Galleries

Stoyanov, Aleksandra
browngrotta arts

Striffler, Dorothee
Charon Kransen Arts

Strokowsky, Cathy
Galerie Elena Lee

Strommen, Jay
Perimeter Gallery

Stronach, Paccy
Brushings, LTD.

Stubbs, Crystal
Kirra Galleries

Stutman, Barbara
Charon Kransen Arts

Sueters, Brigitta
Aaron Faber Gallery

Sugawara, Noriko
Aaron Faber Gallery

Suh, Hye-Young
Charon Kransen Arts

Suidan, Kaiser
Next Step Studio & Gallery

Sullivan, Brandon
Mobilia Gallery

Sultan, Donald
Adamar Fine Arts

Surgent, April
The Bullseye Gallery

Sutton, Polly
Jane Sauer Thirteen
 Moons Gallery

Suzuki, Goro
Dai Ichi Arts, Ltd.

Swanz, Jonathan
Thomas R. Riley Galleries

Swyler, Karen
Dubhe Carreño Gallery

Syron, JM
Function + Art/PRISM
 Contemporary Glass

Syvanoja, Janna
Charon Kransen Arts

Tagliapietra, Lino
Holsten Galleries
Wexler Gallery

Takadoi, Kazuhito
Bluecoat Display Centre

Takaezu, Toshiko
Donna Schneier Fine Arts
Perimeter Gallery

Takamiya, Noriko
browngrotta arts

Takeda, Asayo
KEIKO Gallery

Takeuchi, Kozo
KEIKO Gallery

Tamanian, Paul
Longstreth-Goldberg ART

Tanaka, Chiyoko
browngrotta arts

Tanaka, Hideho
browngrotta arts

Tanikawa, Tsuroko
browngrotta arts

Tanner, James
Maurine Littleton Gallery

Tate, Blair
browngrotta arts

Tawney, Lenore
browngrotta arts

Taylor, Michael
Leo Kaplan Modern

Taylor, Richard
Niemi Sculpture
 Gallery & Garden

Teasdale, Edward
Bluecoat Display Centre

Tecosky, Leo
UrbanGlass

Tessaro, Vittoria
Frederic Got Fine Art

Thai, David
Living Arts Centre

Thakker, Salima
Charon Kransen Arts

Thayer, Susan
Ferrin Gallery

Theide, Billie Jean
Mobilia Gallery

Thiel, Suzanne
Pistachios

Thiele, Mark
Raglan Gallery

Thomas, Cheryl Ann
Jane Sauer Thirteen
 Moons Gallery

Thorp, Charlotte
Snyderman-Works Galleries

Tiitsar, Ketli
Charon Kransen Arts

Timm-Ballard, Charles
Sherry Leedy
 Contemporary Art

Tinsley, Barry
Niemi Sculpture
 Gallery & Garden

Tochilkin, Mark
Eden Gallery

Tolla
Frederic Got Fine Art

Tolvanen, Terhi
Charon Kransen Arts

Tomita, Jun
browngrotta arts

Tornheim, Holly
del Mano Gallery

Toro, Elias
María Elena Kravetz

Toso, Gianni
Leo Kaplan Modern

Toth, Margit
Habatat Galleries

Townsend, Milon
Thomas R. Riley Galleries

Trask, Jennifer
Mobilia Gallery

Trekel, Silke
Charon Kransen Arts

Trenchard, Stephanie
Thomas R. Riley Galleries

Trucchi, Yves
AKTUARYUS - Galerie
 Daniel Guidat

Trujillo, Sandra
Ferrin Gallery

Truman, Catherine
Charon Kransen Arts

Trusso, Russell
Yaw Gallery

Tuccillo, John
Ann Nathan Gallery

Turmon, Henry
Rena Bransten Gallery

Turner, Julia
Ornamentum

Turner, Neil
del Mano Gallery

Tuupanen, Tarja
Ornamentum

Tyler, James
Ann Nathan Gallery

Umbdenstock, Jean Pierre
Modus Art Gallery

Ungvarsky, Melanie
UrbanGlass

Upton, Gary
Mowen Solinsky Gallery

Uravitch, Andrea
Mobilia Gallery

Uribe, Luis Fernando
Aldo Castillo Gallery

Urruty, Joël
del Mano Gallery

Vachtová, Dana
Galerie Meridian

Vagi, Flora
Charon Kransen Arts

Valdes, Carmen
Snyderman-Works Galleries

Valenzuela, Shalene
John Natsoulas Gallery

385

Vallien, Bertil
Donna Schneier Fine Arts
Wexler Gallery

Valoma, Deborah
browngrotta arts

Van Assche, Andrew
Palette Contemporary
 Art & Craft

van Aswegen, Johan
Sienna Gallery

Van Cline, Mary
Leo Kaplan Modern

van der Beugel, Jacob
Joanna Bird Pottery

van der Leest, Felieke
Charon Kransen Arts

van Doorschodt, Wim
Mobilia Gallery

van Joolingen, Machteld
Charon Kransen Arts

Van Oost, Jan
Berengo Fine Arts

VandenBerge, Peter
John Natsoulas Gallery

Vandian, Alto
Yaw Gallery

Vanmechelen, Koen
Berengo Fine Arts

Vasicek, Ales
The William and Joseph Gallery

Vatrin, Gérald
Collection-Ateliers
 d'Art de France

Vaughan, Grant
del Mano Gallery

Veilleux, Luci
CREA, Galerie des Métiers
 d'Art du Québec

Vell, Cris
Frederic Got Fine Art

Venables, Prue
Galerie Besson

Vermette, Claude
browngrotta arts

Vesery, Jacques
del Mano Gallery

Vigas, Oswaldo
Aldo Castillo Gallery

Vigliaturo, Silvio
Berengo Fine Arts

Vikman, Ulla-Maija
browngrotta arts

Vilhena, Manuel
Charon Kransen Arts

Viot, Jean-Pierre
Collection-Ateliers
 d'Art de France

Virden, Jerilyn
Ann Nathan Gallery

Visintin, Graziano
The David Collection

Visser, Vivian
Niemi Sculpture
 Gallery & Garden

Vízner, František
Donna Schneier Fine Arts
Galerie Meridian
Wexler Gallery

Vogel, Kate
Maurine Littleton Gallery

Vogt, Luzia
Ornamentum

Volkov, Noi
William Zimmer Gallery

von Dohnanyi, Babette
Charon Kransen Arts

Voulkos, Peter
Donna Schneier Fine Arts
John Natsoulas Gallery

W

Waal, Edmund de
Joanna Bird Pottery

Wachs, Gretchen
Gallery 500 Consulting

Waddington, Anoush
The David Collection

Wagle, Kristen
browngrotta arts

Wagner, Karin
Charon Kransen Arts

Wague, Baba Diakate
Ferrin Gallery

Wahl, Wendy
browngrotta arts

Walden, Dawn
Jane Sauer Thirteen
 Moons Gallery

Walentynowicz, Janusz
Marx-Saunders Gallery, Ltd.

Walker, Audrey
The Gallery, Ruthin
 Craft Centre

Walker, Jason
Ferrin Gallery

Walker, Robert
Jean Albano Gallery

Wallin, Jeffrey
Function + Art/PRISM
Contemporary Glass

Wallström, Mona
The David Collection

Walsh, Joseph
The National Craft
 Gallery Ireland

Walsh, Michaelene
Dubhe Carreño Gallery

Walters, David
William Traver Gallery

Wang, Qin
Galerie Vee

Wang, Kiwon
Snyderman-Works Galleries

Wasserbauer, Jaroslav
Galerie Meridian
Mostly Glass Gallery

Watanuki, Yasunori
Charon Kransen Arts

Watkins, Alexandra
Mobilia Gallery

Webster, Maryann
Santa Fe Clay

Wegman, Kathy
Snyderman-Works Galleries

Wegman, Tom
Snyderman-Works Galleries

Weinberg, Steven
Leo Kaplan Modern
Marx-Saunders Gallery, Ltd.

Weisel, Mindy
Jean Albano Gallery

Weiss, Beate
Ornamentum

Weissflog, Hans
del Mano Gallery

Wejsmann, Andrée
Option Art

Weldon-Sandlin, Red
Ferrin Gallery

Westphal, Katherine
browngrotta arts

White, Heather
Mobilia Gallery

Whiteley, Richard
The Bullseye Gallery

Wieske, Ellen
Mobilia Gallery

Wiken, Kaaren
Katie Gingrass Gallery

Willenbrink-Johnsen, Karen
Thomas R. Riley Galleries

Williamson, David
Portals Ltd.
Snyderman-Works Galleries

Williamson, Roberta
Portals Ltd.
Snyderman-Works Galleries

Wingfield, Leah
Habatat Galleries

Winqvist, Merja
browngrotta arts

Wirdnam, Nick
Palette Contemporary
 Art & Craft
William Traver Gallery

Wise, Jeff
Aaron Faber Gallery

Wise, Susan
Aaron Faber Gallery

Wittrock, Grethe
Drud & Køppe Gallery

Wolf, Irene
Charon Kransen Arts

Wolfe, Andi
del Mano Gallery

Wolfe, Rusty
William Zimmer Gallery

Wolff, Ann
Habatat Galleries

Wong, Marcelo
María Elena Kravetz

Wong, Patrick
Kirra Galleries

Wood, Beatrice
Donna Schneier Fine Arts

Wood, Joe
Mobilia Gallery

Woodman, Betty
Donna Schneier Fine Arts

Woodward, John
Thomas R. Riley Galleries

Wuensch, Karel
Palette Contemporary
 Art & Craft

Wunderlich, Janis Mars
Santa Fe Clay

Yagi, Yoko
Snyderman-Works Galleries

Yamada, Mizuko
Mobilia Gallery

Yamamoto, Izuru
Dai Ichi Arts, Ltd.

Yamamoto, Yoshiko
Aaron Faber Gallery
Mobilia Gallery

Yamazaki, Fumi
KEIKO Gallery

Yang, Mei Hua
Galerie Vee

Yonezawa, Jiro
browngrotta arts
Katie Gingrass Gallery

York, Julie
Perimeter Gallery

Yoshida, Masako
browngrotta arts

Yoshimura, Toshiharu
KEIKO Gallery

Youn, Soonran
Snyderman-Works Galleries

Young, Albert
Next Step Studio & Gallery

Young, Brent Kee
Jane Sauer Thirteen
 Moons Gallery

Yuh, SunKoo
Santa Fe Clay

Yuki, Yoshiaki
gallery gen

Yun, Hye-Won
Guil-Guem Metal Arts
 Research Center

Z

Zaborski, Maciej
Mattson's Fine Art

Zadeh, Catherine M.
Sabbia

Zadorine, Andrei
Frederic Got Fine Art

Zaluzec, Peter
Niemi Sculpture
 Gallery & Garden

Zander, Malcolm
del Mano Gallery

Zanella, Annamaria
Charon Kransen Arts

Zaslonov, Roman
Frederic Got Fine Art

Zaytceva, Irina
Ferrin Gallery

Zbynovsky, Vladimir
Plateaux Gallery

Zehavi, Michal
Duane Reed Gallery

Žertova, Jiřina
Leo Kaplan Modern

Zhitneva, Sasha
Chappell Gallery

Zhuang, Xiao Wei
Galerie Vee

Zia
Sherry Leedy
 Contemporary Art

Zimmermann, Erich
The David Collection

Zirpel, Mark
The Bullseye Gallery

Zobel, Michael
Aaron Faber Gallery
Sabbia

Zonis, Alexandra
Mostly Glass Gallery

Zoritchak, Yan
AKTUARYUS - Galerie
 Daniel Guidat

Zuber, Czeslaw
AKTUARYUS - Galerie
 Daniel Guidat

Zynsky, Toots
Elliott Brown Gallery
Wexler Gallery

American Airlines Is Proud To Be The Exclusive Airline Of SOFA CHICAGO 2006.

To find out more about American, visit us at AA.com.

AmericanAirlines®